"Our earth is degenerate in these latter days.
Bribery and corruption are common.
Children no longer obey their parents.
Every man wants to write a book…
The end of the world is evidently approaching."

Assyrian stone slab 2800 B.C.

Forgotten Satoris Don't Count

a layman's memoir

Vincent Lynch

 ONE HAND BOOKS

One Hand Books
PO Box 185
Mamaroneck, NY 10543-0185
http://onehandbooks.com

Cover, text and book design by Vincent Lynch

ISBN: 978-0-9913612-5-0

- Nonfiction > Biography & Autobiography > Personal Memoirs
- Nonfiction > Biography & Autobiography > Entertainment &
 Performing Arts

Acknowledgements

I would like to thank Dawn Patrick, John Shine and Ed Massey
for their support and feedback in the process of completing this
tome.

Dedicated to
Dawn
my life partner

TABLE OF CONTENTS

CHAPTER 1

JERSEY CITY

Edward "Eddie" Lynch Thomas "Pop" Lynch William "Willie" Lynch Martin Lynch

The particles seemed to sparkle as they rotated in space in constant movement. On either side of the light shard through the window there was shadow. I thought the particles were delivering the light to the illuminated area on the green carpet floor, as I lay in my bed. This was my earliest memory. Unfortunately, as I grew up, I learned that my magical sparkling light particles were only dust mites.

The youngest of four children I had two brothers and a sister. My mother experienced a miscarriage two years before. She had concern regarding delivery complications, so she hadn't chosen a name. After a successful delivery, she asked the nurse at St. Francis Hospital, a sister of the Sacred Heart, "What saint's day is this? The sister looked at the religious calendar and replied, "St. Vincent de Ferrer" and Vincent became my name. When it was announced that I had arrived my sister,

Maureen, cried. She had hoped for a little sister to balance the family with two boys and two girls. In 1946 you didn't know what the baby's sex would be until it arrived. Her short lived disappointment evaporated, however, and she doted over me throughout my childhood.

We lived in the Greenville section of Jersey City on 314 Fulton Avenue. We had a middle class house of the fifties, a seven room three story house with a finished attic on a single lot. The house had peaked roofs with black asbestos shingles. The sides were maroon clapboard with the lower portion of the house covered in a synthetic siding made to look like stone called "Permastone", which became quite common in neighborhoods in the 1950's. My brothers, Dennis and Tom, were in the attic. My room, my parents and sister's rooms were on the second floor with a full bath at the end. The first floor had the kitchen, den, living room and dining room. It also had a full cellar, in which, my oldest brother, Tom, ten years older than me had a large Lionel train set layout. When we lived in Jersey City, he was dad's favorite…my father favored him. After all he was Thomas E. Lynch Junior. Tom had little to do with me growing up due to our age differences. Dennis on the other hand, four years older than me, would be the one I would go to if I needed "big brother" support for protection in the neighborhood.

My dad, an attorney, had his own firm, "Lynch, Lora and Milstein", with offices in the Trust Company of New Jersey on Journal Square in Jersey City. His success allowed my mother to be able to hire a maid and enjoy a level of leisure time not available to most average upper middle class wives. How my father ended up practicing law is a story about his father, Thomas "Pop" Lynch.

My grandfather, the oldest of thirteen children, came to the USA in the early 20th century from an Irish village, Cloonravn, on the Mayo and Sligo county border. His early history is clouded except for a few stories passed down. It's surmised he came to these shores as an indentured servant. Passage to the new world was expensive and only the rich could afford the costs. In return for passage an indentured servant contracted to work usually on an upstate New York dairy farm for a term of four to seven years. When the immigrants landed in New York, they would

be taken to their work locations and normally were handcuffed to beds at night to avoid escapes.

The Irish were the low rung on the immigrant ladder. There were signs all over New York City that stated, "The Irish need not apply". We assumed he must have escaped the farm because he became a teamster shortly after his arrival. He drove a team of horses not a truck, on the New York waterfront. Eventually, he established himself in Jersey City, New Jersey. He opened a tavern, which was successful, and then

Govenor Candidate
A. Harry Moore Franklin Roosevelt

proceeded to bring over his brothers two at time to open other establishments, one tended the bar and one ran the kitchen. Eventually all the brothers and one sister were able to come to the USA. The "Irish" bars were extensions of the pubs of the old country. They were the hub of political discussions and deals with a clientele consisting mostly men. I remember as a child that taverns had separate entrances on the side for women with table seating, so they wouldn't have to walk past the men sitting at the bar.

My Father
Mayor Hague
Roosevelt Stadium Openning 1946

Frank Hague, the Democratic mayor of Jersey City for thirty years from 1917 to 1947,[i] was a prime example of the "boss" politician of ward politics and patrimony like Curley in Boston or Daly in Chicago. He was the most powerful Democratic politician in New Jersey, more important than the governor or a senator. He also represented the rise of the Irish from the lower rungs of society to positions of power. My grandfather was influential…a player in this political arena.

When my father graduated from law school, he law clerked for A. Harry Moore[ii] then serving his third term as governor of New Jersey. Governor Moore had served the limit of two consecutive terms being governor from 1926 to 1935. He then ran for senator and won serving from 1935 to 1938. He then resigned and ran for his third term as governor in 1938. My aunt, Adelene, the wife of my father's brother, James, was Governor Moore's secretary. My father was eventually appointed to head President Roosevelt's WPA public works program for Hudson County, New Jersey. One of the most powerful non-elected positions in the state. He supervised the construction of many sites including Roosevelt Stadium in Jersey City. On April 18, 1946,

4

Roosevelt Stadium hosted the Jersey City Giants' season opener against the Montreal Royals, marking the professional debut of the Royals' Jackie Robinson and the first time the color barrier had been broken in a game between two minor league clubs.[iii] My father's position reflected his father's powerful influence in local politics at the time.

Jackie Robinson breaking the "color" barrier at Roosevelt Stadium playing for the Montreal Royals [iv]

My father's brother, James, in his early thirties wanted to serve in World War II even though he didn't have to because he was married. He went against "Pop's" wishes and enlisted in the Air Force anyway. In spite of wanting to see action at the front he ended up being stationed at Hamilton Air Force Base in Novato, California. He never left the USA. It was felt his domestic location was an effect of his father's influence with Frank Hague and by extension the Roosevelt administration's War Department. His doctor son would not be allowed to get himself killed overseas with a family to raise at home. The Irish ran the government in Jersey City and Frank Hague had national influence with direct access to President Roosevelt.

John L. Sullivan

Among my grandfather's generation handball was a major sport. He had courts behind the bars and even played with John L. Sullivan, the retired first heavyweight champion of gloved boxing. We would visit my grandfather on Sundays at his house. We were taught to shake hands on greeting "Pop" and say "kayawilfha". I never knew what this meant. I asked Gallic scholars when older, but they didn't have a clue either. I remember how my little hand felt in his massive palm. His palms were rough and his grip extremely powerful…useful for handball or ejecting an unruly patron from his establishment. He had an engaging warm personality…tough with a heart of gold.

In addition to taverns, he also invested in apartment buildings and other commercial properties. Before the stock market crash of 1929 he had 13 apartment buildings, several commercial properties and houses. When the depression hit after the stock market crash of 1929, people couldn't afford their rent. No one had money. There are stories of relations losing their homes and being forced to move into other more solvent family members' homes. The unemployment rate soared over 25%. My grandfather refused to evict people that couldn't pay. Few people had jobs and others couldn't afford to move in anyway. Because of his actions, the banks foreclosed the properties.

My father, who had just graduated from Georgetown Law School, which he also attended as an undergraduate, was called upon to negotiate a deal with the banks for his father. He made a deal with the

banks to trade all thirteen properties including apartment buildings for a house and a block of commercial properties on Jackson Avenue in Jersey City. I think the bankers took advantage of a greenhorn fresh out of law school. He negotiated an extremely bad deal.

I thought the story about my grandfather not evicting people an embellishment, but it was later corroborated by the aunt of my high school girlfriend, who lived in one of my grandfather's apartments. She confirmed it, referring to him as "Tom Lynch, one son a doctor and the other a lawyer". Which brings us to how my father became a lawyer. My grandfather was a first generation immigrant, a self-made man, who wanted a better life for his sons. "Pop", my grandfather, flipped a coin and pointed to my uncle and to my father and said, "You're the doctor and you're the lawyer." The decision had been made. My grandfather had a strong will. When he found out that my father in his teens, who loved to dance, had purchased a pair of tap shoes, he took my father to the basement and burned them in the furnace. His sons would be professionals...not showbiz dancers.

My grandfather lived with his daughter, Marge, my aunt. It was common at the time for one daughter to remain behind and not marry to take care of the parents, as they aged. Also true on my mother's side of the family, my aunt Marjorie took care of my maternal grandmother. My maternal grandfather and paternal grandmother had passed away before I was born. Since the aunts were both Marjorie, the Lynch side became Aunt Marge and the Doust side Aunt Marjorie or Margie.

Descriptions regarding my grandfather's occupation during prohibition were vague. What are the prospects for a former bar owner? An event much later may have shed light on this conundrum. In the 1960's Marge Lynch asked my cousin, James "Cub" Lynch Jr., to clean out our grandfather's old commercial store fronts to prepare them for sale. These properties were the result of my father's earlier settlement with the banks. The store fronts were situated on Jackson Avenue between Fulton and Park Streets in Jersey City. Around the corner on Fulton Avenue my grandfather and Marge lived in the first house. A small dead-end alley sixteen feet wide ran between the rear of the commercial

7

properties and his house. When Cub did the cleanup, he found what appeared to be a card room with green felt tables, located on the second floor of the tavern. In the basement after removing the debris, he revealed a tunnel that connected to the basement of my grandfather's house. Cub's imagination raced with all the implications of what his find meant. He asked Marge about it. Her nonplussed reply, "Oh, I always wondered about that. I used to hear men in the kitchen, but no one came in the front door." Cub pleaded for more information to no avail. No bootlegging or IRA support stories were offered. Cub, flummoxed with the brevity of her reply, received no satisfying answer.

In Jersey City we had a basketball court in the backyard with a backboard on the two-car garage, a feature that made our house a hub for kids. Having a basketball court in the backyard helped Dennis, while still in grammar school, develop his basketball skills by playing with Tom's high school friends. In a city space is precious. There was only one court at the public school yard down the block. You had to wait your turn to play and winners remained on court. Next to the court in the school yard was a wall with a marked rectangular vertical box of the strike zone for playing stick ball. All you needed was a pink Spalding ball and a broom stick to have a game. Handball also had popularity. These were the sports of the city at the time. The National Football League only had eight teams and wasn't that popular. The national sport baseball was unsuitable for cramped urban spaces. Boxing was also very popular having made the transition from radio to television.

When we were dismissed from school, all the kids flooded the streets. Nobody wanted to stay inside the house. At this time in the early 1950's, radio was still the primary medium; televisions were just being introduced and were only for the well off. Our first television was in a wooden box the size of a clothes dresser with a black and white fourteen-inch screen. Three channels were available at different times of the day.

Kids had to devise their own play, which took the form of many street games such as, hop scotch, jumping rope in various styles, ball games against the "stoop" (the steps leading up to a house), dodge ball,

shooting marbles, flipping baseball cards, roller skating etc. I never liked roller skates. They had an adjustable metal platform that fit the shoe size. There were attached to the soles of the shoes with straps across the ankle and toe area. The wheels were metal with "alleged" ball bearings inside. You'd be lucky to go two feet on a thrust forward. I never mastered them, but I did find good use for one skate. The skate could be taken apart. We would then attach one set of wheels to a wooden crate and the other set to the end of a wood strip attached to the bottom of the crate to stand on. On the top of the crate we would attach another strip of wood for steering. The steering mechanism had little effect actually, but it looked cool. Living on a hilly street was all the better for speed, but it came with the issue of how do we stop with no brakes. We learned to bail out at the right time. You always could fix any collateral damage to the scooter, but there could be a parental penalty, if you did something stupid, dangerous and got hurt.

The center for the kids was Snyder's Candy Store, a black hole for all their coins. For a child between seven and nine years old, it didn't get any better. A general store for kids with the windows filled with toys, like the Lone Ranger double six-shooter holster set I got one Christmas, Slinkies, yoyos, dolls, baseball gloves, etc. As you entered on the left, there was a soda fountain with a wooden counter and stainless tubular stools covered in green leather. The back bar had mirrors and the colorful syrups were displayed in clear bottles with chrome spouts. A root beer float with vanilla ice cream was ten cents, root beer by itself five, and only seltzer two cents, called "two cents plain" when ordered. It seemed quite expensive at the time. In rear of the store on the left side were five-gallon jars of penny candy and also the packaged variety. The toy stock in descriptive boxes behind the counters on the right became a magnet for the kids' imagination. When a yoyo champion would come to the store to demonstrate, there would be a big promotion in advance of the event. You would receive merit patches for the tricks you could do. All the kids in the neighborhood had yoyos, a big fad, which preceded the ubiquitous hula hoop.

The neighborhood at the time was primarily composed of second generation immigrants. As first wave immigrants moved into

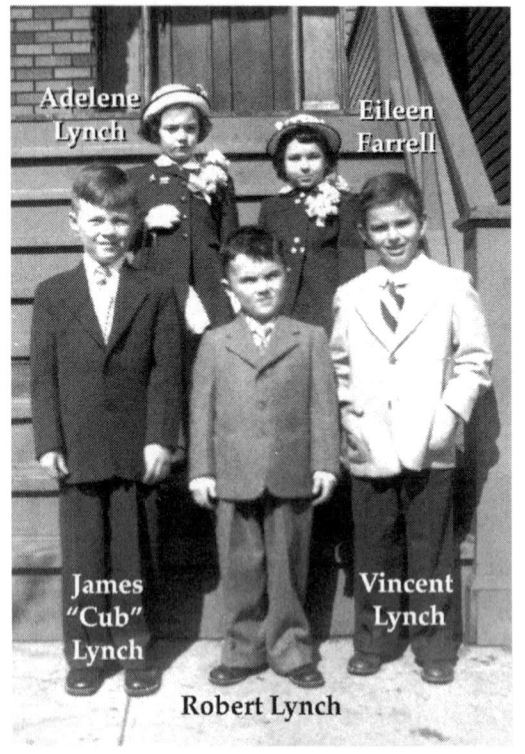

Adelene Lynch

Eileen Farrell

James "Cub" Lynch

Vincent Lynch

Robert Lynch

neighborhoods from the tenements, they still congregated close to one another. My cousin, James "Cub" Lynch Jr., who I played with often, lived up the block on the corner. "Cub's", nickname reflected that of his dad, James "Tiger" Lynch, my father's brother, the doctor. Cub and I invented fantasy adventures. Onetime Cub thought there might be a treasure buried in his back yard in the area where he had interred one of his pet dogs. We dug away and I think we went through the bones, but then there we heard a metal clank from the shovel. We looked at each other with widened eyes and started to dig furiously. We hit the treasure chest. When we ran in to his house to tell his dad, the doctor, we were informed it was the gas pipe and if we broke it, we would be in big trouble. In spite of the result, we had an exciting afternoon. A treasure hunt is always about the journey. Cub and I had a lot of fun together, which often led to trouble. One time we thought it a grand idea to climb up on the roof of the far side of my garage, which was contiguous to a dead-end street behind our property. We ripped the asphalt shingles off the roof and frisbeed them into the street. The Frisbee didn't exist yet. We had no idea of the financial impact of our fun, but we did know it was wrong, but just too much fun to stop. We both suffered the consequences of our acts with our fannies. We were both "divils" in the Irish parlance, yet still beloved by our families. Like our grandfather "Pop" and Cub's father, James, we were of a certain Lynch strain, unlike my father or brothers. Pop and Uncle

James were initiators not reactors like punchers versus counter punchers in boxing.

My grandfather lived two and a half blocks away. The families were still closely knit before the diaspora. People were defined by their nationality as an addition to their given name, Pat, the Irishman or Hans the German. The identities were further defined by religion, the Catholic, the Jew, the Protestant, etc. A mixed marriage at the time consisted of two people of the same faith with different nationalities, a holdover from the first wave of immigration, which dissipated with subsequent generations.

Religion formed the glue that seemed to keep the community together. Regardless of faith all houses of worship were filled to capacity on the weekends. People would attend in their "Sunday Best". There were three levels of kids clothing: play, school, and Sunday best. All the religious denominations had numerous activities for their flocks, such as, bible study clubs, choir, sports, etc., which engaged them during the week. It gave people a sense of community. The year revolved around religious holidays. Easter was the time that most kids got a new outfit to attend services. There were also the Easter Parades in cities where people would stroll showing off their new duds.

When very small, I remember a vendor with a horse drawn cart, a holdover from another time. The knife sharpener had a large black draft horse with bright red tack. The wagon had a roof with red and green decoration on the edges. The four sides of the wagon were open and a gong hung that he would bang to herald his arrival. The housewives would come out of the buildings and give him their knives to sharpen in the wagon on his foot kicked grinding wheel.

My mother enrolled me a year early in kindergarten at St. Aloysius Academy. Her policy was to get the kids out of the house and into school, as soon as possible. Although a Catholic girls school from K through grade 12, boys were allowed to attend through third grade. Cub and I were in the same class. My sister also attended the Academy, so it was convenient for drop offs for my mother. The teachers were nuns,

Sisters of Charity. In their religious style of habit, they were draped in black crepe and their faces were framed by a contrasting starched white linen rectangle with white linen ascot. I became sick in first grade and was diagnosed with Viral Pneumonia. I ended up having to stay at home for a year and had to repeat first grade.

In the year I spent recovering at home, I had to take Aureomycin to combat the Viral Pneumonia. I had trouble swallowing the large capsules, so my parents thought it was a good idea to put it apple sauce to offset the bitter taste. The result tasted horribly bitter and ruined apple sauce for life for me. If they had tasted it themselves, I think they would've come up with an alternative method. My mother was neither a great cook nor maternal, but she did like to shop. I remember her coming home with shopping bags from Kresge's and Ohrbach's, which were stores located in Newark, New Jersey. She would always exclaim how much money she had saved. I could never understand how she saved money by bringing home so many boxes. She was talented musically on the piano, however, and often could become the life of the party playing requests.

In the year I was sick I spent most of my time with our house keeper, Ryan, a charming old Irish woman with weathered skin, blueish gray hair and rimless glasses. She usually wore a plain dark dress accessorized sometimes with a lace collar. Her favorite past time was having a cigarette and a cup of "neskefay" at the kitchen table. She was a saint and I, a terror. Curious and bored one time I tried sticking a fork into the electric receptacle, which ended with an abrupt learning experience. I got it, no need to try again. I would hide under the beds from Ryan and she would try to get me out with a duster. When my mom came home she would ask, "How was he?" She replied with the same answer every time, "He was an angel." She had my back and never turned me in. I loved her very much.

I watched a lot of TV on the small screen shoot 'em up westerns and cartoons literally raining cats and dogs. In the westerns the cowboys were all rolling down the stairs in the fight scenes. I decided I wanted to try it. The steps from the first to second floor of our house contained

two landings and three sets of steps. I went to the top of the stairs, rolled myself into a ball and went for it. As I unfolded on the carpet in the living room, my mother rushed in yelling, "Jaysus, Mary and Joseph, what happened?" when I explained what I did my mom's face changed from fear to anger. I was rewarded with a swift smack to the arse for my movie stunt. I may have been more trouble than most kids. I loved dares.

The Franco brothers lived three houses down the street. Arty was my age, Nicky, two years older and Richie three years older. We had a club house in their garage, a center for planning activities. Richie always in charge being the oldest was a fair leader. Arty and I were best friends. Nicky, another story, was wild, never adhered to his brother Richie's wishes and always got in trouble. He was the kind of kid in the neighborhood that seemed destined for a bad end, like prison.

One time Nicky Franco was bashing a lead pipe on the top of a low concrete wall. The game involved removing your finger before the pipe hit. I was a little slow, hence my curved right pinky finger. Another time Nicky, playing king of the mountain, had surrounded himself with a wall of concrete chunks from the new school under construction down the street. The other kids were making a frontal assault. I came up from the rear and at the last moment he saw me. He pushed one of the walls toward me. It tumbled down and hit me in the head opening a blood vessel above my eyebrow. I arrived at my house in the arms of Leo, a friend of oldest brother Tom, and he presented me to my mother with my face was completely covered in blood and she gasped. When things like this happened, parents would meet to discuss the incident and the ruling more often than not was "Boys will be boys".

One time, when Ryan wasn't there, my sister, Maureen, attending high school was supposed to be home to babysit me. She never arrived. I was six years old and decided I should go find her. I walked up the block to Hudson Boulevard and hopped on the bus in the direction of Maureen's school. I have no memory, if I paid or the bus driver just let me on. The school was a couple of miles from our house and I didn't know its exact location, but I remembered what the school looked like because I attended there the year before. The favorite after school hangout was a

coffee shop called the La Petite. All the girls referred to it as "the La" and eventually the shop changed its name to comply with the students' wishes. I saw the school and the La in the next block. I got off the bus went across the street and entered the coffee shop. My sister and two other girls were drinking a soda in a booth. She screamed and rushed toward me and hugged me. We went back to the booth and her friends smothered me in affection for "being soo cute". I felt a bit embarrassed. This became the first experience Maureen and I would not share with our parents.

My memory of this time is of my father as a distant figure. He was building a successful law practice and we didn't have that much personal interaction. I became aware that he was well respected, however, when we went to his office on the top floor of the Trust Company of New Jersey, the tallest building in Journal Square at the time. All of the people knew him from parking lot attendants, the elevator operator and even the president of the Trust Company. I remember advice he gave me to "always remember the little guy". He said, "Big shots always take them for granted."

We only had two "man to man" conversations that I recall. Once I saw him carrying in glass milk bottles that the milkman had left at the side door of the house. I was about six years old or younger, when I volunteered to help. There were four steps up from the back door to the kitchen. On the second step I lost my grip due the moisture on the bottles from being outside in the metal rack. It crashed on the step. I looked down mortified and I broke into tears. My father consoled me when this happened and explained to me the difference between an accident and a mistake. He told me that I didn't do anything wrong. The other discussion occurred when my brother Dennis and I got in trouble for some infraction, we were sentenced to the "strap". The "strap" was an old leather belt without a buckle. At the time the parental philosophy of "spare the rod and spoil the child" was strictly enforced at home, as well as, in the Catholic schools we attended. My father asked, "Who wants to go first?" I looked at my big brother Dennis and he just stared forward silently. I said, "I'll go." My dad dispensed the beatings, but the next day he took me aside and praised me for going first. I remember this

because the culture in the average Irish home at the time held positive reinforcement in low esteem If you got a 95% on test you would be asked, "What happened to the other five points?"

In second grade I switched schools to Our Lady of Victories, OLV. I would walk down Fulton Avenue with my brother Dennis and we'd take the red and black West Side Avenue bus to school. All the homes on the street were on standard twenty-five by seventy-five foot lots. They were primarily single and two family homes with no apartment buildings. Our street, Fulton Avenue, had Eastern Sycamore trees on either side of the street. The canopy formed a green tunnel over the street, when the leaves came out in the Spring. They also produced a fruit in the Spring that consisted of a hard ball one and a half inches in diameter with little spikes on a thin three-inch stem. We called them "itchy balls". They became ammunition. Somebody would call out, "Itchy ball fight" and the kids would grab the balls duck behind a redoubt of car or wall and it was free for all. There were always plenty of ammo given sycamores were on both sides of the street.

In the mid-fifties boxing was the major national sport. Everyone knew the names of the champions of the different weight divisions and contenders. There was a training systems, such as, the Golden Gloves for amateurs. It was common in school to pick a fight with new arrivals to see where they ranked in the pecking order. There were fist fights all the time. Everyone knew in each grade their rank from the toughest on down like a tennis bumper board. If you were number seven and beat up number three you moved up and he down in the rankings. This was a reflection of the urban society at the time. On Friday everyone, who had a television, tuned to the Gillette Blue Blades Friday Night Fights, the most popular TV show at the time. The power that radio had brought to promote boxing carried over to TV.

There were also gangs in the early 1950's. They were mainly composed of blue collar kids of the second generation immigrant wave. They were drawn from common ethnicity, neighborhood or school. It gave you an identity and the jackets were extremely cool. They were more boy clubs than gangs. At our school OLV there were the "Barons". They had pink

and black corduroy jackets with block lettering of "Barons" on the back. The largest gang at the time in Jersey City were the "Romans". They were composed primarily of Italians. They had corduroy chartreuse and black jackets with a Centurion helmet on the front and "Romans" displayed in script on the back. They also were reversible, which added to their coolness from the perspective of a third grader. Sometimes there were "rumbles" or gang fights. Often there was a discussion beforehand on which weapons were allowed, fists, sticks, brass knuckles, etc. Rules were agreed and location set. In this case I think this had its source in boxing and the idea of a fair match. The concept of fairness is an American trait. These "gangs" existed in a society devoid of drugs and little crime in a time of innocence and prosperity.

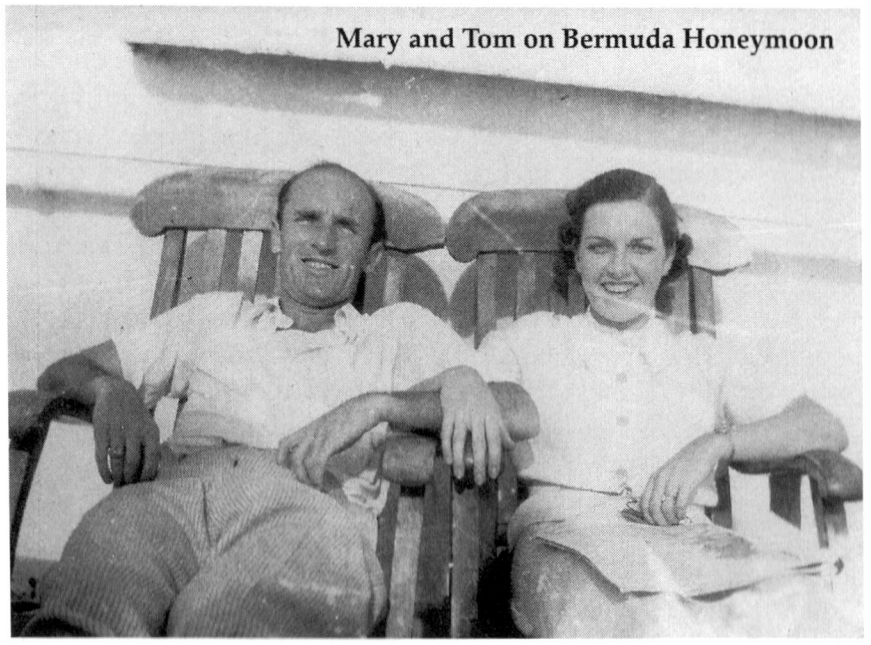

Mary and Tom on Bermuda Honeymoon

Though "boys will be boys" was a common edict of the time, the culture bred corporal punishment and to mitigate its exercise upon me, I came up with a plan. My parents were reluctant to use a hard item like the back of a brush for spankings. Also the human hand had its limits. They kept the "strap" under their mattress. I decided, if I hid the strap, it would reduce the pain of my frequent spankings. It worked. The next

time the strap was called for, it couldn't be found. I have to admit, as a "divil", I enjoyed seeing my parents running around their bedroom searching for their tool of pain in vain. They went back to the hands on approach and I kept my silence.

In the Summer, when I finished third grade, we moved to the Jersey shore. My brother Dennis was going into high school and I was entering fourth grade. Tom and Maureen were already in college. I no longer would have Cub as my best friend. The diaspora had begun.

CHAPTER 2

JERSEY SHORE

Maureen with bike at 20 Ocean Ave., Monmouth Beach in 1946

In the Summer of 1946, after I was born, my parents purchased a home on 20 Ocean Avenue in Monmouth Beach, New Jersey for twelve thousand dollars, a three story Victorian home with a porte-cochere on the left side. Behind the house was a two-car garage and a large mowed field. The property went back 300 feet big enough for the kids to play baseball. At one time it belonged to the film actress Lillian Gish[v] called the "First Lady of American Cinema". Her screen and stage career spanned 75 years, from 1912, in silent films to films and television concluding in 1987. Her home was apparently moved to the Monmouth Beach site from Long Branch, New Jersey. It was not uncommon to move entire intact houses at that time and more cost effective than building from scratch. These were Summer beach homes usually with no basement and a fireplace for heat.

Maureen Tom Dennis

Our family would come to the shore, when school ended in the city, and my dad would stay in Jersey City working. He would come down to the shore early on Fridays for the weekends and sometimes not go back to Jersey City until Tuesday. On the third floor, originally the servant's quarters, a rectangular window in the middle of the chimney became a favorite place. I remember crawling in and watching the ocean across the street. One time I saw dolphins attacking a shark ramming and tossing it up in the air. The Jersey shore, the actual location where the attacks took place, inspired the book and famous movie "Jaws". In early July 1916 five people were attacked and killed by sharks.[vi] I recall being lulled to sleep by the rolling waves. This early imprinting led to my love of nature. My oldest brother Tom loved to fish. My sister, Maureen, socialized with her girlfriends and of course, the boys. My other brother Dennis played baseball and tennis performing equally well in both. At a point my father insisted that he give up baseball and focus only on tennis because, like golf, you could play the sport throughout your life. My father's advice was prescient. Dennis became state champion in the Boys and Junior divisions before going on to become captain of the Yale tennis team. As Dennis started to ascend the ranks in the New Jersey Boys division, my father informed me that Dennis and I couldn't play together anymore because it would "throw him off his game". I don't know if Dennis was even aware of this, but my father wanted nothing to impede his progress in perfecting his tennis skills. I didn't want to be an obstacle in his progress, but it was a big loss for me because I really missed playing with him.

We were on the west side of Ocean Avenue across the street from the beach. Directly across the street was another white Victorian, a summer retreat center situated on the beach, occupied by an order of Catholic nuns. It was not uncommon for wealthy families to donate properties to religious orders in wills. These were extremely large homes generally in beautiful ocean settings. There were several religious order's retreats sprinkled along the Jersey shore in the forties and fifties. Next to the nuns on the left facing the ocean was the Monmouth Beach Borough's town beach called "the pavilion", named for the sole building on site. Unlike California most beach property on the east coast is owned privately. We belonged to the private Monmouth Beach Club, five houses north of "the pavilion" a longer way to walk from my house to the club than it sounds.

The five houses were beautiful estates with long manicured lawns and hedge topiary. Some were designed by famous architects. The Seymore's house next to the beach club was designed by Stanford White[vii]. When you walked into the entrance of their house there were two curved stairways that descended from the second floor like a Hollywood movie set. Unfortunately, I also remember, the ocean surging through engulfing the first four steps of the gracious stairs in hurricane season. These homes were occupied by large families like the

Dormants. They were a large family of eight and Chris, one of the sons a close friend. Large families were common at the time, especially among Catholics, who practiced limited birth control. My friends had families of eight, ten, and even thirteen, which required a lot of housing.

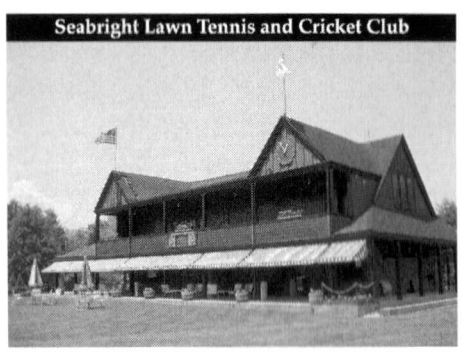
Seabright Lawn Tennis and Cricket Club

The club members were mainly successful Catholic families some of which were local and some from the city. These were Summer homes for many Manhattanites. We did have one Jewish couple, but no people

of color in the club. Country clubs, beach clubs, tennis clubs were exclusive at the time along racial and ethnic lines. Of the various groups Jews were the most discriminated against. Prior to the civil rights movement blacks weren't even on the radar or part of racial discussions. The Jews in protest built their own golf club in Deal, New Jersey, more elegant than any other from which they were refused admission. Discrimination was rampant, but sometimes the rules were bent. For example, we were the second Catholic family in the Seabright Lawn Tennis and Cricket Club[viii], an exclusive WASP (White Anglo Saxon Protestant) institution founded in 1877, the second oldest in the USA. Acceptance had a lot to do with my brother, Dennis, being New Jersey State Champion at the time. Sometimes an exception for religion could be made.

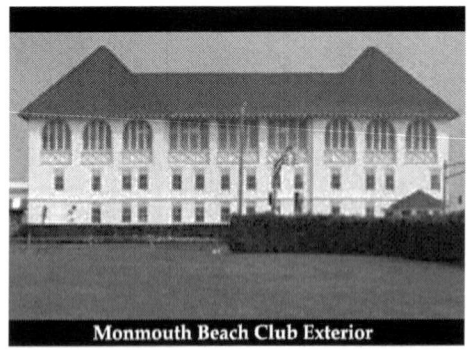

Monmouth Beach Club Exterior

The main building of the Monmouth Beach Club had cedar shingle exterior painted bright white with a black asbestos shingled roof. A three story structure mainly composed of bath houses, rooms where you would change clothes to bathing suits, and store beach gear. The interior of the structure of the bath houses faced three swimming pools. On one side a standard size Olympic pool with low and high diving boards and on the other were two pools separated by a patio with an awning under which to have drinks and snacks. One pool five feet deep was devoted to beginning swimmers and the other a baby pool shallow with a warm yellow tinge. The main structure was connected by a boardwalk next to the beach at the top of the blue gravel parking lot. At the end of the

Monmouth Beach Club Interior

boardwalk there were five cabanas next to the tennis courts. Behind the cabanas were a locker room and tennis pro shop. Across the blue gravel driveway to the rear parking lot, a covered viewing area shaded benches in front of the four red clay tennis courts. The other two courts were located behind the four and had a backboard.

This is where I spent most of my time with my best friend at the club, Alexander Joseph Shanley, better known as "AJ". I actually don't remember not knowing him because we grew up as babies at the club.

Dennis
MBC Boy's
Champion

We played tennis all the time and rarely swam except swimming in the ocean after the hurricanes in August. Finally, we had large waves to ride. We would ride them with canvas covered rubber air mats that had to be blown up. There were no boogie boards or surf boards yet on the east coast. One time I wasn't on a mat and got pulled out off shore by a riptide. Waving to my friends, they didn't realize I needed help and waved back. Fortunately, the riptide dissipated at the end of the jetty. I did learn to not freak out in the ocean and let nature take its course until I could do something about it. Jetties were large rock escarpments usually built to extend from the shore perpendicularly into the sea. They were thought to help reduce beach erosion. In fact, as time went on, they had the reverse effect. They were useful for fishermen, as long as, they could bring home their catch jumping the jagged boulders and avoiding crashing waves.

The tennis pro at the club was Louie Ballatto, a New York City tennis pro and a ranked senior professional. In the Summer he rented a house on the shore and moved his family down to escape the heat of the city and experience shore activities. He would teach tennis for the three months at the club during the Summer. He had dark southern Italian olive skin with slick black hair greying at the temples and a little curly in the back. Although a bit stocky, he moved well on the court and his touch with a tennis racket could be light as a feather. His favorite play, a drop shot just over the

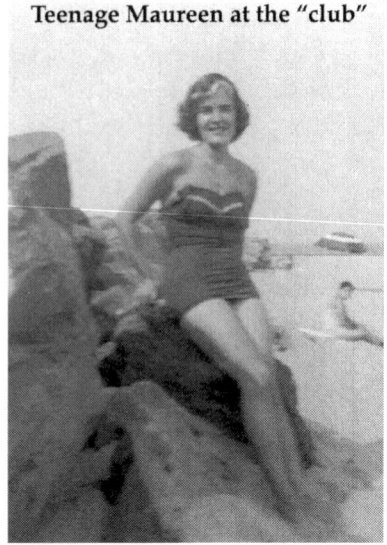

Teenage Maureen at the "club"

net with reverse spin that would bounce back over to his side. It was unplayable.

He had a daughter and a son. Marion would keep track of all the lessons that her dad taught all day long. Her dad would come in covered in sweat between lessons and try to cool down with an iced tea. She had a peculiar talent. In the NY Daily News there's a word puzzle called "Jumble". The point is to unscramble the words, then take the letters circled to form another puzzle, which unscrambled, was the answer to a cartoon on the right. She would just look at the cartoon and get the right answer without unscrambling the words…magic to us kids. Her brother Arthur, attending MIT at the time, would string tennis rackets with gut to classical music in the pro shop. He tried to interest us in the music, but failed. He had success, however, in introducing the kids to chess. They were warm and embracing…in contrast to the competitive Irish family environments that AJ and I had experienced.

We would play tennis for hours on the red clay courts our favorite surface for playing tennis. It had a high bounce, you could slide in the top dressing, when necessary to hit. The ball usually stayed in play longer than on grass. We played singles, doubles, mixed doubles, or

just went out to volley. We lived on the courts. We had "tennis tans". Our head, neck, arms and legs exposed to the sun were tanned, but our chests and feet were not. There were sharp lines of demarcation at the neck, biceps and ankles. After exhaustion we'd cool off with a swim and have a snack. The Summer break from the city became an idyllic time for me filled with the diverse experiences of the Jersey shore.

When not at the club I would spend time with my first cousin, Stephen Raye, a couple of years older than me and the son of my mother's sister,

Beach Day at MBC with Dad

Lillian, a school teacher. In the 1950's the three paths for women were to: get married, join a religious order, or stay at home to take care of aging parents. The best occupations for women were as secretaries, teachers and nurses because, if a husband died, it was a supportable occupation to continue to raise a family. "A woman's place is in the home." stated the mantra of the time. The World War II period began the first time women were added to the larger work force due to the lack of men, who were serving in the armed forces. Rosie the Riveter became a role model. Now, however, the men had returned to the most prosperous time in US history with over seventy-five percent of family income discretionary after food, housing and health care costs were calculated. The production machine built during the war to defend now reaped the benefits of peace time prosperity. President Eisenhower launched the interstate highway system, a massive public works project, which connected all the contiguous forty-eight states with highways to promote interstate commerce.

Stephen lived in Monmouth Beach year around on 10 Riverdale Avenue, which ran parallel to Ocean Avenue two blocks in from the ocean. Monmouth Beach was bordered by the Atlantic Ocean on the East and the Shrewsbury River on the West. Steven and I would spend time at our Aunt Margie's in Port-au-Peck a short bike ride from Monmouth Beach. At the end of the ride we crossed over Pleasure Bay on an old swing bridge that had the look of an Erector set model. We thought it cool because the center part of the bridge rotated to open to allow the boats through versus draw bridges that went up and down. The bridge operator controlled the bridge seated in the center peak of the structure in a room similar to a lighthouse with windows on all sides. The stationary vehicular part of the bridge was supported by sunken pylons. Sometimes large boats would come through like the ferry from New York City to bring people to the Monmouth Park Jockey Club, which had a thoroughbred racing season that ran through the Summer. At the time the only legal places to gamble were at race tracks or in Nevada.

Aunt Margie lived in the summer in a house my maternal grandfather built at 110 Comanche Drive in Port-au-Peck, New Jersey situated on an eight-foot high berm with white clapboard, black trim and a black asbestos shingled roof. The second story had a peaked roof and a dormer with windows. A porch ran the length of the front part of the home.

Margie was very frugal. Her generation lived through the Great Depression of the 1930's, and two world wars. Her father died before her sisters had finished school. She supported my maternal grandmother and her three sister siblings until they married. Margie was an instructor at Georgian Court College in Lakewood, New Jersey, where she arranged a scholarship for her younger sister, Mary, my mother. When she retired, Margie lived on social security and a modest teacher pension. She loved painting and music. A devout Catholic, she played the organ at various church functions at local churches, like Precious Blood in Monmouth Beach or Star of the Sea in Long Branch, New Jersey.

Crabbing and fishing were favorite activities we did with Margie. Each Spring she would descend on a dilapidated boat yard down the street and negotiate for the cheapest old row boat in the yard. We would borrow rollers from Freddie Rensler across the street and we would roll the boat back up Comanche Drive to Margie's to do repairs, caulk the bottom and paint it with barnacle resistant paint to make it sea worthy. The method to get it up the street required three people. The boat was supported on three inflated canvas rollers with Margie and Stephen on the port and starboard sides. As we went up the street, my job was to take the roller from the stern and run around and put it under the bow to continue progress. When finished, we'd reverse the roller process to return to the boat yard for the launch. There were two that I remember *"Footbath 1 & Footbath 2"*. They were christened by my aunt with this name due to our experience as shipmates when launched. Despite our efforts to the plug all the leaks, we were bailing out water, as much as, fishing and crabbing. The Erector set bridge pylons, however, were an excellent spot for blue claw crabs.

Aunt Margie's Port-au-Peck home built by my grandfather

Later, Margie became a principal at a Jersey City public school. During the school year she lived in an apartment near my father's office in Journal Square with a parakeet. She lived on a tight budget and kept track of all of her expenses. In the Spring, she would take me on weekend trips to the shore. As we left Jersey City, we would drive past gas stations having price wars. I remember sixteen cents a gallon. She would always record in a book in the glove box the amount spent for gas and the volume purchased. I had no idea of what purpose this accumulation of data served. A bridge we went over on the way to Route 35 made a humming sound, as the old gray dodge rode over the metal center draw bridge section. We called it the "bumble bee" bridge. It was a much longer car trip than it is today with a one lane highway in each direction. We'd stop at Rollo's in Keyport, New Jersey just past the half way point, for charcoaled burgers and pistachio ice cream, a popular truck stop known for their delicious burgers.

One time after we had gotten off the single lane highway on the way to Port-au-Peck, I asked what the black spots on the secondary roadway were.
She said, "They were pickaninnies."
I asked, "What's a pickaninnie"?
She answered, "It's a little negro. They ran into the street without looking both ways and a car flattened them."
I understood she was trying to teach me a lesson. Confused I started to count the black tar repair spots indicating more corpses. I became horrified by the time I got to the house. I had no idea that so many black kids existed having never met one. Fortunately, these inaccuracies were clarified by my parents at a later date.

As a treat on Saturday we would go out to eat at Tony's Pizza in Long Branch, New Jersey located in close proximity to the Long Branch train station. It was a single storefront with faux marble Formica tables with stainless steel edges and red vinyl booths. There were also a few individual tables on the opposite side. Margie apparently knew Tony having taken Stephen there before me. Tony dressed in a white t-shirt with a pack of Lucky Strike cigarettes in his rolled up left shirt sleeve wore a white apron folded over and cinched in the back. He was five

foot nine with a husky frame with olive skin and balding black hair. He was extraordinarily warm and friendly. One time he took me into the kitchen to demonstrate how the pizzas were made. I loved the way he threw the dough up into the air in a floating disk. One time I noticed that in the pizza oven he was cooking a steak.

Shocked, I asked him, "What's that?"

Tony answered, "That's my dinner." I couldn't understand why he would want a steak, when surrounded by all this great Italian food.

I responded, "Don't you always eat Italian food?" Both Margie and Tony burst into laughter at my question and Tony assured me he ate all kinds of food.

I begged my father to take me there one time when we were living in Monmouth Beach during the Summer. Unimpressed with "Tony's Pizza" in his Irish succinct best he summed it up as, "A place you could spit across." Margie would always remove whatever was left after the meal, rolls, crackers etc. and put them in a napkin in her purse. She would even take extra sugar some times for her tea later at home. Her frugality was balanced by her generosity. At dinner at her house after the first course of a full plate was consumed, she would ask, "Do you want some more?" As she asked, the first spoon of string beans or potatoes was served with "do you want", the second spoon with "some" and, if not intervened, the third spoon with "more?"

When Stephen and I didn't go to Margie's we would entertain ourselves. It would get so hot sometimes in the Summer that we tried the old adage, *"It's so hot, you could fry an egg on the sidewalk."* It worked. It took a little while, but the egg actually turned white. Removing the egg from the sidewalk, when cooked, was another matter. There were two events, which stood out that I recall, one I proposed and the other Stephen. They occurred with a few years in between.

Adults would always say, "Don't play with matches." I thought as long as the fire was contained, it might be fun. It was a brutally hot day in August. Ocean Avenue and Riverdale Avenue converged to a point on the border of Long Branch, New Jersey. There was a drainage ditch between the two roads with a three-inch stream of water at the bottom

framed by dead sea grass on the slopes. Across from the Texaco gas station, about two hundred feet at the end of ditch in the direction of Long Branch, was a fuel oil company that also sold coal. The dry grass seemed perfect for the experiment. We started a little fire and easily tamped it out with our sneakers. We tried it again, but the second time we tamped it out, a piece of burning grass went into the water. All of a sudden the water ignited. We hadn't noticed a film of oil on top of the water from environmental pollution leaking from the oil company. Out of our control, the stream acted like a fuse igniting the grass on its way to the final explosion of the oil company. We ran as fast as we could to our homes and hid. The volunteer fireman siren went off followed in a short time by the sirens of the trucks. I kept waiting for the big bang terrified, but it never came. Apparently, the firemen got there in time. I heard later they said it might have been some kids playing with matches. I decided that perhaps playing with matches wasn't such a good idea, not unlike my early experience with the fork in the receptacle.

The second event was Stephen's idea. He had just gotten a beautiful dark mahogany plywood fourteen-foot runabout with an outboard motor. He wanted to attempt a journey to Coney Island crossing the New York harbor's shipping lanes. He rationalized that after all our maternal grandfather, Edwin Doust, a seafaring man, ran away from home before he reached his sixteenth birthday to ship out as a merchant seaman. His father was one of the Thames River pilots that would take ships and barges up the Thames river in England. Through his influence he brought his son back home only for Edwin to try again at sixteen. The second time his Dad let him go. Edwin became one of the pilots to bring large vessels into New York Harbor. Margie as a young girl would go out on the tug with him sometimes to meet the ships coming in at the Ambrose Lightship. Armed with the maternal sea faring genes we both shared, we departed.

As we travelled up the Shrewsbury River under the Rumson bridge, past Twin Lights and the Highlands bridge, everything went smoothly. As we approached Sandy Hook, the water became more active with swells. Sandy Hook, New Jersey is only fifteen nautical miles from New York. As we proceeded, white caps developed, which were indicative of small

craft warnings of winds over twenty miles per hour. The runabout hull wasn't planing like it did in the calmer river. It was smacking each swell with force as the sea splashed on us. The thin quarter inch plywood hull reverberated under us. The propeller blades on the small ten horse power outboard would come out of the water on the swell dips impeding our progress. We were now in the shipping lanes. Large ships move much faster than they appear on the water. Also, a fourteen-foot runabout doesn't have the right of way with an oil tanker. A large ship bearing down upon us seemed to accelerate. We avoided it, but the wake almost swamped us. We finally made it across. The Coney Island Ferris Wheel and Cyclone Roller Coaster were before us. We were close enough to hear the riders' screams. The return across the shipping lanes equally stressful caused me to seek shelter under the aft deck where the anchor was stored. Meanwhile, Stephen with hand glued to the accelerator on the arm of the outboard motor was steadfast, as the sea splashed his face. He only was missing the yellow oil cloth hat to complete the picture of the ancient mariner on a can of tuna. A second time we made the choice not to share our activities with the parents.

CHAPTER 3

RUMSON

5 Monmouth Avenue, Rumson, NJ

A t nine years old in the Summer of 1955, we moved into our new home on 5 Monmouth Avenue in Rumson, New Jersey. My father would work at his law practice in Jersey City during the week and come down on weekends. Rumson is a peninsula bordered by the Navesink and Shrewsbury Rivers across the bridge from Sea Bright, New Jersey, the first town at the most northern part of the Jersey shore. Our house was a four bed room, red brick, center hall colonial on a 100 by 200 feet lot. The rear of the property faced Woodmere Avenue. The blacktop driveway formed a "T" that had access from both streets and led to a two car garage and a basketball court with backboard. The court saw a lot of action especially by my brother Dennis and his friends. My father even installed spotlights for night play. I don't think this endeared him to our new neighbors in this subdued residential setting. Tom and Maureen were already in college, which left Dennis and me. Dennis entered Red Bank Catholic High School and I began Holy Cross School.

He excelled at basketball and tennis. My father would take me to watch him play. He was my hero and I felt the closest to him of all my other siblings.

One time we went to Forest Hills, New York to the Westside Tennis Club for the National Junior Tennis Championships. Dennis participated in the same year Arthur Ashe played for the first time in the tournament. The Westside Tennis Club, an exclusive private club, hosted the tournament. Two years prior to the event this tennis club refused to admit the son of Ralph Bunche because he was black, even though Bunche was a diplomat, an advisor to the formation of the United Nations and the first African American to win the Nobel Peace prize. It became a national news story, but such discrimination was common then and preceded the full mobilization of the civil rights movement in the later sixties.

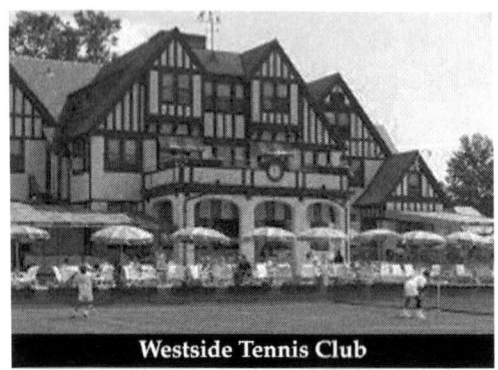
Westside Tennis Club

My father lived as an average first generation Irish American in the ninety-fifties, in that, he liked mostly Irish people, but would tolerate a few other nationalities. The concept of another race was foreign to him. I don't recall meeting any black kids until high school. The members of the club seemed to act cold and standoffish toward Arthur, avoiding him. I realized later in life that this was their racism. My father, however, welcomed Arthur and made him feel comfortable. They had conversations and sipped ice teas together between matches. Arthur went on to win the tournament and became National Junior Champion. Ironically, Arthur didn't know a tennis stadium would be named after him in the shadow of the club, in which, he felt so uncomfortable and spurned. Years later my brother, Dennis, ran into Arthur at an airport. He actually mentioned my dad to Dennis and said he appreciated the way that my father engaged with him. To him, my father appeared to be

a man with a lot of class as contrasted by the attitude of the club members.

My father liked the idea of the low maintenance of owning a brick home. My mother, however, after a few years thought the red brick too dark and needed to be painted. This obviously voided my dad's concept of economy. She decided on a light beige. When the painters were "boxing" the paints, they made a mistake. Boxing is adding several gallons together on a large job to have an even color and avoid slight variations in the paint tinting of individual gallons of custom colors. The north side turned out pinker than the west front, though corrected eventually, it was attributed to too many beers at lunch on the painter's part.

Rumson is a wealthy enclave founded in 1665. When we moved there in 1955, all along Rumson Road were estates of ten acres or more. They were large homes, mansions, which required staff. In the kitchens near the ceiling a line of numbers were attached to a rod. When a bell rang, a number popped up revealing the room number and the servant would go to the room requested. Most of the workers lived in the Oceanic section near the Oceanic bridge that crossed the Navesink River. Eventually, as time passed, the estates were subdivided. AJ lived on one of these estates and Mr. Henry D. Mercer[ix] lived next door. Mr. Mercer was the president and chairman of the States Marine Corporation, one of the largest shipping companies in the world and one of the principal patrons of the 12-meter sloop *Weatherly*, which successfully defended the America's Cup in 1962 against the Australian challenger *Gretel*. He commissioned naval architect Philp Rhoades to design a boat to defend the cup and informed him, "The cup has to be defended and money isn't involved." Mr. Mercer had a brick home of Federalist design with large white columns in the front like the White House situated on top of the hill at the end of a long driveway. He purchased the property opposing his on the south side of Rumson Road to prevent development and not spoil his bucolic view of the Shrewsbury River.

Behind the house was a manicured nine-hole golf course designed by Robert Trent Jones[x]. Behind the golf course an area of water gardens

33

had been completely neglected and over grown. The pathways and sides of the pools covered with moss were made of marble. It had a spooky dark feeling from the overgrown tree canopy with the pools covered in green algae recalling a popular horror movie at the time *"Creature from the Black Lagoon"*[xi]. This might have added to the sensation, albeit an excellent place for AJ and me to catch frogs.

The Jersey shore was a completely different environment from the urban one we had just left. There were all kinds of deciduous and conifer trees. The homes were much more spread out on larger lots than the city. Everything seemed so green and lush with landscaping compared to the barrenness of the narrower streets and buildings of the city.

In the Fall I started fourth grade at Holy Cross School. A new school, a one story brick building with class rooms on both sides, had just been built for grades kindergarten thru eighth. At the end was the auditorium/cafeteria. Fortunately, A.J. Shanley and I were in the same class and he introduced me to the other kids. The first thing I asked was, "Who is the toughest kid ?" AJ said, "I don't know". I had expected to have to prove myself as the new arrival given the rule at grammar school in Jersey City. He added," Kids don't get into fights much here." This was a complete contrast to what I had experienced previously and at the time confused me.

We were taught by the Sister of Mercy order of Catholic nuns. They had different habits from the Sisters of Charity in Jersey City at Our Lady of Victories. Basically most nuns at the time had the same long black layered skirt with smock top and long black sleeves. They also had a silver ring on their ring finger indicating their marriage to the Lord. The orders differed in the way the faces were framed. Sisters of Mercy had a long white bib on the chest, a semi-circle veil supported by a starched crown on the top of the head.

We had to wear uniforms also. The girls had blue jumpers with rounded collar and long sleeve white shirts. The boys had to wear the school tie, light blue with "H.C." in yellow embroidered on it, slacks and a sport coat. Our fourth grade teacher, Sister Teresa, five foot two and stocky

with dark rimmed glasses, was the principal and head of the convent, everyone feared her, students, as well as, the nuns. I remember her armed with her rubber tipped wooden pointer in hand, which she used for things other than pointing things out. A rite of passage for fourth graders was to master the art of writing in script using the Palmer method. When you finally passed inspection by Sister Teresa, you were awarded a ball point pen. My pen came late in the year. The girls always got them right away. Now it may seem strange that penmanship was studied as a subject. It took a lot of time to practice. One way I perfected my penmanship were assignments to write a sentence a hundred times for misdeeds. I had a lot of practice doing that.

As principal, Sister Teresa, instituted a demerit system for offenses of varying degrees: running in hall, talking in class, no homework, etc. They ranged in color from light colors for minor things to orange and red, the worst offence. The theory was you had to take the notification of the demerit home for your parents to sign and return it to the teacher. The lighter color demerits weren't that big a deal, but an orange or red could mean corporal punishment for me. This is the point where I perhaps went astray of the law for the first time. I had different methods for not obtaining a signature: I'd claim it had been lost, sometimes the teacher would forget to ask for the replacement; or in a worst case scenario, I'd forge a signature. I remember one time I got a red demerit, tore it up and put it in the base of the school flag pole. For some reason I thought it would be a safe place to dispose it. Perhaps I was unknowingly being passive aggressive.

At the parent teacher conference held in the beginning of the school year, my father always indicated that, if the sister wanted to use me as an example for the class, she should feel free to apply any punishment she wished. The nuns were gracious and assured him it wouldn't be necessary, but in seventh grade the teacher, Sister Reparata, took him at his word. On a rainy day, when the auditorium was already crowded, we were told we had to eat our lunches in the classroom. Sister Reparata told us to remain at our desks until she came back from lunch in the convent.

35

When she returned, everyone was out of the seats talking and milling around. She walked into the room and flashed a look, furious that we disobeyed. She started yelling for us to return to our desks. She started making her way through a group of students ignoring them striding toward me. She went nuts and started to thump me. When she finished, she told me to sit down. I just stood there. I didn't mind taking responsibility for my own misdeeds and accepted the consequences, but I felt this was unfair that she chose to single me out for the class' offence. When she was finished disciplining me she said, "Sit down!". With my fists clenched I stood long enough to make my protest clear, eventually sitting down of my own volition. It was the closest I ever came to reacting physically. This defiance made me extremely unpopular with the girls, but the guys approved.

All religions played an important part in the community. Everyone went to services. As students at a Catholic school, we had to prepare for Confirmation, one of the religion's sacraments. In the Catholic religion, when a baby was baptized, original sin was removed. At the age of reason around seven, first communion is taken and you are welcomed into the church. Confirmation occurs in late elementary school. It is a rite of passage in the church to become a "Soldier of Christ". To prepare you must memorize by rote the entire Catholic catechism. The catechism is divided into four parts in a question and answer format. The answers had to be letter perfect to the book text or you were whacked with the pointer. The bishop would come every two years to interrogate the candidates at a ceremony in Holy Cross Church. The catechism study would go on for two grades and the nuns were relentless. They feared embarrassment, if any of the students would not give a correct answer. At a point in the ceremony in the old wooden church cloaked in red for the event, the bishop would walk down the center aisle, ask a question and then point to a student. Only God could help you later, if you got it wrong. Fortunately, he only asked about ten questions and there were over seventy of us, so the odds were good on not being called.

I served as an altar boy at Holy Cross Church. Built in the late 1880's of wood construction, the beautiful woodwork inside resembled the

inside of a ship. The exterior had white wood shingles with two doors in the center above five steps. Two windows above the doors that were curved at the top matched the silhouette of the doors. A bell chamber and steeple topped off the roof. The face of the church also had four white square columns with peaks aligning with the center interior of the nave and both sides of the church.

We arrived about fifteen minutes before the priest. We would put on our black cassocks and white chasubles and lay out the various layers of vestments for the priest. We would also prepare the water and wine cruets, incense burners and light the candles on the altar. It's true that altar boys would also eat unconsecrated hosts and sip the church wine. The wine tasted terrible to us.

We also had to memorize the mass in Latin with prayers and responses. I still remember the "Our Father or "Pater Nostra" prayer. We also got to ring the bells at the most solemn point in the service, add the water and wine to the chalice and light the incense, if it was a high mass. When the school had events in the church, the nuns would use clickers to signal various actions for the students to take: stand, kneel, or sit. Father Sullivan, the pastor, usually had another priest that lived in the rectory with a limited tenure. I think the diocese used Holy Cross as a place to dry out rotating priests with alcohol addiction. To my knowledge, there were never any abuse issues other than the normal corporal punishment.

After-school play at the shore was different than the city. Kids had a lot more options. In the city due to space limitations sports were few. On the shore space wasn't an issue. There were places to play all the seasonal sports, such as, football, baseball, basketball and nature could be explored. We were bordered by two rivers. Boating, fishing and crabbing in the Summer and in the Winter we go out on the river ice. Migrating birds would be on the water in the Fall and Spring. After school it was the same drill as in the city. Get home from school, change to play clothes, grab a snack and out the door to friends until called for dinner.

Sometimes we would also go butterfly hunting or catch frogs in one of the Douglas estate's two ponds. This was one of the large estates on the corner of Rumson Road and Avenue of Two Rivers. A caretaker on the estate would often chase us off the property. Rich Cook, a friend who lived close by, and I decided to take the matter into our own hands and talk to the owner. We approached the mansion and nervously knocked on the back door. A gentleman answered dressed in a white shirt and tie with a gray vest, gold watch chain and matching pants. His black shoes were brightly shined. Balding with gray on the sides wearing rimless glasses, we assumed he was the butler.

"Could we please speak to Mr. Douglas in regard to an important matter?", I asked.

The butler looked at us curiously and said, "Oh really?"

I responded, "Yes, and it's only a question he can answer." I assumed the butler didn't have the authority for our request.

"What is this regarding?", he asked.

"We keep getting chased by the caretaker, when we try to catch frogs in the pond. We wanted to ask Mr. Douglas for permission to catch them so we wouldn't get chased."

The butler burst out laughing.

We didn't think our request humorous; we were serious.

He smiled and said, "I think I can help with that."

I asked, "How?"

He answered, "I'm Mr. Douglas."

Our mouths dropped open. We were stunned. This was the caretaker's boss not the butler. He laughed again and said, "I'll speak to the caretaker and tell him you have my permission to catch as many frogs as you want." We found out later, when we grew up, that Mr. Douglas turned out to be a scion of Wall Street. To us he would always be the nice friendly man, who allowed us to catch frogs in his two ponds.

I wouldn't say I was accident prone, but I seemed to have more of them than the average child. There were two that stood out in the elementary years. One happened during a frigid Winter with a lot of snowfall. The snow articulated the bare branches of the trees in beautiful quiet serenity. For kids, snow meant "snow days" off from school. Kids would ice skate and play hockey on the small ponds in the

neighborhood. We were hanging out at a frozen pond on the Douglas estate. On a dare I decided to walk out on the ice to test it. Everything went well at first in spite of the cracking sounds, which the ice made adjusting to the water below. This was common and didn't scare me. About twenty feet into the pond the ice gave way and I heard the kids scream. I went in over my head. I popped up with the water literally freezing on my clothes. I tried to boost myself up on the ice to get out, but it would give way breaking. Winter clothing in the mid 1950's was primary wool. Goose down outer wear hadn't been invented yet. I had on a knit cap, wool gloves, a couple of wool sweaters, a heavy wool jacket and flannel lined levis. When my clothes got wet, they became heavier making it more difficult to boost myself on the ice due to the additional weight of the soaked clothes. I panicked, I thought I was going to die, but I kept breaking the ice in front of me trying to get out. Eventually, I worked my way close enough for the kids put out an eight-foot branch to grab and dragged me out on the ice to the shore. The kids walked home with me from the pond a few blocks away. By the time we arrived my clothes were completely iced. My mother greeted me by her favorite prayer, "Jaysus, Mary and Joseph", and yelled, "What happened to you…this time?"

Bicycles were the standard transportation mode for kids. The thin tire English three speed bike with low, medium and high gears was the newest innovation. Prior to that bike tires were fatter, frames heavier and had only one set of gears. Bikes gave kids freedom to travel by themselves to ball fields, remote fishing ponds, etc. Everything in Rumson was more spread out than the city and the bikes liberated us. A bike also enabled me to have paper route. I liked earning my own money. I also worked as a gas station attendant. In the 1950's when a car needed gas, it pulled in to a "service station". As you pulled up, uniformed attendants would run out to pump gas, clean windows and check the radiator water, oil and battery, such service was expected each time you pulled in for gas.

There were two newspapers, the Red Bank Register and the Long Branch Record. The Register was a better paper, but the Record paid more thirty-five cents versus fifteen cents per week to paperboys. I had

one customer, who lived in a house on Rumson Road across from Monmouth Avenue, where we lived. My father told me later, that when my mother and he were looking for homes, they previewed this house. My mom rejected it due to its size and desire for something more modest. The third floor, for example, were servant's quarters. The former owner, Mrs. Needles, had an appropriate name because on her property footage on Rumson Road there were stands of white pines fifty feet deep. The rear and sides of the property were also rimmed with pine woods. On the rear of the property were bright spotlights aimed into the woods. It turns out this little old lady, was a full blown pyromaniac, guilty of numerous unsolved arsons in Rumson until they finally caught her. The lights in the rear blinded surveillance from the woods and concealed her in her nighttime jaunts to spread the flame.

This mansion was set back from the road three hundred feet with a long deep blue gravel driveway. It took forever on the bike to get to the house to collect my money for the week. I rang the bell and the door opened. A man appeared with shinny slick black hair parted on the right side holding a gin and tonic in left hand. He was wearing a white tuxedo jacket with shirt and black tie finished off with plaid madras shorts. On his feet were black patent leather slippers with large bows and black sheer knee socks. Flabbergasted, I had only seen something like him in old black and white movies from the 1940's, when the upper classes dressed for dinner. He was very nice, but only had large bills in his wallet, not my monthly dollar and forty cents newspaper fee. He rounded up change from his amused guests and gave it to me. While waiting there, I looked into the house. Men were in formal Summer attire and women in long flowing gowns, a vision from another time. A world, which was far from my own reality, a half a block away from where I lived.

Eventually I got permission to ride my bike to school on Rumson Road about five blocks away. One day, while riding in file with three friends against the oncoming traffic on the way to school, we were having insulting verbal exchanges as kids do at that age. At one point the chatter stopped and I turned around because I thought someone was giving me the finger. As I turned to look, my torso followed my hands on the

handle bar grips. I turned back and saw a blond haired woman's face with her eyes opened wide screaming silently behind the wheel of a station wagon with her arms out stretched her back pressing against the seat before me. I bounced on the hood and glanced off the windshield. The woman rushed out of the car in hysterics to see, if I was hurt. I stood up and told her, "I'm OK", but my left leg gave out and I collapsed. I looked down at my completely mangled bike as they took me away in the ambulance. When I arrived home after my mother's normal, "Jaysus, Mary and Joseph", prayer, exclamation or curse depending on interpretation, she continued, "Not again? What's next? I need the patience of Job in order to deal with you."

CHAPTER 4

HIGH SCHOOL

CBA Student Council Election

When we graduated from Holy Cross we went to different schools, primarily, Rumson High School, Red Bank Catholic High School and Christian Brothers Academy, CBA. CBA was originally a horse farm of one hundred and fifty-seven acres owned by the prominent Whitney Family of New York City, and home to their renowned Greentree Stable[xii]. The Whitney's donated the land in Lincroft, New Jersey to the La Salle Christian Brothers for a school. We were in the second graduating class. The first two years were spent in classrooms in converted stables with approximately 150 boys per class. Originally, only one sport track…well suited to a horse farm…cross country in the Fall, and track and field in the Spring. In the Winter for indoor track we used a covered indoor horse track, made entirely of wood with no nails only wooden pegs in order to protect the thoroughbreds in case they would brush the interior walls.

In freshman year, Brother Basilian blew his whistle and announced after class it was time for cross-country tryouts and to change into our gym clothes and sweats. Some kids said they weren't interested in trying out. Brother Basilian at six feet tall, in excellent shape, bald with frizzy white hair on the sides and rimless glasses, a jock at heart, told them they didn't have a choice. Basilian also had a warm and enthusiastic, exuberant personality and to all injuries he had one answer, "Walk it off." On his whistle the entire freshman class took off on the cross country course of two and a half miles. Some of the heavier kids ended up walking at the end, but everyone finished. They took the first 25 for the team and weaned it down to 15 for the travel team.

We ran in meets and against other local individual schools. The meets with other Christian Brother schools from the greater metropolitan area took place in Van Cortlandt Park in New York. One time we were running against Asbury Park High School on the shore, it was the first time we ran against black kids. They had a nice course in a park with pine woods and sandy soil. Running down a hill in the course, a couple of Asbury Park runners came out of the woods. They apparently knew all the short cuts on the course. Unfortunately, their lack of sportsmanship re-enforced a negative stereotype for a first encounter of white kids who had never interacted with blacks before.

In the second year, we vacated the stables for classrooms in a new brick faced single story building. Every morning we were bused to school ten miles from my house. There were two bus departures in the afternoon. One at 2:30 PM after school and one at 4:30 PM after sports. We all had blue and white canvas book bags in the school's colors. Sometimes they were a detriment. The students that couldn't be bused took the train from the Red Bank train station to return home. Students came from all over the county. An incident at the station got back to the brothers about a group with blue and white bags. They were hauled in to the vice principal's office and reprimanded. The bags branded us and we were expected to be "brother's boys", which meant perfect deportment at all times even when not attending school.

We were taught by French Christian brothers, a Catholic order founded by St. Jean Baptiste de La Salle. They had several schools in the greater New York area at the time. They were a different order from the Irish Christian brothers, who also had many schools. Both orders were known for high academic standards and strict discipline. The brothers wore black cassocks with a starched white color with a couple of two by four inch linen rectangles hanging down. In the first two years, corporal punishment was applied with open hand and in the latter two with fists or books.

For offenses not able to be handled in class, you were sent to Brother Amedy, the vice-principal. The first person I met at the school was Brother Bernard, the principal, a charming Irishman, who had red hair, light blue eyes and a perpetual smile. The Vice-Principal, Brother Amedy, however, contrasted to him as the "enforcer" of the day to day operations. About five feet eight he had the build of welterweight with thick black hair, a large nose and big hands. His distinctive low class Bronx Irish accent with a few deese and do's made him the brunt of humor among the privileged upper class boys.

We had a dress code comprised of sport coats, ties, dress shirts and slacks with cuffs. We had to have cuffs because pants with no cuffs were considered too radical and were worn by "hoods". Basically, there

were three distinct male social groups: preppies, jocks, and hoods. Obviously, groups overlapped. Preps wore sport coats and ties, jocks always had their varsity club jackets and hoods, jeans and short jackets. Pants with no cuffs were considered "hoodish", thus banned. Brother Amedy would stand at the entrance of the new school with his hands behind his back as the yellow school buses arrived. He would scan all the boy's slacks for violations. Pointed toe shoes were also banned. He would call out the names to step aside for a personal office visit. The next day new shoes and cuffs on pants were back.

One time I got thrown out of second year Latin class near the end of the period for poor deportment and sent to Brother Amedy's office. It was close to the end of the period and I decided to hide in the bathroom until the bell rang to avoid Brother Amedy's wrath. I waited for the class changes until the halls were full and went to the next class. On arrival in the morning the brothers would stand in the hall next to the door of their own homerooms and the boys would peel off. Brother Patrick's home room came before mine. As I walked past him, he stopped me.
"Mr. Lynch, Brother Amedy told me you didn't go to the office yesterday."

I didn't take into consideration that all the brothers would dine communally and discuss the school events of the day. Busted I didn't know what to do. I put out my right hand and said, "Let's be friends. I won't give you a hard time anymore." He burst into laughter and put out his hand and said, "OK, but this is the last time." Six foot four weighing about 250 pounds with oval face and pink cheeks he could be described as jolly, congenial and in my case merciful. Relieved to be spared from Brother Amedy's correction, I also learned the power of negotiation.

Being in an all boy's school had its advantages. Interscholastic sports were mainly for boys. Few sports were offered to girls at the time. We consequently had an advantage from coed schools of the same size student body. Socially, there were also advantages. If a boy from a school would take out a girl from another high school, he would take a

lot of heat from his female classmates. We were able to poach girls from the other schools without liability.

Rock and roll started in the mid-fifties evolving out of black rhythm and blues, which had its roots in church and field music. The sound track of my high school years happened to be one of the greatest periods of popular music, the Motown era. Starting with *"Please Mr. Postman"*[xiii] by the Marvelettes, Berry Gordy, from "Hitsville USA"[xiv] in Detroit, transformed popular music of the time by crossing over rhythm and blues music to the popular music genre that got played on national radio. There wasn't any better music to sing along with and dance.

The Beatles began the British invasion in senior year, but they didn't do it for me. They were too clean cut with the bowl haircuts and matching suits. The girls on the other hand, thought the "Beatles" were the tops. I preferred the "Rolling Stones", who were actually just starting out and had more of a bad boy image and sang American Rhythm & Blues. Eventually Keith Richards and Mick Jagger developed their own style from those blues roots. I saw them on their first American tour with Brian Jones three times. They were extremely loud and played a relatively short set.

When we got our driver licenses in Junior year, our world expanded dramatically. Our student body came from all over Monmouth County. The car culture of the sixties was in full bloom and gas at thirty cents a gallon fueled the large displacement engines Detroit had built in a contest between brands like Ford and Chevrolet to be the fastest. The song by the "Beach Boys", *"She's Real Fine, My 409"*, referred to the cubic inch displacement of the largest Chevy engine. A 409 with two four barrel carburetors would get about six miles per gallon. The teen culture revolved around the automobile. There were drive-in restaurants, with waitresses on roller skates. McDonald's golden arches had just arrived with a drive through window selling nineteen cent burgers with ten cent cokes. We'd go to drive-in theaters the perfect place to congregate on the weekends. You could bop around to other cars or have privacy with your girlfriend. Double dates were the norm and the windows would become fogged from heated activity inside,

which provided additional privacy. Illegal drag racing was a favorite car sport, as well as, drag racing between traffic lights in Asbury Park, New Jersey.

My senior year was one of the happiest times in my life. I had a lot of friends in the various social groups. I went to school with "preps". I played sports and had "jock" friends on other school's teams. I also loved cars and speed, which is the arena, in which, I interacted with my "hood" friends. I had good grades, was a varsity athlete and had a cheerleader girlfriend, the first love of my life, Sharyn Santonello. I had freedom with little responsibility and only worried about getting into college. Sharyn, a year behind me in Red Bank Catholic High School, half Italian and half Irish had a unique energy that attracted me. She came from a warm Italian family starkly different from mine. I would often go over for Sunday dinners that lasted hours and the courses just kept coming. Her mom's sister, a tenant of my grandfather, corroborated the story about him not evicting people during the Great Depression.

Our world was aptly depicted in the 1970's TV sitcom *"Happy Days"*[xv] based on George Lucas's movie *"American Graffiti"*[xvi]. After school "The Campus Luncheonette" in Rumson provided a hub for high school hormones. All the social groups interacted in this setting. A horizontal scanning Seeburg Jukebox with Cadillac chrome fins and red tail lights in the blue lit grill played 45 rpm records adding the soundtrack. Often, while hanging out socializing, checking out cars and motorcycles, the crowd outside exceeded the interior.

One sunny November day during the last class period of class, Brother Bernard, came on the PA to make an announcement and said, "Attention please. This is Brother Bernard. I have an important announcement…the president has been shot." There was a long pause. There were gasps; we were stunned in complete silence. He continued, "The president has been shot in Dallas and at this time we do not know any more or even, if he is still alive. I want you to join me in a silent moment of prayer for President Kennedy and pray that he will recover." When Brother Bernard came back on the PA, he announced that he had

called the bus company to arrange for early dismissal and all sports were cancelled.

Our world shattered in a way we had never experienced. John Fitzgerald Kennedy was the hero of every Roman Catholic, especially the Irish. To them he represented their journey from being reviled and discriminated against as immigrants, to one of their own becoming the president of the United States. A year before he had avoided a nuclear war with Russia over the Cuban missile crises. He was charming, handsome, intelligent, and young with a sophisticated wife, Jacqueline, a fashion icon and admired First Lady; the press corps loved him for his witty exchanges. Assassinations happened in "Banana Republics" often with the aid of the CIA to protect American business interests, but not here in the USA. It was an event of such magnitude that anyone, who experienced it, can tell what they were doing, when they heard the news. The country had lost its innocence.

In my senior year I decided not to play tennis in the Spring even though we were Central Jersey Champions. I didn't get along with Brother Denis, the coach. With idle time on our hands, Keith Mast and I came up what we considered a brilliant idea. Although we were both competing campaign managers in the student council elections, we had become good friends and together cooked up this scheme, which involved driving to Staten Island after school via the Outer Bridge Crossing from Perth Amboy, New Jersey. In New York, the drinking age was eighteen and in New Jersey, twenty-one. We thought, if we could make the round trip before the late afternoon buses left after sports, we could give our classmates their supplies for weekend revelry.

We left after classes at two thirty with our orders and raced up the newly constructed Garden State Parkway in two cars. It took about forty-five-minutes to drive depending on speed each way and we only had a two-hour time window to drive and complete the "legal" transaction in Staten Island. We had to drive fast. We found a bar across the bridge in Staten Island called the "Pirate's Nest", which had an off sale liquor license. We would arrive mid-afternoon, when they had few customers. It was obviously a night joint. We were a bit awkward the first time, but

Pete, the bartender, warmed up over the weeks and knew exactly what we were doing. We'd give him the list and he'd pack it up in cardboard boxes. Pete, a dark Italian with slick black hair in a "hood" hair cut style combed back on the sides with a DA ("Duck's Ass") in the back, sold us full bottles of booze at inflated prices and liked our enterprise. No doubt he was a tough guy, who had seen action bartending in an obviously mafia joint. A couple of "preppies" with our Brooks Brothers' attire was quite a contrast to the other patrons in the seedy nautical themed dive. I'm sure the few patrons there had a few laughs at our expense. We loaded the trunk of each car and took off. We fantasized being rum runners or moonshiners, as we raced back. Sometimes for added adrenaline we'd go through the mechanical twenty-five cent toll lanes at Raritan bridge at high speeds to see, if we could hit the basket. When we returned, a little after 4:00 PM, we gave the boys the loot. They placed it in their blue and white canvas book bags and got on the yellow buses to be ferried home at 4:30 PM. In addition to taking care of our own needs, we were happy to take care of our fellow classmates need for libations for weekend parties. The reward for our non-profit service was the adrenaline rush of the run.

When I didn't get into an ivy league school, my father decided I should follow in my brother Dennis' footsteps and attend Phillips Exeter Academy in Exeter, New Hampshire, after graduating from CBA. My father drove me up for a personal interview. It was a large campus with red brick three story buildings covered in ivy, a picturesque New England boarding school spread over several acres. I had an interview with the acting principal, Doctor Gillespee. He had just replaced William Saltonstall, who had left to head the Peace Corps in Nigeria.

The large office was appointed in dark woods with high back maroon leather chairs. Doctor Gillespee, about sixty years old and six feet tall, was wearing a gray herringbone tweed three-piece suit with watch chain, a white Brooks Brothers button down shirt and a striped regimental tie with Windsor knot. He had a full head of black hair streaked with gray. On his clean shaven oval face, he wore rimless glasses on the lower part of his nose. He looked extremely professorial.

He stood up from behind his large desk situated near the fireplace pipe in hand.

My father said "Vincent, this is Dr. Gillespee." He extended his hand to shake and I said, "Oh, Dr. Gillespie, Where's Dr. Kildare?" My father's mouth dropped open and Dr. Gillespie looked at me deadpanned. After a moment he looked over his glasses and seemed to crack a smirk on the right side of his thin lips. To explain this reference, one of the most popular TV shows at the time was "Dr. Kildare", an episodic series, which took place in hospital setting. Richard Chamberlain starred as a young heart throb doctor, Dr. Kildare and Lionel Barrymore played his seasoned elderly mentor, Dr. Gillespee. My nervous joke to break the ice bombed. The joke discussion continued with my father on the entire four and one half hour ride home to New Jersey. He assumed I blew the interview for being a "wise guy" in such a staid atmosphere. Fortunately, the Exeter acceptance letter eventually arrived in the mail.

My sister Maureen, lived in New York City and worked in the fashion industry. Devoted to me, she would bring me into to the city to explore the more cosmopolitan aspects of New York. She would take me to performances like Pete Seeger at Carnegie Hall or to museums. One time she took me to a foreign film called *"The Seven Deadly Sins"*[xvii]. a French film with each sin a separate movie made by a famous European director like Roger Vadim or Jean Luc Goddard. It was the first film I saw in a foreign language with sub-titles. Condemned by the Catholic church, Maureen made me promise not to mention the movie to our parents. It would be our secret. Another time she took me to the play *"Becket"*[xviii] written in French by Jean Anouilh, translated and performed on Broadway in 1960 at the St. James Theatre. Produced by David Merrick and directed by Peter Glenville, it starred Laurence Olivier as Thomas Becket and Anthony Quinn as King Henry II. The production nominated for five Tony Awards won four, including Best Play. The play is a re-enactment of the conflicts between King Henry II and Thomas Becket. Becket begins as a clever, hedonistic, companion of Henry's; but as a result of being created Archbishop of Canterbury, he is transformed into an ascetic, who does his best to preserve the rights of the church against the king's power. Ultimately, Becket is slaughtered

by several of the king's nobles. At the end we find the king thrust into penance for the murder. Contrary to Wikipedia, the night we saw the show they switched roles an extraordinary two-man performance.

Jerzy Kosinski

Her support of me continued through the years. When I started art school, she introduced me to New York artists and well known photographers in the fashion industry. She had access to the art and fashion world as a result of being the Beauty Editor of the Ladies Home Journal, one of the top five magazines at the time. Maureen liked to do what she called "salons", when I came in from the West Coast. She would have a dinner party of six to eight guests composed of intellectuals or artists of various disciplines. At one of these events in the late sixties the after dinner discussion moved to LSD. At the time I considered myself a proponent. One of the attendees was a Polish author. He recounted his experience to me. He took LSD in Switzerland in a medical experiment setting and said he had the feeling of going down a long spiral tunnel. He said he didn't get any reality shift under the drug, but the concept of alternate realities appealed to him. He told me he was currently engaged writing a novel, a satire, in which the protagonist is a dim witted gardener, whose reality is only based on what he sees on television or what he experienced in his small garden. When he wanders off after his master passes away, he is discovered to be a sage by powerful men interpreting his oblique metaphors to gardening, as salient advice. The concept seemed a bit "far out" for me, but I wished him luck. His name was Jerzy Kosinski and the satire, the best-selling

novel, *"Being There"*. He also co-wrote the screenplay for the movie, which won British and American Writer's Guild awards. Peter Sellers was nominated for best actor and Melvyn Douglas won the Oscar for Best Supporting Actor. Apparently, it wasn't that "far out".

Maureen and Me

MONMOUTH PARK JOCKEY CLUB

Monmouth Park Jockey Club

In the summers I worked at the Monmouth Park Jockey Club in Oceanport, New Jersey, a thoroughbred racetrack open in the Summer for fifty-seven days. At the time gambling was only legal at horse racing tracks or in the state of Nevada. When Aqueduct Race Track in New York closed an influx of rude NY gamblers came to the track in the last three weeks of the season. I worked in the parking lots as an attendant the first year because at seventeen I couldn't join the union. Management wanted us to have the cars parked close in the spots and most drivers obeyed directions. The New Yorkers were another issue. They'd pull in and throw the doors open to prevent others from parking close. One time a car ran over my foot, which was not uncommon. The next Summer, when I turned eighteen, I became a teamster gaining a better job, which paid well and had the added benefit of not being exposed to the general public.

Monmouth Park Jockey Club was beautifully laid out over several acres in a rustic setting, a resort compared to the urban race tracks. At one time a large boat departing from New York ferried passengers to Oceanport, New Jersey for a day's outing at the shore and track. As a teamster, I worked in an area called the rake yard, the place where all the equipment: trucks, tractors and rakes were stored. It was located at the beginning of the home stretch of the race track across from the quarter mile pole. I worked from 6:00 AM to 2:30 PM. Early morning workouts began at first light and there were breaks to re-rake the track. The water trucks would go out first and spray the loose top dressing of the track about eight inches deep. They were followed by two large tractors and three smaller ones pulling triangular pin rakes. This routine was also repeated after each race. Driving the tractors had benefits. Often the teamsters would hook a thrown shoe from a thoroughbred. These were often custom made and warranted a big tip from the trainer, when found, due to the cost of being reproduced.

It was exciting to work at the track. The thoroughbreds were magnificent animals to watch as they ran in the morning workouts and during the races with the jockey's in their colorful silks. The rake yard situated at the turn for the home stretch became the point in the race where the thoroughbreds would make their final move to the finish line. The sound of the thundering hooves, jockey's whips, mud flying and the sheer energy the horses exuded created an extraordinary moment.

I got the jobs that no one else wanted as the new kid. One day I heard the foreman, Eddie Lord, employed directly by the track and not a teamster, yelling at our teamster shop steward, John Riley. Eddie Lord was about six feet four inches, 230 pounds and fifty years old. He had a booming voice and towered over a frail seventy-eight-year-old, five foot eight inch, 130-pound John Riley. John deserved to be shop steward. He had paid his dues. He fought the scabs with Jimmy Hoffa in the 1940's. He'd tell us stories of the early days of organized labor. He would always tell us how we didn't appreciate anything that had been done for us in the past. He had the face of a grumpy Irish gargoyle with thin frizzy snow white hair on the sides. His large red nose

protruded and it seemed that his forehead and chin were collapsing toward it.

As Lord was in the bully mode, I stepped in between them and yelled at Lord to back down with my fists clenched and chest out. I said, "Who do you think you ARE talking to John Riley, our shop steward, like this?". Lord became shocked and stepped back. Who was this young punk telling the rake yard boss what to do? He paused and then mumbled something to the effect about speaking to the general manager, Mr. Wilson. He turned and walked off in a huff. John didn't smile or have much of a reaction. Ready to take him on himself at seventy-eight. John didn't say anything to me after it happened. As the rake yard gossip spread, however, I got a lot of props from my teamster brothers especially Packy Riley, his nephew, who was influential in the union. Nobody liked Eddie Lord and nothing came of my defiance. I was still low man on the totem pole, however, driving the dump trucks, making coffee break and lunch runs for the crew and cleaning the tote board. The worst job I had was the horse ambulance duty. Nobody wanted to do it.

When a thoroughbred broke a leg during the race, I had to drive out the tractor pulling the horse van to the high side of the track. The riders on the quarter horses would round up and calm down the injured horse. The starting gate attendants in tan uniforms and panama hats would guide the injured horse into the van. I would then return to the rake yard with the horse. Horse racing is a business. It's better for an owner to put down a horse and collect the insurance than to suffer the cost of putting the horse out to pasture because the racing days were over. The vet came with a pistol concealed behind his back. He took the bridle and shot the horse in the middle of the forehead. The horse dropped and another man took a large knife and cut the jugular vein and the blood gushed out. It steamed on the ground, as the saw dust absorbed the fluid.

The wild look in the horse's eye is something I will never forget. The stallion knew its destiny. It was a shocking experience for me from the sheltered life I had lived to that point. We then put rope around the horse's neck and winched him into the van. The van delivered the horse

to Amory Haskell's farm. The dead horse became food for his hunting dogs, "who never ate anything, but thoroughbred horse meat". Haskell's arrogance disgusted me. Amory Haskell was responsible for introducing horse track betting in New Jersey in 1945 and

Amory L. Haskell

[xix]founded the Monmouth Park Jockey Club.[xx] He was the most powerful person in thoroughbred racing in New Jersey, President and Chairman of the Board of the Monmouth Park Jockey Club for over twenty years.

Being witness to a horse being put down changed the way I viewed horse racing. I had seen the darker underside of the business. These were equine gladiators. They were pampered until they could no longer run and then disposed of like an old shoe. When I saw the look in the eye of the thoroughbred being put down, I realized he wasn't just a beast of burden for man's use. This animal had a spirit within his body, which left when executed. A sentient being judged to be more valuable dead than alive.

PHILLIPS EXETER ACADEMY

Exeter 1965

When I arrived in September, the campus was a typical New England prep school with organized quadrangles of brick buildings covered in ivy. Soon after arrival as the Fall progressed the ivy fell and left a more austere environment. When parents returned in the spring, it resumed its bucolic beauty. Since I had already graduated from high school, I only had four courses Math, English, Russian History, and Architectural Design, but I never worked harder in my life academically.

Architecture Design, an allegedly easy course, turned out to be the one that consumed the majority of my time. I had an enthusiastic teacher, Mr. Constantine Demos in his first year teaching at the Academy. Five foot eight, clean shaven a bit stocky with wild salt and pepper hair wearing a grey herringbone sport jacket and corduroy pants held up with a tied Mexican cloth belt strode into the first class and announced, "This is not going to be a "gut" course". He loaded us up with projects, such

as, designing an entire village square with drawings, models and flow charts. He seemed oblivious to our commitments to other academic subjects.

He became my most influential teacher. When I became depressed in the Winter, he gave me a small space in his home to write, so I could get out of the dorm. When compared to the freedom experienced in my highly social senior year in high school, the dorm was like a prison to me. I immersed myself writing poetry. He also spurred my interest in UC Berkeley, his alma mater. When I discussed with my father other schools to apply to instead of Yale in case I didn't get in he said, "You can apply to whatever school you want."
I said, "I want to apply to the University of California Berkeley."
He replied, "You can apply to any university you want except the University of California Berkeley". I ended up applying only to the University of North Carolina at Chapel Hill because I thought it would be interesting to experience another part of the country, where I had no prior knowledge. I had southern friends at Exeter and we got along well. I had experienced New England and the mid-Atlantic states and I thought it would interesting to explore a different culture in another region of the country.

I'd usually study until two in the morning because the Harkness[xxi] method of teaching, a seminar table with fewer than ten students with the instructor at the head, demanded that everyone had to be prepared. Teachers would pose a question, which would often be followed with a deadly silence until someone responded. In addition to papers, heavy reading assignments were required as preparation for class discussions. In order to fulfill all requirements, I often worked late into the night and since my first class was third period. I frequently slept through breakfast and the required first period chapel assembly. This led to being on "restriction" for two thirds of my tenure, which meant among other things I had to be in the dorm by 8 PM. As the year progressed the sky took on a gray monochrome quality, sometimes called a "snow sky", which lasted for two thirds of the school year. It was at Exeter that I had the first understanding of the effect that light and environment could have on mental wellbeing. I found the lack of sun exceedingly

depressing, but decided to throw myself into work to mitigate the effect. Depression can have a whirlpool effect. The more it is focused upon, the more it draws you deeper. I felt I could stick it out to fulfill my father's wishes that I would attend Yale.

Coming to Exeter as a post grad student and not knowing anyone was a challenge since most of the students had been there for three or four years. As I learned people names, I'd greet them by name, when I saw them on campus. If they didn't know me, they would inquire to find out my identity. The strategy worked and eventually I got to know the other students. This proved to be a good strategy later in life. The dorm life had its moments at times with pranks. Pranks ranged from a mild prank to the more complex. The beds were wood frames with foam mattress and springs. The wooden legs screwed in. Unscrewing one of the bed legs and leaving it in place had the obvious effect of dumping the returning student on the floor, when he sat on the bed. Examples of more complex pranks were when other students would leave on a weekend. The guys would do things like disassembling their room and reassemble it in in the common floor bathroom or run a spool of a thousand feet of string attached to various room objects creating a jagged maze to navigate through on return. The pranks were effective in relieving the academic pressure a tradition in prep schools like Exeter. A prior class disassembled the Dean's Volkswagen bug and reassembled it on the chapel's stage to be revealed at the morning assembly to the surprise of all.

As a senior, I was assigned to be an advisor to a first year student, Ricky Butler, an energetic young African American, from southern California. He had a hard time adjusting due to his race and age. Exeter was predominantly a white all male privileged class institution with few minorities, but he had an engaging personality and eventually he adjusted. While working as a tour manager, I ran into Ricky years later in the San Francisco Bay area, at the sound check for Herbie Hancock at the Berkeley Community Theater. He was in charge of the crew for the local NBC affiliate filming a clip for the six o'clock news to promote the show. He told me he appreciated his time with me and it turned out he lived in Berkeley three blocks from our house. He went on to a

successful career in the film and television industry as a production designer for shows like "Person of Interest" and "Law and Order".

The schedule at Exeter began with breakfast, academics in the morning, lunch, sports break and classes before dinner. I enjoyed working on the daily paper, the Exonian. We'd go to the local printer and pick the issues up. It was fascinating to observe the whole process of the linotype machines and the sounds of the presses, as well as, seeing the finished product of our writing. I played football, squash and, in spite of pressure to play on the tennis team, I decided to row crew in the four-man sculls. Being on the Squamscott River in the Spring was in retrospect especially therapeutic for me. It also reinforced my love of nature, which began while growing up on the Jersey shore. Depressed that I didn't get into Yale, it seemed to me to void the whole point of going to Exeter instead of going to college directly after high school and a complete waste of my time. I wanted to drop out of Exeter. From my point of view I didn't need another diploma. My father bribed me to not drop out by giving his permission to get a Honda 50cc scooter the following Summer. The beginning of my love of motorcycles had begun.

After riding the Honda for a while it became apparent that in some situations in traffic acceleration was a bit under powered. I knew my father wouldn't take my word for it, so I enlisted my brother, Dennis, who had ridden the scooter a few times to confirm it. With Dennis's endorsement my father relented and I traded in my scooter and purchased my first motorcycle, a Yamaha 250cc "Big Bear" Scrambler with money I had earned at the race track. Painted candy apple red and white, I customized the seat with alternating black and white leather roll and pleat upholstery and had "Candy Man" painted in old English type on the gas tank. Mississippi John Hurt's *Candy Man* was my favorite blues song at the time. I had seen him perform at the Gaslight in Greenwich Village in NYC and he made the strings of the guitar speak. The exhilarative freedom granted with new bike inspired long road trips sometimes as far New Hope, Pennsylvania with my friends.

This scrambler style of motorcycle had upswept exhaust pipes designed for going "off road". I would ride for hours on the deer trails in the Highlands area. I cut through a field, undeveloped and probably privately owned at the time, to get access to trails in the hills. One time, while practicing hill climbing I came to the top of the hill airborne and landed on a blacktop road instead of earth. I didn't understand how it came to be in the woods. The road wound around. After seeing the uniforms and military vehicles I came to realize this is the Nike missile base allegedly protecting New York City. The Highlands is only fifteen nautical miles from New York City. I made my way through the base and went out the front gate. The MP in a white helmet and gloves observed me leaving and then did a double take turned and started to blow his whistle. I gunned the Yamaha and disappeared down the hill. In the mid nineteen sixties the "cold war" with Russia became more intense. We still had "duck and cover" drills in the elementary schools. I remember at the time I thought *"how secure are we, if the ICBM missile base protecting New York could be penetrated by a teenager like me on a motorcycle?"*

An opportunity came up to buy a rare motorcycle a 1953 Vincent "Series C" Black Shadow, the ultimate motorcycle for me in addition to the eponymous name. It held the Bonneville Salt Flat record for motorcycles. There is a famous photo of the 150 mph record with Rollie Free lying on the rear fender in a bathing suit with tennis shoes and bathing cap[xxii]. I convinced my dad he should think of it as an antique investment, when restored, not a second motorcycle, since it was twelve years old at the time and quite rare. I also thought it wise not to share the photograph of Rollie. The practical Yamaha dependable for multiple uses contrasted to the Vincent used only for touring. The Vincent, which I bought for $450, had starting issues and required a lot of work.

Greg Gill, George his older brother and I worked at nights in the garage separated from our house. George was the Vincent expert having done a frame off restoration of his own "Black Shadow. He also became our break down assistance angel when Greg and I had mechanical issues on the road riding the two Vincents. One night about 10 PM we were ready to attempt to start the Vincent up. We lived in a suburban neighborhood

of houses evenly spaced on double or triple lots. At this time of night, they were mostly dark with only porch lights on. When the Vincent finally started we were overjoyed with the thundering sound of the straight pipes. I decided to take it around the block with no head light. As I proceeded through the gears down Woodmere Avenue, the house lights went on in syncopation, as if triggered by this invisible sound roaring down the street. By the time I came back we were in stiches laughing, as I coasted in the driveway with the engine off.

Rollie Free breaking the motorcycle record at 150 mph on a Vincent at the Bonneville Salt Flats in 1948

The Vincent is a great touring bike, when running well. A compression release on the handlebars, which looked like a small English bicycle brake, raised the rear valve to allow the manual kick starter to work on the 998cc (61 cu") engine. If it didn't start right away, your leg could wear out first. Unfortunately, I never got a chance to restore my Vincent, when forced to sell it due to lack of funds while in California. My assessment, however, on the Vincent's investment potential proved true. A fully restored 1952 Vincent Black Shadow has sold just under a million dollars at auction.

CHAPTER 7

UNIVERSITY OF NORTH CAROLINA

The first thing that struck me, when I arrived at the University of North Carolina in Chapel Hill, was the way in which most male students dressed. They wore chino pants, oxford shirts and London fog jackets with large effeminate embroidery with their initials in the same style of embroidery my mother had on her sweaters. The campus filled with duplicates identically dressed became more surreal, when it snowed. They used umbrellas and transformed into a Rene Magritte[xxiii] painting in motion.

UNC was a typical Southeastern Conference university with fraternities and heavy drinking. It had a nickname in the South as "the little red school house on the hill" due to its relative liberal policies geographically. In late 1965 the South was in the beginning of the civil rights movement. Most of my northern friend's views differed from a large part of the student body's southern students. My view on civil rights was not based on politics, however, but rather in religion. "In the eyes of God", the teaching of my Roman Catholic education, all men were equal. It was easy to entertain this point of view, when surrounded by like minds at home, but naïve to think this would be easily accepted because racial integration, as a concept, was not embraced. The impact of which would change the South forever. We were viewed as "northern agitators" because of our support for voter rights and registration. At this time there were still segregated bath rooms in Chapel Hill and a TV show from the nineteen fifties, "Amos & Andy"[xxiv], depicting black race stereotypes, continued to be broadcast. In the North they had stopped showing these programs years before due to its offensive racism toward blacks.

Walking down the main street in Chapel Hill, I had an experience that drove me to become more involved in the Civil Rights movement. A wrinkled old black man in flannel shirt and overalls stepped into the street, when we met on the sidewalk. I asked him why he did it. He said, "Cause youse white. Gots to give respect to the white man." I helped

him back on the sidewalk. He bowed and walked on. This behavior echoed a time I thought had passed. As I watched him walk away, I stood dumbfounded feeling a range of emotions simultaneously from sadness to anger to resolve. Segregation HAD to end!

For distraction I decided that we should do a road trip to Washington, DC so I could visit my girlfriend, Judy Chamberlain, who was attending George Washington University. Judy, the sister of my brother's wife, and I had been going out over the Summer. She enjoyed off road riding with me on my motorcycle on the Highlands deer paths. She was a good sport, especially when the bike went down. We enjoyed each other's sense of humor and company.

A fellow Exonian, Ted Larson, loaned me his vehicle, a matte black 1949 Cadillac hearse. The black monster was over fifteen years old and had apparently in one of its lives been used as an ambulance. Hugh McKenna and I took off and drove up I-85 to Washington, DC. The only road lighting was when you drove into towns, in between, the road was pitch black. We discovered an interesting feature in the hearse, a second metal button on the driver side floor next to the metal high beam button to the left of the rubber gas and brake pedals. It was siren, a relic from its old days as an ambulance. The vintage siren started at a lower pitch and gradually became louder to its final loud volume like a mini air raid siren, a new distraction to break up the monotony of the ride. We would come up behind another car fast with bright lights on and hit the siren. The front car would slow down to pull over and the black ghost would streak by with its small red tail lights…disappearing into the night. We thought it hilarious until we arrived in Dinwiddie, Virginia.

The red and blue lights were flashing in the rear view mirror. We pulled over to the road shoulder and a sheriff with brown uniform and smoky the bear hat strolled up and requested the license and registration. I explained we were students heading to Washington, DC and I assumed we'd get a ticket. He wrote up the speeding ticket and handed it to me. About to take off I asked, if we could go. He replied, "Oh no, you'll have to see the Justice of the Peace to set bail, so follow me." We were

64

starting to get worried. A couple of northern boys could easily disappear in a state that had been known for its Ku Klux Klan activity. The Justice of the Peace's courthouse was a gas station office. We pulled in and entered the "courthouse". The justice had thick black rimmed glasses, a rumpled baseball cap and was seated behind an old desk littered with papers. He wore no judicial robes and he looked like the owner of the station in soiled work clothes.

When we went into the office, there was a traveling salesman from Massachusetts being "tried" before us. The Justice and the arresting officer retired to the justice's "chambers", the john. When they came out, they announced the bail for speeding for the business man was $240. He protested and they explained he could come back to Dinwiddie for the trial in sixty days and make his case. He gave up and had to pay the fine in cash. No credit cards or checks were accepted. We were next. Our officer spoke into to the justice's ear apparently, he wanted to avoid the chamber consultation. He said our fine for the same offence that business man had was $80, a third of what they charged him.

The justice explained, "We give discounts to students and servicemen, but the officer wants to ask you something" The smoky stepped up with his hand relaxed on the gun in his holster and the other hand on his hip. "Y'all wouldin' happen to be the boys that there were some complaints about using an illegal siren?"

"Why officer ?", I replied.

"Cause if ya are, I'd like ya to show it to me."

I nodded. We went outside to the hearse and I popped the hood. The Cadillac had plenty of room in the engine compartment and on the driver's side in the front next to the radiator was a large siren that had been installed in a twelve-inch metal cube.

"Whoa, that's a beaut!", the sheriff said.

"Tell ya what. If y'all give us the siren, we'll forget about the fine." I considered the offer because eighty dollars was a large portion of our budget for the weekend, but I replied, "I'm sorry sheriff, but this is my buddy's car. I only borrowed it. I would need to get his permission."

"I respect that," he replied. "When you get to DC, y'all ask your friend, if he wants to sell it and if so, you can stop by here on your way back to UNC."

We paid the "bail", left the courthouse and continued on our way. I found out later from southern friends at college that Dinwiddie was known as a notorious speed trap due to a mile stretch of road where the speed dropped from 60 to 50 mph. Serviced by seven patrol cars at that time we went through, it proved to be the town's primary source of municipal income.

As we continued North on I-85 the hearse started to have issues with the radiator over-heating and we had to pull over to add water. In the middle of the night few gas stations were open. We plodded along and everything seemed fine until the interior of the hearse started to fill up with steam. Instead of the radiator in the front of the hood smoking, the interior of the hearse started to fog up. We assumed later that the hearse at some point it might have had an air conditioning system for the coffins that malfunctioned. Impossible to drive with the steam inside even with the windows open, we pulled over. Since we were on the shoulder of the highway we decided to get some sleep. We were exhausted. I was awakened by a state trooper tapping on the window in the morning. Our parking brake fortunately held because it turned out we had stopped on the top of a hill in our steamed blindness. We explained our situation and the trooper told us we were in Alexandria, Virginia. We limped into Washington, D.C., parked the hearse at a gas station and I called my friend. He was really cool about it after I explained what had happened and told me not to worry and he'd take care of it. He even apologized for the hearse breaking down, which I thought showed incredible class from my fellow Exonian.

Another time I borrowed a 90cc Honda motorcycle from Greg Harris another classmate from Exeter at UNC. I was accustomed to large motorcycles like my scrambler or the Vincent, ten times the displacement capacity of Greg's Honda. Coming to a T-intersection in the road, the accelerator got stuck at full throttle. I looked for a kill button or ignition switch, but couldn't locate it because it was on the side and I was unfamiliar with the bike. As I approached the end of the

road, I realized I had to lay the bike down. Due to adrenaline everything went into slow motion mode. I lifted my leg over the tank and launched off the side of the bike into a belly flop on my chest. I had successfully separated myself from the machine, but I was still travelling at several miles per hour with my arms and legs splayed skidding on my chest heading toward the concrete curb with no helmet. I finally came to rest eyeballing the curb three feet away. My wool sweater shredded, as I skidded on the pavement, but fortunately, I had a leather shirt on underneath, which avoided some injuries to my chest. I ended up in the hospital with elbow contusions and a couple of cracked knee caps. I decided in the future that it would perhaps be better not to borrow vehicles from friends.

By the time I started the second semester I felt lost. The prospect of four years of college, grad school and a married life in the suburbs seemed unappealing. I decided that I would drop out of college and become a Green Beret. For Roman Catholics, John Kennedy stood out as a hero to Irish Americans. He lauded the Green Berets, "The Green Beret is a symbol of excellence, a badge of courage, a mark of distinction in the fight for freedom."[xxv] It seemed like a good idea at the time. How my parents would react leaving college would be another story.

I dropped out of school and ended up working as an electrician's apprentice. Toward the end of the Summer I was working on the top corner of a new house installing three flood lights on an extension ladder effectively three stories high. The cinder block basement of the house hadn't been backfilled yet with dirt. An apprentice carpenter picked up a twenty foot two by four and turned 180 degrees with the board. Instead of turning his body and shifting hands, he held it and turned in an arc. A scene out of an old Charlie Chaplin slap stick movie unfolded. The two by four hit the bottom of the ladder and I went flying. I landed on the excavated dirt on the side of the house and broke my wrist. My career, as an electrician, came to an abrupt end.

Around this time John Shine, my friend from high school, had just to come back to visit family. Attending UC Berkeley after transferring from Rutgers University, he told me about California. It sounded great.

Since my wrist was broken and I couldn't work, it seemed like a good idea to explore California. I was either going back to school or joining the Green Berets in September. These were the only options open to me at the time due the draft and the Vietnam war. With no student deferment, I would be drafted.

I approached my father and told him of my plans, but he informed he would not allow it. We got into a heated argument at the climax he said, "If you go to California, don't come back." At this point the communication broke down and I went to pack my "suitcase", a green rubber lined laundry bag. My mother, passive throughout of the encounter, drove me to Sea Bright to catch the bus to the Port Authority Bus Terminal in New York. As it pulled out, I was in tears upset at the encounter with my father and afraid of the abrupt unknown facing me. I arrived at the Port Authority Terminal and purchased a Trailways bus pass for 30 days for $99. It allowed you to travel anywhere in the country on any Trailways bus for the time period.

CHAPTER 8

OAKLAND, CA

The bus left the Port Authority around 10:30 PM and it took about three days to cross the country due to all the stops. I found it interesting to observe how the landscape changed, as we journeyed West. The entire day we went through Nebraska we were surrounded by an endless horizon of monotonous corn on both sides of the bus. There was a moment when the bus driver mentioned we were just crossing the Great Divide. From this point on all the waters flowed into the Pacific Ocean. I looked out the window and saw my first prong horn antelope bounding up the side of a mountain. We had officially crossed into the western part of the continent.

The bus arrived in Oakland, California around 1:30 AM. The terminal located in the downtown area was a bit sinister with the passed out drunks in storefront doorways and insufficient street lighting. I saw a lone diner, glowing in the darkness with three patrons depicting a live version of *"Nighthawks"*[xxvi] by Edward Hopper. I walked by carrying my sack and spotted down the street a red neon sign on the top of a five story building, "The Grand Hotel". I walked in the fluorescent blue lit lobby with extremely used over stuffed furniture and linoleum floor. With only the night man seated at the counter, I got a room and walked up the stairs, since I previously observed the "out of order" sign on the elevator as I entered. Completely exhausted I just wanted to crash. I entered the room looked around and decided that it best to sleep on top of the covers not trusting what might be underneath. I arose at first light anxious to depart my luxurious accommodations. The only thing "grand" about the "Grand Hotel" was that it was situated on Grand Street in Oakland. I asked a man on the sidewalk the direction to Berkeley. I followed the way he pointed and thanked him. I had no idea how long it would take to get there on foot. I walked about an hour and a half and finally arrived at the Berkeley city border. I saw a little luncheonette named "The Brick House", a small café with only a counter, and I decided to reward myself with breakfast after my five-mile hike. A one-man operation, the owner was thin, average height and

wore glasses. He reminded me of Ichabod Crane[xxvii]. After breakfast I asked the proprietor for directions to the address I had been given, thanked him and resumed my trek.

I arrived at the address that John and Debbie Shine had given me. They were still on the east coast visiting family, so I couldn't stay with them. It was a duplex in the back yard of another building. I knocked on the door and a guy in his twenties answered the door. A little over weight about five ten tall, he had sandy curly hair and a distant look in his eyes. His name was Bruce Cotrell. I explained that John and Debbie told me to contact him about a place to "crash". He listened silently frowned a bit and the first words out of his mouth were, "Well…you can't stay here." I had expected a warmer greeting. Great, I thought. An emotional three-day bus trip, a night in a probable bed bug infested skid row hotel, a long hike and still no place to rest. Bruce gave me another address for a guy named Vinny Woods. I went to his address, a large dark brown shingle home in the 2400 block of Prospect Avenue, three blocks from UC Berkeley's football stadium. I located him and explained I needed housing.

Vinny, a graduate student in Economics, was a very friendly guy unlike Bruce. He managed the house. Students would rent the bedrooms and the living area and kitchen were common to all. My financial reserves from working as an electrician were diminishing, but I could afford the rent of forty dollars per month. I needed to get some work. At first I tried working as a temp doing warehouse work for a company called Manpower. An acceptable job other than having to get to the work location by public transit and working at minimum wage with union dues deducted.

Being in a communal house facilitated meeting other people. I met my first California girlfriend, Anya, a Russian ballerina, who also resided at the Prospect Avenue house. Most of the other renters were friendly grad students, but there was an older grumpy German guy with a bushy mustache that smoked a pipe named Gunter, writing a novel. Anya told me he was a famous German novelist named Grass and he should be left to his work and not be disturbed.

There were only seven TV stations in the Bay Area and CBS was the gold standard of reporting. At six o'clock everyone would gather in the living room and watch the CBS evening news with Walter Cronkite[xxviii] monitoring the alleged progress of the war in Vietnam. The first time scenes of live warfare were delivered to the homes of America. This had a positive effect in helping generate the antiwar movement. It was no longer abstract. We felt we were being lied to at the time in regard to the government's depiction of America's progress in the war.

Anya also introduced me to her friend, Ronaldo, who showed me the ropes on how to work on the waterfront docks in San Francisco. We would leave Berkeley at 5:30 AM and take the bus to San Francisco. We'd walk from the bus terminal to the Scalers and Painters union hall, a faded gray wood clapboard structure located in an alley near the Brannan Street train yard. It had sawdust on the wooden floor and depending on what time you arrived to "shape up" you got a peg with a number. The interior of the building was at least fifty years old and I'm doubtful it ever had been repainted. On a stool behind a cashier's type window with bars the dispatcher called out the numbers to assign the jobs. Sitting on the backless oak bench waiting, I felt I was going back in time. I thought this is how my grandfather began working on the docks of New York as a teamster, when he emigrated from Ireland.

The Scalers and Painters union got all the jobs that the Longshoreman's union didn't want, such as, hauling bails of raw rubber with the bailing hooks. It was tough work, but, if you got out, the pay was good. Three times a week could be sufficient to survive. If our number wasn't called, we'd walk up ten blocks to the Longshoreman's Hall to repeat the process. If we were unsuccessful getting work in the morning shift, we'd go to a movie theater that showed films all day long on Market Street and sleep. We'd leave around 3 PM and go repeat the shaping up process again at the union halls for the night shift.

One day we were walking up Market Street on our way the afternoon "shape up" at the Longshoremen's Hall and a panhandler approached us obviously suffering from some substance abuse, most likely alcohol.

I started to reach in my pocket and Ronaldo shouted at me, "What the fuck are you doing!"

He turned to the panhandler and said, "Fuck You! We work hard for our money, you bum. Go get a job."

The panhandler said, "Sorry man", then looked away and shuffled along.

Ronaldo looked at me said, "We bust our ass to make a buck and you give it away. You're fuckin' crazy."

Speechless, I had no reply. On the one hand I felt sorry for the guy, but on the other hand I realized that I was being instructed by Ronaldo of the cold reality of living on the streets. What did hit me was how naïve I was, as to the reality of worlds I had never experienced before, given my comfortable suburban upbringing.

Debbie and John Shine

When Debbie and John Shine came back to Berkeley, they would often invite me for dinner. One time I came over and asked Debbie, "What's for dinner?"

"Chicken Necks", she replied.

"Chicken necks? How do you eat chicken necks?", I responded.

"You boil it to make a broth, remove any bones, strip off the cooked meat and add vegetables like carrots or celery.", Debbie answered.

"That's it? It doesn't sound that appetizing.", I said.

Debbie replied, "You're not in Rumson anymore…Vinny."

When she said that my mind exploded at the impact of her words, some might say a satori. The reality of my life became apparent. I was alone. The idyllic experience I had growing up as a kid in an insulated upper middle class environment had passed. The influence of my family's status, which I was unaware of at the time, evaporated. I was just another raisin in the sun.

CHAPTER 9

FRUITVALE CANNERY

One of the hardest jobs I had was working at the Fruitvale Cannery in Oakland, California. California grows most of the fruits and vegetables that America consumes and a lot of it has to be canned. A seasonal job straight out of Steinbeck's "*Cannery Row*"[xxix] began as the fruits started to harvest and went through the various varieties plums, peaches, pears, etc., as the season progressed. Fruit Cocktail canned last consisted of the dregs. To this day I will never touch Fruit Cocktail. At first I had to stack cans into cardboard boxes with a two handed tool that could hook eight cans at a time. The cans came down a silver conveyer belt to a four-foot circular area which rotated, in which, to hook them. It was difficult to keep up with machines, as well as, the audio assault of the high volume of their operation. Identified as a good worker they kept moving me to different jobs. My second job, stacking the boxes on palates, had the same negative aspect of keeping up with a machine. Next I was assigned to the cat walk making sure the fruit cocktail flowed smoothly on the conveyor belts and also making sure people were working. I thought this ridiculous because these people were forced to work as fast they could keeping up with the machines. We got paid a flat hourly rate for forty-eight hours versus the normal forty hours. If you went over forty-eight hours you got time and a half, demonstrating the labor union being obviously in management's pocket. Our union dues had no impact on improved conditions.

The cannery kept me on until the end of the season. On the last job I worked with another man named Algenon. We worked with no supervision. We took grapes from the wooden field boxes and threw them into turning cylindrical stainless steel tubes, eight feet in diameter and thirty feet long. It was like a giant colander which cleaned the grapes with sprayed water and separated the stems and shaft. I was bit intimidated, when I first met Algenon. He was six foot eight, about three hundred pounds, clean shaven bald, blue black skin, with enormous hands, which his gloves enlarged that much more. In spite of his size,

74

he had no fat. We got along great. We were located in rear of the cannery near the loading docks where the fruit was brought in from farms far from the eyes of management. They never bothered us because we were good workers. The hippie and the black in the back of the "bus" or in this case the cannery.

No one called Algenon, Algenon, however, his nickname was "treetop". He talked about the jobs he had in his life and he thought this one wasn't so bad except for one thing.
I asked, "What?"
"Spiders," he replied, "Black Widows"
"Black Widows?"
"Yeah, dese grapes are crawin' wit' im."
"What!" I said, as I dropped the wooden box in my hands.
Treetop burst into laughter, but finally contained himself and sputtered out.
"Ain't as bad as Panama. Had tarantulas in bananas there."
I didn't have a reply. He got me and I joined in laughing.

We would smoke weed in the back sometimes and he told a story of when he worked in Panama. He was merchant seaman and had gotten some weed locally before going back to the ship. He had smoked a bunch of it, but he didn't seem to feel high. As he started going up the gangplank, he noticed that everybody was looking at him, the sailors, seamen, the officers. He felt they must know he had brought contraband on board. He freaked out and immediately went to the head and flushed the rest of the weed he had. He said he never wanted to smoke that variety again. He was smoking a strain of marijuana known as Panama Red. It has a unique effect. It is very mild and cool on the throat versus other strains. The effect, however, comes on very strong, as if from nowhere, like vodka or tequila. This effect is what fueled Treetop's extreme paranoia.

CHAPTER 10

BERKELEY 1966

In August of 1966 UC Berkeley had just gone through the "Free Speech Movement" the year before. Students insisted that the university administration lift the ban of on-campus political activities and acknowledge the students' right to free speech and academic freedom. Later this would be expanded to the civil rights movement and protesting the Vietnam war[xxx]. This period proceeded the Summer of Love of 1967. Berkeley had not yet become famous or notorious depending on your point of view, as a national center of protest or a mecca to attract disenfranchised youth from across the country. If a man's hair was touching the top of his ear, his hair was considered long. LSD was legal and available as "Electric Kool Aid" at rock shows at the Avalon Ballroom for twenty-five cents. This was the lull before the psychedelic storm that would become the "counterculture".

Berkeley still had the feeling of a college town. The "avenue", where most of the action took place, was the part of Telegraph Avenue that extended four blocks from the South entrance of the UC campus on Bancroft Way to Dwight Way. What Haight Street is to San Francisco, Telegraph Avenue is to Berkeley. It was very colorful and eclectic with students, intellectuals, professors, bikers and beatniks or sometimes neo-beatniks, as we were sometimes called, since the "hippie" name hadn't been coined yet. It would not be uncommon to see a professor having coffee with his seminar students next to a table of Hell's Angels having cappuccinos at The Forum coffee house on the corner of Haste and Telegraph Avenues. A vibrant music scene illustrated by colorful posters that promoted band performances at various venues were attached to the street light posts, along with flyers for political and cultural events.

Berkeley had a reputation as a political center for leftists, focused on civil rights activists and opposition to the Vietnam War. And though, I came to California with the idea of visiting and returning to New Jersey

to enlist in the Army, as a Green Beret, my mind changed through my experience there. One day I remember seeing a photo of a baby burned by napalm[xxxi] in Vietnam. This struck a chord in me similar to my experience in North Carolina with the black man on the sidewalk. It was wrong based on my belief system. The napalm was shipped to Vietnam by DOW Chemical from Port Chicago, California thirty miles northwest of Berkeley. There were busses that left from Berkeley carrying protesters. The protest centered on the railroad delivery of the napalm to the ships heading to Vietnam. The concept was to try to block the train and protest with signs on the side of the access road. During one trip a protester's legs were run over by the train. On the road we were assaulted with cans of paint and sometimes shotguns fired in our direction. Protesting did have some positive side benefits, however. Other than confirming that I wasn't going to go to Vietnam, it was a great place to meet women. Eventually, the government took over the area under eminent domain and it became a part of the Port Chicago Naval Magazine, the main facility for shipping to the Pacific Theater of Operations[xxxii].

For men of my age the draft of the Selective Service System[xxxiii] loomed large as a dark thunder storm ready to burst. Within thirty days of your eighteenth birthday you had to register with the government and complete a physical at the Induction Center. There were a few exceptions for deferment: you could be a Conscientious Objector, have a health condition, be sole support of a family, be a homosexual, go to college or be married. The other option was to flee to Canada. The Bay Area was a hotbed of protest against the Vietnam war. There were demonstrations at the Oakland Induction Center where draft cards were burned and protesters beaten and arrested.

We were the first generation to experience "duck and cover" drills in elementary school acknowledging the fact that we could be vaporized by a nuclear bomb during the "Cold War"[xxxiv] with Russia. The Cuban missile crisis[xxxv] occurred in our later years of high school. People had the insecure feeling that your life could be altered in seconds. As the Vietnam War went on, there was growing distrust of the reports of war progress by Presidents Nixon and Johnson. A favorite bumper sticker

Huey Newton
co-founder of Black Panter Party

[xxxvi]of the time was "Question Authority" popularized by Timothy Leary. This concept was indicated years earlier by C. Wright Mills in his 1956 book, *"The Power Elite"*. quoting: "Authority *formally* resides 'in the people,' but the power of initiation is in fact held by small circles of men. That is why the standard strategy of manipulation is to make it appear that the people, or at least a large group of them, 'really made the decision.' That is why even when authority is available, men with access to it may still prefer the secret, quieter ways of manipulation." Mills noted earlier that "It is in this mixed case—as in the intermediate reality of the American today—that manipulation is a prime way of exercising power."[xxxvii] We felt the government was lying to us and couldn't be trusted. This was proven to be the case years later due the Freedom of Information Act[xxxviii] enabling the release of files, which confirmed it.

In order to have a student deferment I enrolled in Merritt College, a junior college on Grove Street in Oakland. California had one of the finest educational systems in the USA from grade school through college. Junior college was essentially free in California other than the cost for class materials. I took Chinese, art and writing courses. I also participated in poetry readings at college, which is where I met Gail Carby, my first wife. I used to sign the poems with my initials "val". When we first met, she thought Val was my name and that I looked like the comic book character "Prince Valiant" with my hair style.

A group of black students in the halls hanging out together with black berets and three quarter hip length black leather jackets were called the Police Alert Patrol They wore arm bands with "PAL" and a drawing of

an eye on an arm band. While the Berkeley police were college educated and more like frat boys, the Oakland Police had a reputation of being brutal and racist "good ole boys". The PAL members would follow Oakland police cars at night to observe stops to make sure that black people weren't abused by the police and had their rights protected. This group became the Black Panther Party[xxxix]. I had a creative writing class with Huey P. Newton, one of the founders. Huey was intelligent, articulate and had a charismatic personality. Unfortunately, he met a bad end years later due to drug abuse.

Tom Oliver Super Joel Pat owner of "The Store"
at the Mediterrean Cafe on Telegraph Avenue in Berkeley

Telegraph Avenue, typical of college towns, had in one block alone four books stores, Shakespeare & Co., Moe's, Cody's and Shambala. Shakespeare's and Cody's had new books and textbooks; Moe's specialized in used books you could trade for credit to apply to more book purchases or get cash. Shambala was one of the first metaphysical bookstores. There were also different types of specialty stores, such as, Yarmo, for handmade clothing, a bakery, antique stores, leather shops, sandal makers, all owned by individual proprietors serving the greater student community. It was an advantage being in a student community.

Money was scarce, but students usually got better deals. Robbie's, a hofbrau style restaurant with steam tables located a block down Telegraph Avenue from the university's South Gate serviced their needs. Poor students and street people would frequent it because you could get a bowl of rice for one dollar and if you were polite, the Chinese cook would pour a ladle of roast beef juice on it for free.

SAN FRANCISCO 1966

Human Be-in San Francisco 1967
Golden Gate Park Polo Fields

ocused primarily on political issues like civil rights and emphasis on the opposition to the Vietnam war, the people in Berkeley were quite serious in their convictions and some advocated militant resistance. The scene in San Francisco, however, seemed more playful and hedonistic albeit resistance to the war and support for civil rights echoed Berkeley. In the Haight Ashbury in San Francisco there was a group called the Diggers. They took their name from an old English group from the 17th century that espoused a society free from private property and all forms of buying and selling. The San Francisco Diggers came from the bohemian underground artists, the theater scene and the New Left. They were associated with the SF Mime Troupe, a radical left theater company, that would perform guerrilla theater and happenings for free in the park. The Diggers distributed free food in the Golden Gate Park every day. They also set up a series of free stores, in

which, everything was free for the taking. The store motto was *"Take what you need and leave the rest."* It worked. A spirit of sharing and support for the collective good permeated the Bay Area at the time. They tried the same experiment in the East Village in New York. The store was emptied and no further donations were made. Apparently, the "love thing" appeared to be too complex a concept for Manhattan at that time. The Diggers also set up the first free clinic, which inspired the establishment of the Haight–Ashbury Free Medical Clinic and distributed free baked bread baked in old coffee cans. We even had a free funky old bus that traveled back and forth from Berkeley to SF for a short period of time. "Do your own thing" and "Today is the first day of the rest of your life." were coined by the Diggers.[xl]

Human Be-In Poster

In January of 1967 a "gathering of the tribes" the first "Human Be-In" was announced in the San Francisco Oracle, the Haight–Ashbury newspaper. The poster on the lamp posts appeared a bit strange not like ones for shows at the Fillmore or Avalon Ballroom. It was purple inked with a picture of a guy that looked like an Indian guru with a yellow pyramid with eye at the top super-imposed on the third eye of the man in the picture. Nobody knew what to expect. It was later recalled by poet Allen Cohen, who assisted the artist Michael Bowen in the organizational work, as a necessary meld that brought together philosophically opposed factions of the current San Francisco-based counterculture. On one side, the Berkeley radicals, who were tending toward increased militancy in response to the government's Vietnam

war policies, and, on the other side, the rather non-political Haight-Ashbury hippies, who urged peaceful protest. Their means were drastically different, but they held many of the same goals. Twenty to thirty thousand people showed up in Golden Gate Park, which surprised everyone including those who were attending. We didn't know that there were that many of us.

Human Be-in 1967 San Francisco
Golden Gate Park Polo Fields

The event went on through the whole day. The speakers included Timothy Leary in his first San Francisco appearance, who set the tone that afternoon with his famous phrase "Turn on, tune in, drop out". Richard Alpert ("Ram Dass") also spoke, as well as, poets like Gary Snyder, Michael McClure, and Allen Ginsberg, who chanted mantras. Other counterculture gurus included comedian Dick Gregory, Lenore Kandel, Lawrence Ferlinghetti, Jerry Rubin and Alan Watts. The Hells Angels, who were at the peak of their "outlaw" reputation, corralled lost children. Music was provided by a host of local rock bands including The "Jefferson Airplane", "Grateful Dead", "Big Brother and the Holding Company", "Quicksilver Messenger Service" and "Blue Cheer", who were all common performers at the Fillmore and the

Avalon Ballrooms. Underground chemist Owsley Stanley, nicknamed "Bear", provided massive amounts of his "White Lightning" LSD, especially produced for the event, to be distributed for free. To clarify a reported myth, Owsley never parachuted to the Polo Fields dropping LSD from the sky, but a parachutist did glide into the field. Given the circumstances it was easy to see how the two events might be conflated. The Diggers also provided seventy-five twenty-pound turkeys for free distribution. If this wasn't the birth of the counter culture movement, it was definitely its baptism. The irony is that the anti-materialistic values of the hippies were possible only because of an affluent booming war time economy and low cost of housing.

A lot of the unexpected local news coverage became broadcasted nationally. It popularized the hippie culture of fashion, music, customs and beliefs to a national audience. The media painted an idealistic mecca for the disenfranchised youth of America, who were willing to reject the conformist and materialist values of modern life with an emphasis on sharing and community in which they could participate. Estimates of 100,000 young people across the country decided to make the pilgrimage to the Bay Area to attend the 1967 Summer of Love. This caused its own set of problems. Two years after the Summer of Love the Haight-Ashbury descended into a hard drug war zone unrecognizable from its status in 1967. Peace and love had departed. Beads and sandals were replaced with police in riot gear. The music displaced by the sound of the sirens and helicopters. Instead of a colorful light show, it was the intense Xenon spotlights of the police helicopters at night, which created an eerie blue light. The Black Power movement began cresting, while cities were burning.

I returned to the East Coast around Christmas. I got off the plane at the Newark airport wearing a gray glen plaid suit and trench coat. I had let my hair grow, while in California. At first my father didn't recognize me and walked past me. When he turned around and realized it was me, he freaked out on the length of my hair. To keep it in perspective my hair was half way down my ear. It probably would have been called "mod" at the time. We are not talking about pony tails. When we left the airport, he angrily walked six feet in front to avoid being associated

with me. For a moment I considered getting back on a plane to California, but my mother next to me asked that I yield. After an argument at home I told him that I would cut my hair, if it really mattered that much to him. When I left for the West Coast on the plane to return, I realized that I couldn't go home anymore. I was on my own extremely depressed and completely lost.

I had been selling speed, methamphetamine HCL, and using it intravenously. I met Jerry Miller, a speed dealer that had a direct connection to an underground chemist. Generally speaking, the closer you are to the source of the drug supply the more insulated you are from the street and potential arrest. I was successfully selling the high quality product in Los Angeles and flying back and forth to San Francisco. Flights from San Francisco to Los Angeles ran like a bus schedule at two per hour for around $25 on PSA Airlines. The hard drug scene consisted of speed, methamphetamine HCL and two forms of heroin Mexican brown and China white. Powdered cocaine was very rare and considered exotic. No "crack", "ice" or stimulants derived from pharmaceutical drugs existed. Drug addicts were vampires of the night sleeping in the day and staying up all night. The effect of using "speed" intravenously created a euphoria for a few hours and a very long "crash" or coming down from the high. This induces an addict to shoot up again to regain the endorphin rush from the high. People would stay up for days on end. When I went back East for Christmas, I had stopped using speed. When I returned, I tried it again, but it was too intense and I started to use heroin. I tried to commit suicide two times intentionally overdosing. I remember being furious when I woke up 14 and 22 hours later, respectively. If you commit to suicide, you feel you have nothing to lose. You go through a period of detaching from people and create fantasies of how the world would be better without you. I had this concept of myself as a poet and my loss would create a vacuum for a better poet than me. Logic did not apply.

This period of haze culminated one night in North Beach in San Francisco. My girlfriend and later first wife, Gail Carby, and I were visiting a connection's apartment on the top floor of a five story apartment building on Fresno Alley just off Grant Street in San

Francisco's North Beach. There was a pounding on the door; it was the police. We were busted. Bob, the renter of the apartment, had installed special metal doors with metal jams that delayed the police breaking in the door. Garry, also known as "Garuu", one of people hanging out looked at me and said we should try to escape. We went into the bedroom and there was another apartment building next door separated by a fire escape. It was a hot August night and a bedroom window in the other building was open. Garry went for it and bounced off the occupied bed. He motioned for me to follow, but I knew Gail couldn't make it and shook my head. After a mad scramble, drugs were flushed, contraband stuffed into bags and thrown out the window by "Bummer", Bob's girlfriend. Unfortunately, in the parking lot next to the apartment building the agents were waiting below and were catching the bags, as they fell, before they touched the ground. The police arrested everyone in the apartment on the same charges. Three felonies and two misdemeanors for distribution of drugs with intent to sell, and possession of guns and stolen property. Since Bob was a dealer, addicts would often barter for jewelry or other stolen goods, which became the source of the stolen property charge. Despite just being in the apartment, we were charged with all the crimes.

The first night in jail I was in my own cell in a row of four. There is a sound that I will never forget, the double clunk thud of the jail bar doors closing and then silence. We were taken to court and paced in the holding tank to wait until called into court. Among the motley male perpetrators in the "tank" a very attractive woman sitting on one of the concrete benches smiled at me. I was so naïve; it turned out to be a transvestite prostitute. I was in the middle of going through heroin withdrawal, physically crashing and mentally confused, when I heard my name called. I leaned on the rostrum in the court room and was reprimanded by the judge. The bailiff recited the charges and I pleaded not guilty. I heard them call out, "OR" after the charges, which meant you were on your "own recognizance" and bail unnecessary.

After court we were taken to the "Show Up". A popular TV show in the 1950's called "The Lineup[xli]" used San Francisco as the venue. The "Lineup" wasn't called the "Lineup", but rather named the "Show Up".

I can't tell how disappointed I was that the name was different. In a relatively good mood at the thought of being released, they shuffled us in and I was number five. Detectives and undercover officers used these events to familiarize them with faces they might encounter on the street. There were two hippies, two blacks and three Hispanics. After they called number three the other hippie stepped forward and did a little dance, as they read his charges. When my turn came, I did the same thing and he joined in. We broke up the cops…a moment of levity in prison.

When returned to jail, I moved into the general population, composed of dorms with two rows of ten double bunk beds against the gray walls and two long concrete tables with benches in the center. At the end of the room there was an exposed commode. I was waiting to be released on the "OR" charges, but no one came, as days passed. I eventually got to talk to a legal aid and found out that only a few of the charges were "OR"ed and bail was needed for the others. I didn't know what to do. I had no one to call to bail me out. I considered calling my father, but rejected it because it would be too big an embarrassment for him given his concern for "appearances". I decided to stick it out. I didn't feel I had any choice. It was close to my twenty first birthday. Every time I hear "Mama Tried" by Merle Haggard…"*turning twenty one in prison doin' life without parole*" it takes me back to feeling of desperation I had at the time. It seemed appropriate considering Merle was a former San Quentin inmate.

One day an old straight guy that looked very clean cut in his fifties went into an epileptic seizure foaming at the mouth. The guards came in and pinned him down. It turned out he was withdrawing from barbiturate addiction. Awake a lot at night due to the heroin withdrawal, I kept seeing an inmate not sleeping at the end of the other row of bunks giving me weird looks. The next day around noon the same guy about six two, a lanky black man in his forties, started to pace around the table, while I sat on the concrete bench. In a loud voice he stated, "The grapevine has it that there's a hippie snitch in here wearing corduroy bell bottoms." There were a couple of other hippies among the forty inmates, but no else had corduroy bell bottoms. I found out later that there was

in fact a snitch with blond hair that fit the description in one of the other dorms. He kept pacing around the table. He said, "Let me see your sheet." I handed him the paper with my charges and he said, "Three felonies and two misdemeanors, I'm gonna see you in "Q." meaning San Quentin. I was terrified. I sensed him warming up to attack pacing around the table in a circle like a predator and then I heard my name called by a guard in the hall. "Lynch, you're bailed out, get your stuff." At this point I believed I had a guardian angel. I came out of the jail on Bryant street and my girlfriend Gail and her former boyfriend Kenny Specter were waiting for me. She convinced Kenny to bail me out. I knew he wasn't into it, but I appreciated the act. Kenny almost became one of the "Monkees" for Don Kirchner. He just missed the final cut. His personality would've been a perfect fit.

None of my addict friends did anything to help me. For me this was the end of my hard drug use. We had a choice that we would go free and Bob the dealer would get felony charges for hard time in prison or we would plea to lesser charges and accept a misdemeanor for "visiting a place where narcotics is used". We chose the latter and I got probation for three years. Eventually, the law was found to be unconstitutional and eliminated from the California Health and Safety code.

In the Spring the Bay area swelled attracting more kids every day; with them came a rise in experimentation of psychedelic drugs. There were organic substances like peyote cactus buttons, psilocybin mushrooms and chemicals like LSD and DMT, as well as, multiple varieties of hashish and marijuana, such as, Panama Red, Acapulco Gold, Mexican Michoacán or Columbian brown. At the time drugs were mainly imported and not much was grown domestically. It was not just about drugs although that was a large emphasis in the media. As "Grateful Dead", guitarist, Phil Lesh, said, "It wasn't about drugs. It was about exploration, finding new ways of expression, being aware of one's existence."

People had respect for LSD especially because in early years there was a lot of experimentation before dosages were standardized. Dosages varied from strong to very strong depending on how many tablets were

made from the gram of LSD. A gram would yield 4,000 250 microgram dose tablets. A "trip" could last from eight to twelve hours. More experienced "trippers" recommended that you use a "guide" on your first trip to facilitate the event.

I took my first acid trip with a friend named Ray Belcher, a photographer. He agreed to act as my guide. He had it all planned out. We left Berkeley about 5:30 AM and drove over the Bay Bridge through San Francisco to the Golden Gate Bridge. We got off the highway in Marin and drove up a foggy winding road in the dark to the parking lot at the top of Mt. Tamalpais in Marin County. We hiked up with our flashlights and positioned ourselves under the ranger cabin overlooking Mill Valley below and waited for the sun to rise in the East. It was hard to say how long we were there because of the effect of the drug. As the sun rose and wind kicked up, the fog started to diminish on the top of mountain. Below the valleys were filled with rivers of moving clouds in streams. We were lost in observing the valley below, when all of a sudden a shrill bell rang. We were startled. We looked at each other wide eyed. The alarm clock of the ranger in the cabin above our heads destroyed the serenity of the moment. We had no idea that the cabin was occupied. As we heard the fire ranger get out of bed and start to walk around on the creaking wooden floor above us, we quietly crept out from under the cabin and made our way back to the car.

We drove down the hill and entered Muir Woods national monument,[xlii] which consisted of approximately 500 acres with half the area covered in old growth redwood trees. As we walked back into the far end of the park, the ferns and moss next to the clear streams with crayfish exuded a primeval feeling. You could feel the intense energy emitted by the old growth redwood trees. I remember at one point sitting next to the bank of the stream coming down off the LSD and I looked to my right and I saw this large yellow thing on the log next to me about ten inches long and an inch in diameter. At first I thought I was hallucinating, but then I noticed it was moving slowly and alive. It startled me at first. It turned out to be a banana slug, a species I had never seen on the East Coast. My hilarious reaction set off a laugh attack that lasted several minutes. At the end my stomach hurt from laughing so hard. We made our way

out at the end of day after we had come down from the drug. We drove uneventfully back to Berkeley and had dinner. My first positive experience with LSD altered the way I would look at nature the rest of my life.

The Spring going into the Summer of 1967 was a period of great enthusiasm and hope in the Bay Area. Hope that a new culture based on different values than the "Establishment" was forming. We thought a revolution had started and the fact the area flooded with like-minded young people from all over the country seemed to confirm it. The center of the action in Berkeley, the 2400 block of Telegraph Avenue between Dwight Way and Haste Street, was a very colorful place, not only in dress, but also in the street characters. The players had monikers such as: "Eastside", an Italian kid from New York, a follower of Lobsang Rama, developing his "third eye" in flowing robes with beads hawking LSD; "Three-wheel Chuck", named for his transportation mode, a converted Oakland police meter maid three wheeler; easy going "Captain Zen" to be distinguish from the moody "Zen or Z", the Richmond Hell's Angel and "Chick Z", his Rubenesque girlfriend, who were regulars at the Blue Cue Pool Hall on Telegraph avenue, "a drug dealing den" according to Berkeley police. Barry stood out, called the "African Queen", six feet four, two hundred and thirty pounds with milk chocolate skin. He didn't walk, he sauntered. His thin cane actually a prop, swayed in unison with his movement. He leaned slightly backward and his legs preceded his torso. He had a very attractive face with perfectly groomed hair and always had a smile with a diamond in one tooth adding sparkle. He wore long flowing white robes and would bless us as he passed. We didn't give him his name. He used to hang out in Cambridge, Massachusetts, a favorite of Harvard Square. Harvard going through a Bogart movie fad at the time christened him with the honorific: the "African Queen".

One time, "Tiny", the giant Sargent-at–Arms of the Oakland Hell's Angels, told me he needed to speak to Allen Ginsberg and asked, if I knew him or his whereabouts. There was an anti-war march planned for the East Bay by the Vietnam Day Committee and a meeting was planned with the demonstrators and the Angels in an attempt to avoid

violence. I think I was type cast. He assumed because I looked like a hippie, I must know him. I told him I didn't. He reacted quite surprised. In addition to protests and demonstrations there were always a lot of activities on Telegraph Avenue, such as, "happenings" or bands playing for free on flatbed trucks with generators.

I needed cash in this period of time, so I had to sell both my Yamaha Scrambler and my beloved Vincent Black Shadow motorcycles that were stored on the East Coast. I got married to Gail Carby in the Spring. We had lived together and it seemed to be a good idea at the time. We had a hippy wedding in the "Little Church in the Vail" in Soquel, California. To indicate the formality of the venue the groom of the couple before us got married in his bath robe.

CHAPTER 12

MONTEREY POP FESTIVAL

Ravi Shankar at the Monterey Pop Festival 1967

G ail and I decided to go to the Monterey Pop Festival. We had seen a lot of the local bands like the "Grateful Dead", the "Jefferson Airplane", "Big Brother & the Holding Company" with Janis Joplin, at the Fillmore and Avalon ballrooms, as well as, for free in the park. We could only afford to buy tickets for one show and we chose Ravi Shankar on Sunday afternoon the third day of the event. He composed the music for the famous Indian films of the *Apu Trilogy* of Satyajit Ray[xliii], an art theater favorite. There is a moment in *"Pather Panchali"*, when a woman screams silently in remorse, as the sitar becomes her voice. It's an extraordinary film moment. Ravi Shankar also became a favorite to play for background music on LSD trips. You felt, as if, you were "in" the strings. With eyes closed different colors were generated in your mind, as he ascended the sitar's scales.

We decided to go down early and camp out at one of the camp grounds on the coast. We got a ride with Barry Powell and Pat, his wife, in his VW bug. Barry was completing his doctorate in the Classics at UC Berkeley and Pat was a teaching assistant in the graduate school. As we approached Monterey, we were greeted with a lot of traffic and police from several different jurisdictions. No one expected the crush of people that arrived. The performance area of the festival only seated a little over seven thousand people. Even with afternoon and evening shows over three days that was fewer than 50,000 people. As it turned out, four times that many showed up over the weekend. There were volunteers with arm bands directing people and the police were extremely helpful and friendly. They seemed to be enjoying the spectacle.

When we were on the outskirts of Monterey, we were directed by the police to the local junior college's football field. We arrived relatively early and set up camp and tents around the twenty-yard line from the goal post. Eventually, as the day wore on the whole field became filled. Around sunset a psychedelic painted school bus pulled up to the end zone and hung some sheets using the goal post as the frame for a projection screen. On top of the bus they set up a generator and the light show projectors. A flatbed truck also with a generator and a back line of band equipment parked to the right. When the sun went down the bands started to play and continued with the light show all night long. A lot of the artists that were performing at the paid venue played on the flatbed, such as, members of the "Grateful Dead", "Eric Burton" and the Animals", "the Byrds", and "Buffalo Springfield".

At one point the Hells Angels' choppers roared up creating enlarged silhouettes on the goal post screen. Most of the people had ingested acid and as the night wore on were getting sleepy or had crashed. Around 3 AM a lone nasal singer with acoustic guitar on the stage sang *"Sad Eyed Lady of the Lowlands"*, a Bob Dylan song about Joan Baez, who at one time lived nearby. Mist not quite rain soaked us, quite common in that time of year because of Monterey's location next to the sea. It became a scene from George Romero's *"Night of the Living Dead"*.[xliv] People rose from tents and walked like zombies toward the stage. A single collective unconscious moving as an organism toward the source. It's

an extremely long song, which took up the whole side of a 33 1/3 LP vinyl record. By the time he finished the whole stage was packed with fans. When he walked off stage a girl asked, "Are you Bob Dylan"? He replied, "No" and walked off. The zombies returned to their tents, resumed their slumber and the collective unconscious dissolved.

The next day we went to see Ravi Shankar. The weather had cleared illuminating a beautiful day. A whole village outside of the venue of artisans offered handcrafts and foods. There were roaming street performers and "peace and love" reigned. When we sat down inside the arena, we were a few seats down from some Hell's Angels in full "colors", sleeveless jean jackets covered in patches of the regional club affiliate, death skull logo and the ubiquitous diamond shaped "one percent" patch. The AMA, American Motorcycle Association, had declared that, "99% of motorcyclists were honest, law abiding American citizens," hence the patch.

The Angels were wearing flower necklaces and smoking joints. The contrast of their dress and selection of Ravi Shankar, as a show to see, is still a mystery for me to this day. All the artists were allocated 40 minutes for their set. Some like "the Who" even played less.[xlv] Ravi Shankar was the exception with a three-hour time slot in the afternoon. At one point in the performance a helicopter ferrying artists back and forth from back stage flew overhead almost obliterating the sound from the stage at an intense moment in the raga. Shankar never lost concentration and when the helicopter passed he got a standing ovation in the middle of the performance. It was inspiring and at the end of the three-hour performance, he got a five-minute standing ovation. Ravi Shankar had arrived in the USA.

As the year progressed the street scene became more crowded and descended into more hard drug use and violence. I decided we should go back East to regroup. A large group of the original people in the movement in the Bay Area had already fled to the country and began communes. My wife Gail and I returned to New Jersey just before Christmas.

After Christmas I attempted to get a job on road construction that my father had arranged as a laborer in Local 472, but it snowed and construction was delayed. We were running out of money and I decided to look in the newspaper. I got a job in a low rent car wash on Highway 35 in Eatontown, New Jersey for minimum wage. We didn't have a enough workers at each station, as a result, you had to do two operations instead of one cleaning the cars. One day I was wiping down a new corvette. It turned out to be a guy I knew from high school. I said, "Hello Jay" and he was startled. I was the invisible guy drying his car. "Vinny is that you?"

"Yeah, how's it going?'

"Great how about you?"

"I've been better." I responded with a shrug.

He seemed quite uncomfortable and said, "Well take it easy, so long." He got back in his car and entered the highway. As I watched him drive away, I felt that I was a total failure and hadn't accomplished anything. Fortunately, the job came through on the road construction and I could quit the car wash.

Building roads is hard work. I did a variety of jobs, but the union pay compensated for it. The work entailed all aspects of road work, we had to clear woods and haul the trees out. I worked with masons mixing cement and hauling solid cinder blocks for the sewer chambers. I was taught to float cement finishes. I worked hard and kept getting promoted to better labor jobs. By the end of the Summer of 1968 the construction management company, S.J Groves, the fifth largest in the world, offered me a job in Brazil. I declined. I had something else in mind.

While in California, I explored many different eastern philosophies. I believed in a concept of "ahimsa", or "not to harm" from Hinduism, which is also reflected in various ways in other belief systems. Ahimsa's precept of "cause no injury" includes one's deeds, words, and thoughts[xlvi]. From my idealistic point of view I felt in our society capitalism was based on winners and losers. I felt the only safe occupation seemed to be in the field of art. When in San Francisco, I discovered the San Francisco Art Institute located on 800 Chestnut Street. The place had a great energy, but I had a problem. I had never

done anything other than writing poetry. I didn't have an art portfolio to submit. I decided to take a flyer and applied by sending my poetry instead of an art portfolio. To my surprise I was accepted.

At the end of the Summer our Studebaker Lark had an accident being hit by another car and totaled. With the insurance settlement and savings from work, we bought a VW bus, which we converted it into a camper. Gail and I loaded it up with two Siamese cats and all our worldly possessions. We drove cross country to California. We took a northern route on I-84 through Minnesota, Wyoming, and down through Idaho camping out along the way and stopping for cat walks. The snow-capped mountains and breath taking nature was something I never had experienced being in this part of the country for the first time. The weather changed dramatically from teaming rain storms to clear sunshine an hour later. You couldn't miss feeling the raw experience of nature.

1444 FIFTH STREET

1444 Fifth Street

I lived in the south Berkeley flats on 1444 Fifth Street. The flats are the lowlands of west Berkeley closer to the Bay and the railroad tracks. My original residence was located in a nice residential neighborhood close to the football stadium and campus. Through various rentals my housing slid down hill to end on Fifth Street, a mixed use neighborhood with older cheap housing and some light industry, the best value for a starving artist. Originally, a four room house it had a faded white clap board exterior and peaked roof. The front door and porch up eight dilapidated wooden steps were flanked by two windows on either side. The interior had four small rooms in the front, which included the kitchen. Beyond the kitchen a two room addition had been added at a later time. The claw foot tub, almost poking through the old rotted wooden floor, was next to galvanized industrial sink. It appeared

at one time the bathroom might have been outside the house before the additional two rooms were attached to the original house. The two rooms in the back were separated by a narrow hall to the back door. It always leaked between the addition and original structure in the rain season in spite of numerous roof repairs on my part. Fortunately, the rain season didn't last that long. Part of my deal for rent of seventy-five dollars a month with the landlord, The Haws Drinking Fountain Company, located on Fourth street behind us, was that I'd maintain the house. Since the house was elevated about eight feet and we had cats, I built a zig zag ramp on the side with a twelve-inch plywood shelf on the bottom just above the ground so the cats could go out to the yard from the side window.

We lived next door to a large Mexican family, the Fernandez. I watched the kids grow up. There were several daughters and Manuel, a younger son. The dad, Luis or "Louie", worked for the company behind us that made drinking fountains, which also owned his house. When I first moved in with Gail, my first wife, he would come over on Saturday nights stomp up the stairs and pound on the door. My wife, terrified literally shaking like a timid lap dog, didn't want me to answer the door. At first I went along, but eventually I told her this would continue unless we dealt with it.

Luis, a large Mexican man about 230 pounds and 6'3" tall was in his mid-fifties with olive skin, curly salt and pepper shiny hair and scraggly beard. A cross with three lines at the top radiating from it tattooed on his left hand between his thumb and index finger indicated he was a "Pachuco"[xlvii], a member of the famous Mexican gang in California in the fifties, in his youth. On his right hand he had "L" tattooed on his little finger, "U" on his ring finger, "I" on his middle finger and "S" on his index finger. When he made a fist, the size of softball, it spelled out "Luis". It was the last thing you saw before you were rendered unconscious.

When I opened the door, Luis was standing in front of me with a glazed look with rumpled hair and a bottle in his left hand. Aside from being intimidated, an image flashed into my mind, the scene from the Bogart

movie *High Sierra*[xlviii] and the character who stated the famous movie line, "Baadges? We don't need no stinkin' badges." He mumbled something and extended his right hand, as if, to shake. I grasped his hand and a different look came into his dark brown eyes and the side of his mouth sneered. He started to squeeze my hand rather than shake it. I realized what was happening, a "macho" thing. I resisted by squeezing myself. If I did not, he would have crushed my hand. This went on for a while and he finally relaxed harrumphed and turned. He stumbled down the steps almost losing his balance. I saw him during the next week back to his sober calm self and he looked away quite embarrassed. It was just part of the neighborhood. After the hand shake encounter, he stopped visiting.

Art the Machinist

After my first wife, Gail and I divorced, she moved out, and Debbie Shine became my roommate. She had broken up with John her husband. We were all friends from school in New Jersey. Her bedroom was in the front next to the living room and mine was in the back addition. I loved listening to the sound of the long freight trains on the tracks late at night, which were a few blocks away. The trains were sometimes a hundred cars long. Debbie used the room off the kitchen for the construction of her design work. She made custom clothes at the time, such as, elaborate cowboy shirts and stage apparel. Many of which were used by professional performers like John, her husband. We had friends in Berkeley with various talents. We were a community that supported one another, for example, when John Shine

had a gig with his band, I'd design hand silk screened posters to put up on the light poles on Telegraph Avenue and other public Berkeley locations to publicize the shows. They were often ripped off, which I took as a compliment. Concert posters were the primary apartment decoration. John's stage clothes were made by Debbie. Art, a local machinist and big fan, would loan us his truck to haul the gear. Everyone pitched in and there seemed to be a benefit every other week to raise bail for people busted for pot.

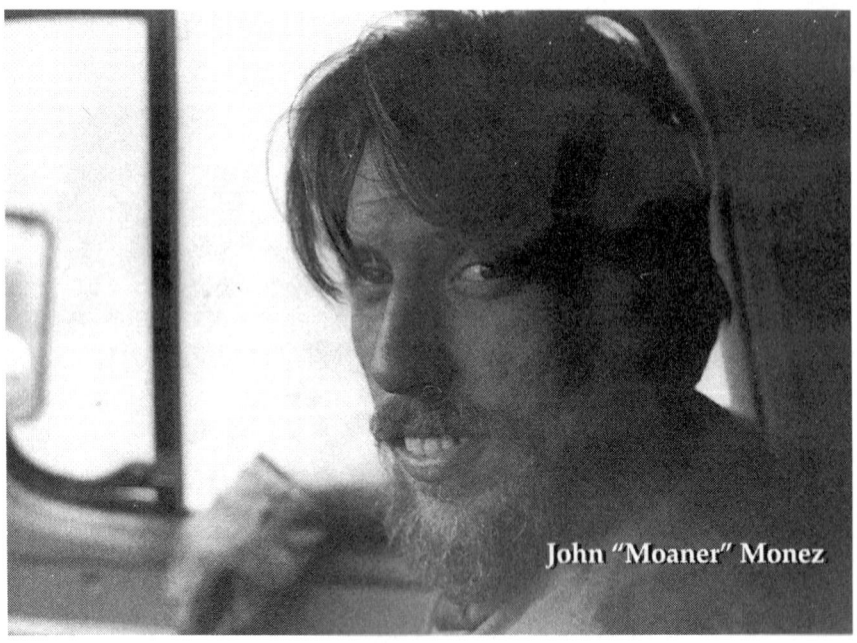

John "Moaner" Monez

John Monez was my primary distributor. He was from LA and a master sheet metal worker. He was a biker and formally raced cars. He walked with a hitch. One leg was shorter than the other a result of rolling an Austin Healy in a race. John combined his love of motorcycles and sheet metal skill to create the first sheet metal motorcycle. He combined the frame and tank sections into one unit. It became a cover of Cycle Magazine. I loved John's unflappable attitude. One time he was riding his Norton 750 Atlas down the I-95 "Grapevine" highway and his primary chain broke at about 80 mph. The wheels froze throwing the bike into a skid. A car behind him tried to avoid John and his bike. At

the end of the adrenaline dance the driver pulled over to the shoulder. He ran back to John and asked if he was alright. John got up dusted off his leathers and replied "Yeh, but I'd appreciate it if you could give me a ride to a gas station to get a link for my primary chain?"

One day there was knock on the door and two guys with camping back packs, a tall one with black shoulder length hair who resembled George Harrison, the Beatle, and a shorter guy with close cropped light brown hair both dressed in the hippie garb stood before us. The taller guy said, "Hi, I'm Bloom and this is John. We met Debbie's friend Carol in England and she said we should look you guys up, if we came to California." I looked at Debbie and she seemed baffled. Her friend Carol was in England, but these guys were complete strangers. We asked them in and they explained that they were hitch hiking across the country over the Summer. We determined they were real and they weren't cops, which could be a possibility. I also remembered my first experience in Berkeley with Bruce Cotrell being informed there was "no room in the inn." They needed a place to stay and we told them they could crash at our house. They were both art students at Leeds University in the UK. Bloom, an Englishman, was more outgoing than John, but John, the Scotsman, had an acerbic dry sense of humor. They had sort of a Holmes and Watson relationship. They were interested with experiencing the "California scene", as well as, interacting with other American artist friends of ours to view their work.

Over the time they stayed with us, they were especially entertained by some of the phone activities within the house. Berkeley at the time had a tremendous influx of young people and the soft drug market for drugs like marijuana, hashish, psychedelic organic and non-organic substances was booming. The "blokes", which became their collective nickname were entertained by the colorful coded phone dialogs regarding the buying and selling of relatively small quantities of drugs. There were many different varieties available in marijuana, such as, Acapulco Gold, Michoacan Green, Panama Red, Columbian Brown, etc. These activities helped to fund the rent. The codes were not infallible, however. For example, "red wine" for Panama Red, a bottle of wine meant an ounce or "lid" and a case was a kilo. Often executed

101

like the comedy the "gang that couldn't shoot straight". One time I got the message the two cases of red wine were under the seat of the blue VW bug.

There was also a guy named "little Louie" to be distinguished from "big Louie". He had long black hair and slight of build. He worked with a group called "the Brotherhood"[xlix] from southern California. He had picked up a load of marijuana in the state of Michoacan in Mexico and had somehow successfully crossed the border. He was using a pickup truck with a camper in the bed of the truck that had a sleeping area that extended over the driver's cab of the truck. He drove over the Golden Gate bridge into Marin county. He exited off Highway 101 and pulled into the driveway to the motel next to the highway into an area similar to a car port, in which, to park to check in for rooms. The top of the camper hit the edge of the roof and the entire camper slid off the bed of the truck and landing in the middle of the driveway in front of the office with the entire load of weed inside. Louie panicked. He ran from the camper into the suburban Mill Valley neighborhood. The police were notified of the accident immediately and when they examined the contents of the camper they launched a search for the escaped felon. They came to a house and knocked on the door answered by a little old gray haired lady. The police asked if she had seen any strangers in the neighborhood.
She replied, "As a matter of fact I have. There is a small man hiding under my porch." After that incident we didn't see Little Louie for a while.

The "blokes" wanted to explore more of California. They decided to hitchhike up to northern California. The Bay area was extremely liberal, but parts of northern California were just the opposite. Apparently, they got picked up by some "rednecks" with shotguns in the rack inside the cab. The "rednecks" indicated their distaste for hippies and thought them un-American. The blokes said they were terrified and thought they were in a scene from the movie *"Easy Rider"*[l]. When they explained they were English and not American, the mood in the cab seemed to change.

"You mean you're just a couple of English faggots." The driver said and laughed.

He dropped them off and they avoided a close call with disaster. Apparently, the "rednecks" were only interested in eliminating un-American hippies.

CHAPTER 14

FIFTH STREET BUST

It was a rainy Thursday night. I stayed overnight at the studio a lot, but since I had no shower, I decided to go back to home to 1444 Fifth street to get cleaned up. I arrived at the house in "White Lighting", a faded white original paint 1948 Ford pickup truck with rubber running boards with "White Lightning" hand painted on the side. The hand painted moniker looked more like a child's faded red crayon. It was a flathead six with floor shift. As long as you didn't go over fifty miles per hour on the highway, it wouldn't blow the head gasket. The rain was really coming down and the funky wipers were slapping on the windshield with little effect. When I pulled up, I noticed two people on the porch outside my front door. Something didn't seem right. I parked past my house a few of houses down and waited.

The two people walked past the truck, the first Michael Maloney, a LSD dealer, whom I knew and the second another guy with short hair and a Hitler mustache holding a brown paper bag. Michael didn't acknowledge me, when he past. I realized this is a bust. I had a choice to flee or go into the house to remove any additional evidence because I assumed Debbie was still inside. I decided to go for it and felt an extraordinary rush of adrenalin. I opened the truck door and walked back down the block past my house and went into the Fernandez's back yard next door. I climbed over the fence, went around the back of my house to the fenced yard on the right side of my house. I climbed up the cat ramps and did a chin up on the open window and yelled in "Debbie, it's a BUST! Bring everything to the back door now!" I frightened her, a disembodied head yelling at her from the cat window eight feet off the ground. She jumped back, paused and said, "Fuck" and ran out of the room. I went around to the back door and met her. I was throwing everything into the parking lot behind the house attached to the drinking fountain company. I was almost finished when I heard "FREEZE". There were a group of Berkeley cops with flashlights and guns trained on me. I yielded and by that time the police had reached the back door from inside the house.

We were moved to the living room, handcuffed and I was placed in a rocking chair. As I sat there, I couldn't figure out why there were so many police. There were the local Berkeley police, state police, DEA and the FBI. It didn't make sense, but it didn't matter because I was so pumped up on adrenalin. The Hitler mustache turned out to be the head FBI agent. Standing near the galvanized sink, he turned around holding a bag of colored powder in his hand and said, "What's this?"

"It's dye", I responded.

"What do you use it for?", he asked.

"To dye things", I said.

"Like What?"

"Anything you wish t-shirts, clothes."

"What about pills?"

The agent thought he had found the vegetable dyes used in coloring LSD tablets.

I continued, "If you don't believe me, try some, but I am telling you that procion dyes are poisonous."

He paused with his finger in the bag, but didn't sample it. This pissed him off and he started to fire questions at me and I asked, if we were under arrest. He ignored me, but I persisted and finally he said "Fine, you're under arrest." He didn't indicate the Miranda warning or charges. I turned to Debbie sitting on the couch across the living room and said,

"We're arrested. You have the right to remain silent. Use it."

At that point I felt a night stick punch my back from behind and fell forward out the rocking chair to the floor still hand cuffed.

We were arrested on Thursday night, but not booked until after midnight intentionally. By law you have to be arraigned in seventy-two hours, but weekends don't count. This way you could be held without being formally charged until Wednesday morning, which is what happened. I didn't know exactly what my charges were and still couldn't figure out why there were so many cops at the bust. I was placed in the Berkeley City Jail, a temporary holding place before being transferred to the county jail in Santa Rita, California, luxurious, compared to the San Francisco County Jail. There were eight cells, four

105

on each side facing each other with an interior painted pale industrial green. The other cells were empty. In the corner a locked barred door connected to a day room area painted like a kindergarten class room. I found out later the color scheme assignment had to do with felony and misdemeanor offenders. I saw one of my sculpture teachers, Jesse, from the Art Institute on the other side of the bars. He told me he was in for parking ticket warrants. He asked me what happen and I told him I got busted last Thursday night by the feds.

"That was you in the headline of Berkeley Gazette *"Global LSD Ring Broken Here"*, Jesse exclaimed.

"What are you talking about?", I responded.

"Yeah, the headline in the newspaper yesterday."

I was still mystified. Over the weekend another inmate was added in a cell across from me allegedly busted for pot. He looked like a hippie, talked like one, but was a "nark". He gave me this lame sob story about himself and the "scene". I told him over an exchange of cigarettes that he should go back home to his parent's strawberry farm and the "scene" wasn't for him. He disappeared a day later. Finally released without being charged on Wednesday morning, I was greeted by a group of cheering friends. I felt like a released political prisoner. Anna Rizzo, my girlfriend at the time, picked me up whisked me away to Marin county to Janis Joplin's house in San Anselmo, California

I found out on the ride to Marin county what had happened. Debbie and I shared the house, but were involved in different activities. Apparently, she had brokered a sale of a gram of LSD, 5,000 pills, with Michael Maloney. That's why the bust occurred. It turns out that it traced back to Art, our friend the machinist, who was involved with a guy named Benny. Benny did sales and Art did the nuts and bolts of the tabbing. Apparently, Benny had made over forty sales of LSD to federal agents posing as drug dealers from Russia. If he had done the math, he would have realized the quantities he sold to the agents was enough for four tabs each for the entire population of Russia. I knew Art participated in the underground economy, but I had nothing to do with it and glad he seemed to be doing well. Another factor unaware to me was that the tabbing operation, apparently under surveillance by the FBI, was in my neighborhood, which had a lot of industrial buildings. Sometimes Art

Anna Rizzo

would arrive at my door a bit spaced out and I'd make some tea to calm him down. From those observations the FBI must have assumed we were part of the operation, which we were not. The FBI Hitler mustache did want to know the identity of the guy in the white truck that kept losing their tails. Eventually, Art took responsibility for everything, so we weren't charged

Michael Maloney went to court on his sales count. Prior to the court appearance his high powered Harvard educated criminal attorney, Avi Stachenfeld, suggested he change his look for the trial. Michael had long shoulder length hair with a van dyke beard. He wore jeans, leather vest, beads and high heeled Frye cowboy boots. By the time he appeared in court he had short close cropped hair and a small neat mustache. He wore a gray suit and tie and looked like an altar boy. The undercover narks that were testifying against him looked like a group of scruffy hippies. His defense of *"not knowing what was in the bag"* supported by Art's testimony combined with Avi's brilliant defense made the "narks" look like the "perps" and won Michael an acquittal.

We pulled into the driveway at Janis' house. She lived at the end of a cul-de-sac contiguous to the park at the foot of Mount Tamalpais in Marin County. The house was a modern redwood design with her psychedelic painted Porsche parked in the garage. Janis had recently passed away from an accidental heroin overdose. Her unexpected death had a devastating effect on her friends in Bay Area music scene, as well as, the public at large. Her career as a solo artist was coming together after Big Brother and the Holding Company. In process of finishing her

107

album, *"Pearl"* she was in great spirits. She had a manager, Albert Grossman, Bob Dylan's manager at the time, and her future looked bright. Janis had directed in her will that she didn't want a funeral. Instead she wanted to throw an enormous party for her friends. Anna was staying at the house with Lindall, Janis's assistant. Consistent with the cold hearted nature of the music business at the time, common knowledge indicated that Grossman might be looking for a new female singer and Anna could be a possible candidate.

The interior had an open floor plan with high ceilings and large floor to ceiling windows facing the redwood forest of the mountain. There was a pool room off to the side next to the garage. Janis had a bedroom as large as her sexual reputation. Above the king size bed was a giant Catholic rosary on the wall. The type you see in Mexico. I thought she would have a water bed due to their popularity at the time, but she did not. The bed did have something extra, however, it could vibrate like the beds at old cheap motels, in which, you inserted a quarter for a few minutes. It was extremely relaxing and a bit goofy.

I hung out for a couple of days and helped to set up for the party. Most of the party is a blur now, but it had all the typical excesses of a Rock 'n' Roll party. Her musician friends jammed, people danced and imbibed, and I'm sure overall it made Janis happy. You could feel her presence in the house, especially in the bedroom, spooky, but fascinating. I awoke to the wreckage and decided the time had come to hit the road and head back to Berkeley.

Back at 1444 Fifth Street for a few days there was another knock on the door. This time, a Mexican low rider with a purple customized chartreuse scalloped vintage 1963 Chevy Impala sitting at the curb stood in front of me. He had long black shiny hair with a goatee. He wore a lot of chains and crosses and had a tear tattoo below his right eye. Startled at first, I recognized that he was one of Maria's boyfriends, Manuel's older sister, who lived next door.
"Can I talk to you man?", he asked.
"Sure come in.", I said and he sat down on the couch.

He exploded. "Cops, man! Cops, fuckin' heat, they were crawlin' all over the fuckin' place. We thought WE were getting busted. Fuck, you guys must be heavy to have that "pig" action. You should have told us. We're in the same business, maybe we could do some shit together in the future." I didn't want to offend him. I told him that because of the bust I had to cool it for now, but in the future it could be possible. He smiled, gave me the brother handshake and left. Later, when I would see him in the neighborhood "cruzin'", he always smiled and give me a knowing nod.

CHAPTER 15

SAN FRANCISCO ART INSTITUTE

SFAI Main Gallery site of the mylar maze installation

The current San Francisco Art Institute structure was built in 1926 in the Spanish mission style with a bell tower and red clay barrel tiled roof. As you walk into the entrance there is a square courtyard with small mosaic fountain in the center surrounded by arches. In the main gallery on the left occupying an entire wall is *"The Making of a Fresco Showing the Building of a City[li]"* executed in the 1930's by legendary muralist Diego Rivera. One aspect of SFAI that appealed to me over other art schools was that you only had to take one course in the humanities and the rest could be art courses. In other schools there were fewer art classes until the last two years, a better fit for me since I wanted to focus purely on art. They also credited the academic units I had accumulated in Merritt College and UNC. I majored in painting. In the beginning I liked to draw realistically and

paint abstractly. I also enjoyed doing printmaking especially etching and silk screen. I entered in the Fall of 1968 and by the second semester I was on a partial scholarship. From the second year on I had a full scholarship for the remainder of my stay. In January of 1971 I had a choice of receiving a BFA degree or entering the Master's program. I opted for the diploma, which I immediately mailed to my parents with a note that said, "I know you really wanted one of these. Love your son, Vincent." I already had my own studio in the produce district near Jack London Square in Oakland, California and didn't see the benefit in acquiring the degree. I just wanted to paint on my own in the studio.

The period of time in the late sixties into the early seventies was turbulent time in American society. There were protests on college campuses all across the country against the escalation of the war in Vietnam after Richard Nixon became president. The evening news broadcasted images of the war, which brought the carnage into people's living rooms. Many families were divided advocating the two different points of view usually divided along age lines.

I went back to New Jersey for my mother's birthday and the Vietnam War came up at dinner. I was anti-war and the "Chicago Eight"[lii] were on trial accused of inciting riots at the 1968 Democratic Convention in Chicago. Julius Hoffman[liii] presided as the trial judge. The trial ran from

April 9, 1969 to February 20, 1970. Hoffman refused to allow defendant Bobby Seale of the Black Panthers to represent himself after Seale's original attorney became ill. This prompted conflicts with Seale that led to Hoffman ordering Seale to be gagged and shackled in the courtroom and eventually jailed for contempt. Hoffman removed Seale from the trial, leaving the case with only seven defendants, at which point the tria became known as the "Chicago Seven" trial.

Chicago Seven

Judge Hoffman became the favorite courtroom target of the defendants, who often openly insulted the judge. Abbie Hoffman (no relation) told Judge Hoffman "you are a 'shande fur de Goyim'" ("disgrace in front of the Gentiles"). You would have served Hitler better." He later added that "your idea of justice is the only obscenity in the room." Both Davis and Rubin told the Judge "this court is bullshit." All seven were found by a jury to be not guilty of conspiracy, but five of the defendants were found guilty of inciting a riot, and Judge Hoffman sentenced each of the five to the maximum penalty: five years in prison and a fine of $5,000, plus court costs. In addition, Hoffman sentenced all eight defendants

and both of their lawyers, William Kunstler and Leonard Weinglass to lengthy jail terms for contempt of court.

On May 11, 1972, the United States Court of Appeals for the Seventh Circuit vacated all of the contempt convictions, and on November 21, 1972 reversed all of the substantive convictions on a number of grounds. Among other things, the appeals court found that Judge Hoffman had not sufficiently measured the biases of the jury and that he had exhibited a "deprecatory and often antagonistic attitude toward the defense."

I went on a rant attacking Julius Hoffman. I pointed out the "riot" they were accused of inciting was characterized as a "police riot" by the U.S. National Commission on the Causes and Prevention of Violence.

"He is a senile old man, completely out of touch with the times he's living in. His rulings are unfair and biased. He's incompetent and should be removed from the bench."

I noticed my mother's eyes began to widen reacting to my speech. She blurted out, "You couldn't be more wrong. You don't know what you are talking

Julius Hoffman

about. Julius Hoffman is a lovely man. He's charming and funny. We played bridge with him at the Breakers in Palm Beach. Those defendants were a bunch of bums." At this point I gave up. The generation gap was too vast. Unfortunately, this scene played out in many families, that had children that grew up spanning the fifties and sixties.

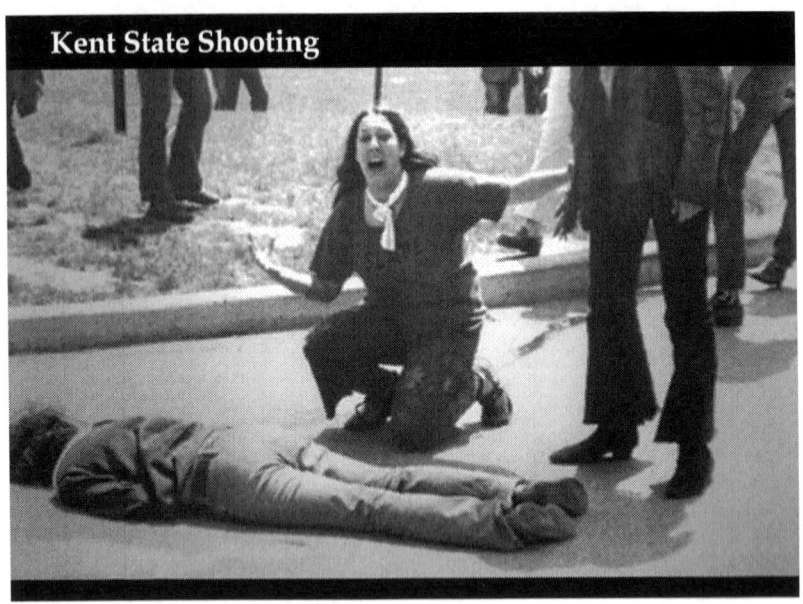

Kent State Shooting

In May of 1970 protests came to a climax due to President Nixon's expansion of bombing in Cambodia. In Ohio there were shootings on May 4, 1970, of unarmed college students by members of the Ohio National Guard at Kent State University in Kent, Ohio during a mass protest against the bombing of Cambodia by United States military forces. Twenty-eight guardsmen fired approximately 67 rounds over a period of 13 seconds, killing four students and wounding nine others, one of whom suffered permanent paralysis. Other [liv] students, who were shot, had been walking nearby or observing the protest from a distance. There was a significant national response to the shootings: hundreds of universities, colleges, and high schools closed throughout the United States due to four million students on strike. The event further affected public opinion, at an already socially contentious time, over the role of the United States in the Vietnam War. [lv]

At San Francisco Art Institute the teachers and students joined the national strike and as a group decided to make masks for the protesters that were marching, so their identities would be concealed from the police. We were suspicious that the police were doing a lot of illegal surveillance and photographing demonstrators. As it turned out, the

theory was correct. Years later it was revealed that the police and J. Edgar Hoover's FBI were doing illegal surveillance. The design of the masks were three caricature versions of President Nixon's face. The ceramics department made the clay and plaster molds. The sculpture department used the plastic vacuum forming machine to make the masks and trim the plastic edges. The masks were then taken to the painting department's spray booth for finishing. We made over a thousand masks and distributed them to marchers. The irony of the masks was appreciated by the local media and it helped to publicize the protests.

One morning I was having a café latte sitting at one of the Italian marble tables with black iron legs in the Mediterranean Café on Telegraph Avenue in Berkeley. One of our friends Tom Oliver walked in and sat down with this extremely attractive woman. She was wearing a one-piece black wool hot pants jump suit with high black leather boots. Her legs went on for days. Tom was a tall guy with black curly hair, a bon vivant and libertine. He had a great sense of humor and fun to be around. I thought she looked hot and I decided to approach their table under the guise of informing Tom of the benefit that night at the New Orleans House on San Pablo Avenue in Berkeley. Tom introduced us and I found out that her name was Dawn. I sort of ignored her for most of the conversation, but at the end I told Tom, who said he would attend, to bring Dawn with him to the benefit.

The benefit was held at the New Orleans House on San Pablo Avenue headlined by a band named *Grootna*. Marty Balin of the Jefferson Airplane had just signed them to the Airplane's label Grunt. I was going out with the soulful lead singer Anna Rizzo, a beautiful Italian girl with long black raven hair. She commanded the stage. I didn't think Dawn

would show up, but she did and looked sexy. I then had a bit of a problem trying to balance attention between Anna and Dawn. Dawn picked up on it and I saw her walk briskly out of the club. I caught up to her on the sidewalk and explained I had to take off the next day for the East coast, but that I'd like to get together, when I got back. She agreed and I salvaged the situation. Tom Oliver told me that she had recently separated from her husband and had a four-year old son, which for me was a detriment. Being completely self-absorbed as an artist, I wanted to be the center of attention in any relationship. A child requires a lot of attention from a mother. After my first marriage I didn't want to get into another exclusive relationship anyway. An actual starving artist for some women is romantic. When I had two girlfriends, there was always jealousy about the other. By participating in three simultaneous relationships it made it more difficult for them to be possessive.

My first wife, Gail, and I had amicably divorced at this time. I lived in Berkeley and had a studio in Oakland, where I spent most of my time. Sounds luxurious, but I had low overhead. I had a roommate and the rent on the house at 1444 Fifth Street in Berkeley was $75 per month and my twenty-five hundred square foot studio in Oakland was $120. Originally the Oakland studio had three artists sharing the space for $40 a month each. When I took over a third, the other artists were Ken MacDonald, finishing his MFA at UC Berkeley and Jack Frost, a teacher of mine at SFAI and friend. Jack lived in my house on Fifth Street before me. I took it over, when he left for the Southwest with Ken MacDonald and his wife, Joan. Joan was actually the one who charmed Leon Hersh into renting us his top floor. Joan was a beautiful, sexy, Sephardic young woman with a charming Leo personality, as well as, an excellent artist. Leon Hersh was a portly old Jewish man with a jovial disposition close to the end of his life. Joan mesmerized him and he agreed to rent the space. In the later years he always wanted me to entertain the possibility of "running a few girls up there" for the produce market "lumpers", the laborers who unloaded the trucks. I told him I wasn't into that type of thing. He countered on how the guys had seen all these "beautiful chicks" going up there. I told him they were just friends. To the "guys" these artistic "chicks" were quite exotic.

"Wolfman"

The studio was located on 415 Fourth Street in Oakland, California in the produce district next to Jack London Square. I had the top floor of

the two story building of the Leon Hersh Onion Company. Leon earned his living as a produce broker, who dealt only in onions primarily from Las Cruces, New Mexico. The smell permeated the space, but kept bugs away. The door on the right side was access to the second floor up a dark cobweb filled stairway that had never been cleaned. When a meat packing company operated on the second floor at one time, they installed a cement floor. The dimensions were twenty-five feet wide by one hundred feet long. A large skylight covered a third of the space in the center and in the rear an old ice box that had wooden walls insulated with saw dust installed by the prior tenant. In the back corner was a john with a sink and commode with a wooden box with pull chain above. The walls were brick, which made it difficult to adhere sheetrock walls. I gradually rebuilt the place. Due to shortage of money I would take 2X4's and rip them on the length to make 2X2's. After measuring and drilling the 2X2's I then had to drill the mortar between the bricks to sink wood dowels in order to adhere the wood strips with screws on sixteen inch centers for the future sheer rock walls. A tedious process, but it worked. Poverty is the mother of creativity. I used all the skills of all the building trades in the reconstruction of the space.

The produce district was on a twelve-hour nocturnal schedule. The produce trucks would arrive in the late afternoon. Lunch at midnight and finished by eight in the morning. I often worked late at night and would have "lunch" with them. Sometimes I worked so late I slept on the couch in the studio. In the Winter it was really cold because I had no heat. I often had to paint in an Afghan sheepherder's coat with gloves. I bought old cheap eight by ten foot rugs from Goodwill to lay over the concrete floor for warmth and to give some relief for standing on the concrete floor, while working. Eventually, I installed a space heater for the open loft that Dawn gave me and it made the space much more commodious, as well as, more comfortable for her.

There was always a need at the Art Institute for more space for the advanced students to work. We had made some progress, in that, the Institute gave honor students space in old studio classrooms in the original building after the new classrooms were built in the addition. I was assigned to Studio 17 with four other artists. I greatly appreciated

having a designated area to work in and being able to leave the work in place rather than having to put the work in racks after classes. We also had a great asset - a spray booth. Due to the scale of paintings I executed, the space was a bit cramped for me. For larger work I had the Oakland studio. I had taken over the entire studio in Oakland at this time because Jack Frost and Ken MacDonald had left.

As a way to expand our studio space at school, we proposed that we should use vacant buildings that hadn't

Honors Studio 17

been demolished yet in the process of the redevelopment on Sansome Street near the San Francisco's Fisherman's Wharf. One of these was an old chicken factory, a large four story wooden structure. The lower floors were divided in studio spaces and on the top floor the San Francisco band Santana had their management offices. This became the site of most of the wild art school parties. Sparing the sordid details, suffice it to say it was "Sex, drugs, and rock'n'roll". A great way to blow off the energy from long hours working in the studio. Many of the students were also musicians. The two "school" bands we used were the Tubes and the Redlegs. I preferred the Redlegs because they were a more down home boogie band. We charged admission of ten dollars and supplied a large alcohol punch along with multiple kegs of beer and music. We eventually became a victim of our own success. As the event's reputation grew, too many people started to show up and we had to cease operations. Fortunately, we were never

busted by the fire department or the police for selling the booze or for running an illegal cabaret.

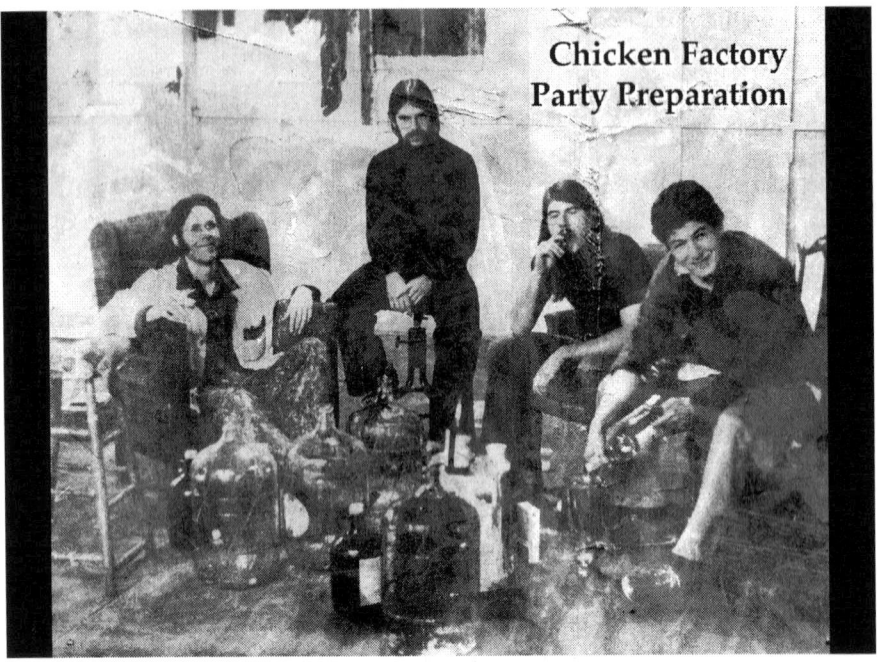

Chicken Factory Party Preparation

The Art Institute announced a special event for San Francisco society donors and supporters of the arts to celebrate the completion of the new building. Jack Frost, a teacher, Bob Mifsud, a film student and myself decided we wanted to do an environment for the party. Jack had come back from the Southwest to resume teaching at the Art Institute. Jack was experimenting with overhead projectors, so I gave him the freezer to work in until he got his own studio space. I liked having Jack Frost in my freezer. Performance and environmental art had not yet been introduced to the art scene. I asked permission from Jerry Buchard, the head of the photography department, who controlled the main gallery off the plaza for the entire space. He refused at first and said, "No way. You are not touching my pristine walls." I explained the concept and he eventually relented and gave us half of the gallery on the side of the Diego Rivera mural. It was about fifteen hundred square feet in the shape of a rectangle. A condition of using the space was that we had to

protect the gallery walls, so we covered them in thin cardboard. There is a high twenty-foot ceiling in the space, but fortunately the wall that separated the photo gallery and our space measured eight feet. We anchored string on the top of eight-foot wall and attached it to the side and far walls at the same height creating a maze of string at the eight-foot level. From the string we hung four-foot wide silver Mylar plastic sheets to the floor to create a maze. We also covered the walls in the same Mylar. Mylar has the quality of being transparent, when light is shined on one side of the surface. From above we had four strobe lights in the corners firing randomly, so at times you would see another body on the other side of the Mylar sheet and then not. The strobes were the only light source in the blackened room. We composed the sound element from instrumental recordings, such as, *"Paul Horn at the Taj Mahal"* and other ethnic renditions. The sound element started with peaceful serene flutes in open spaces and as the evening proceeded, we introduced more indigenous recordings and chants.

By this time Dawn and I were in an exclusive relationship. She arrived at the party dressed in an outfit that required comment. Wearing a body stocking with a one piece crocheted mini dress, she looked hot, attracted a lot of attention and almost got kidnapped by the Mayor of Bolinas at one point in the party. Bolinas is an unincorporated coastal community in Marin County, California. The community is known for its reclusive residents. It is only accessible via unmarked roads; any road signs along State Highway One that points the way into town have been torn down by local residents. Paul Kantner and Grace Slick used to live there, when they were together, but the Pacific Ocean consumed their home. Bolinas always had an outlier reputation as an outlaw haven for people who wanted to not be disturbed. The mayor, a large fellow at six four and about three hundred pounds had oily red shoulder length hair and a red beard. He wore a black cowboy hat decorated with a silver Conchos with turquoise on a leather head band. A biker from head to boot accessorized with black leather sleeveless vest and unwashed jeans. He had picked Dawn up bodily holding her under one arm. He indicated he was taking her back to Bolinas on his chopper waiting at the curb outside the Institute. I complimented him on his taste in choppers and women, but I explained that the kidnapping wasn't an option. After further civilized discussion he relented, released Dawn and returned to

the festivities. In martial art training you always tried to avoid physical violence and use it only as a last resort. During the smiling negotiations with the mayor I also considered the best method to attack, if necessary, without harming Dawn.

Snake Mounds 1 & 2 - SFAI Gallery

We opened the doors half way through the party. Dawn and I were able to view the scene from above from a stair landing next to the Diego Rivera mural. At first the maze operated, as we had planned. The people were finding their way with silhouettes of others appearing and disappearing through the Mylar sheets. As the evening wore on, people started to become emboldened and began touching other people in the maze on the other side of the sheets. Fueled by the combination of alcohol and drugs at the party, another effect occurred unexpectedly. As the night wore on the combination of the soundtrack of African tribal drums and strobe lights caused the people to freak out and revert to more primal behavior. They started to rip down the sheets and ended up destroying the entire maze. The room destroyed by the end of the night with remnants of silver Mylar souvenirs littered all over the Institute. We were extremely satisfied with the results of the environmental event, however. It was born, lived for two hours and died, a complete experience, not unlike the life of a Tibetan sand mandala.

There were always interesting cultural events at the Art Institute. Film festivals, music performances, visiting lecturers, etc. One time there was a demonstration by a small Chinese man doing this slow motion exercise that looked like dancing with smooth even movements. He had brought a few of his students with him. When he finished, he asked the

Master Choy Kam Man

students to push him and try to dislodge him from his stance. As they tried to push the teacher off-balance, he'd absorb the attack, parry it and then…with a mere six-inch push…send his attackers "flying". All the students were much taller than the man and outweighed him by several pounds. It confused me. I had studied Tae Kwon Do, a Korean martial art, in the first semester at UNC, which focused on punching and kicking effectively. I also had studied Kodenkan Jujitsu in Berkeley, a Japanese martial art, which emphasized throwing and using leverage, but I had never witnessed anything like this demonstration. Afterwards, I found out that the man's name was Choy Kam Man, a Master of taijiquan. His students said they were repelled the master because he used his qi, an internal body energy. I decided to explore further to find out what the "energy" was all about. I began taking classes with him first in Berkeley and later for many years in San Francisco Chinatown.

123

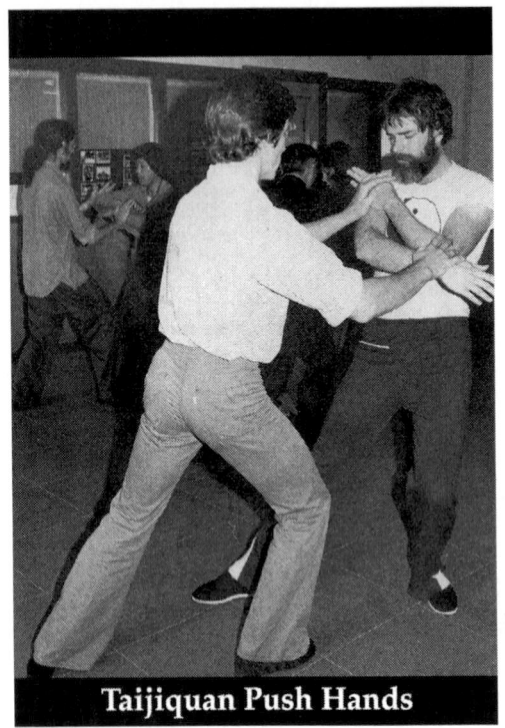

Taijiquan Push Hands

His father, Choy Hok Peng, studied with Yang Cheng Fu in southern China before the 1949 Chinese revolution. Yang Cheng Fu, the originator of the most ubiquitous form of taijiquan practiced worldwide, holds this positon because he was the first to teach taijiquan to people who were not Chinese. Master Choy Hok Peng, the father of American taijiquan came to the USA in the 1940's to teach the generation of teachers in San Francisco, Los Angeles, New York and Oakland, California, who would later teach students like me. My study with Master Choy Kam Man, his son, lasted until he passed away. Over the years he taught over two thousand students. I felt fortunate to be the last one of thirty five students he officially certified to teach. He was the first of two martial masters who had significant impact on my life.

CHAPTER 16

GIBBONS DRIVE / VALLEY STREET

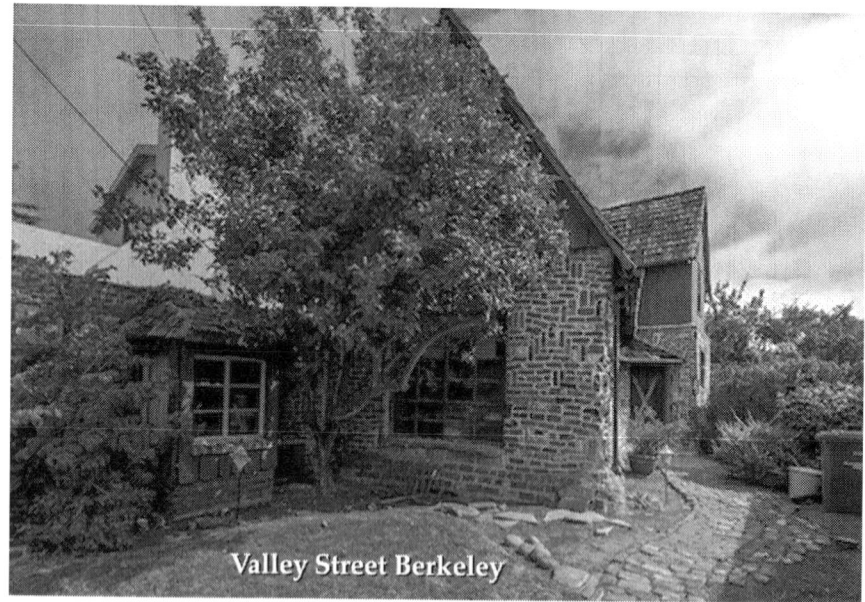

Valley Street Berkeley

After Dawn got a divorce she moved out of Berkeley and rented a house in Alameda, California, an island connected by three bridges to Oakland. This is the first house we lived in together. The new house, also close to my studio in Oakland, was a white stucco Post-modern house built in the 1930's with tile roof and a two car garage. One night after we first moved into the house Russell at age five came running into our room in the middle of the night screaming that he had seen a ghost. His hair stood on end like in a cartoon. We attributed it to the shadows on the wall of the pine tree next to his window and the strangeness of a new home. It turned out he may have been right. At times Dawn saw, without the influence of drugs, a family with two elementary age children sitting at the table in the dining room. They were dressed in the conservative style of the 1940's and the dad had a brown military uniform of an officer and wireless rim glasses.

Since Alameda has large naval base, the brown uniform seemed out of place for the vision. It should have been Navy blue. A Marine officer could have been an explanation. Unfortunately, Dawn couldn't ask him. One morning Dawn rode her bicycle over the rental agency to deliver the rent check. She asked about who owned the house, but the agent said it was against policy to divulge the name. Dawn then told her of her experience and the woman softened. She said an officer with two children was an attaché from the Army assigned to the Alameda Naval base during the Second World War. Other than that she didn't know anything else. Later we thought this might have been the reason we got such a good deal on the rent.

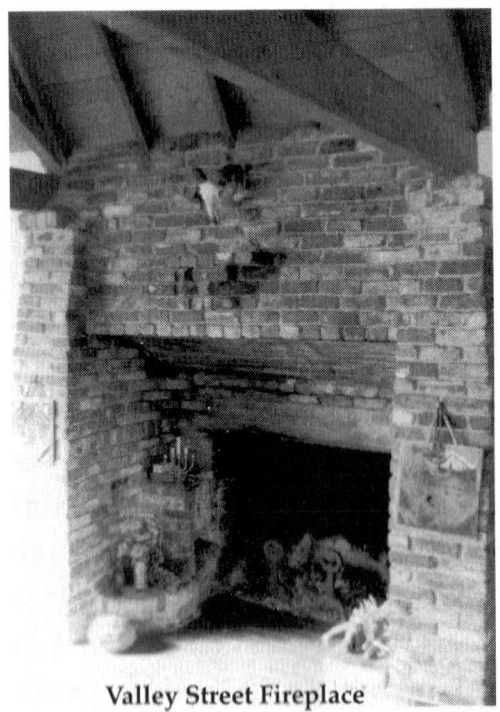

Valley Street Fireplace

We also had a spirit in the next house we rented on Valley Street in Berkeley, California. We decided we wanted to move back to Berkeley and we saw a house for rent in the paper and the ad indicated that you had to show up on a Saturday morning to meet the landlord at the house to be interviewed. When we arrived, a line of over 120 people trailed down the street. In addition to Berkeley residents, we had the university of 30,000 students with which to compete for housing. The odds looked grim, but we got on line. The architecturally unique house was in the style of homes in the Normandy region of France. Carl Fox, the architect that designed this house and a few other structures in Berkeley in the same style became enamored by the time he had spent in homes in Normandy and wanted to recreate the experience. The exterior had a high peaked roof

126

with cedar shingles and stone sides with amber glass iron frame windows. The interior floors were dark oak planks, but the main feature of the open front room was the enormous fireplace. The fireplace was so massive and central to the house; it could more easily be said the house was attached to the fireplace rather than the other way around. It had an eight-foot wide by four foot deep alcove of brick before the hearth began that you could walk into it and sit on a brick bench. It took five logs not three as a normal size fireplace to feed the beast.

Our turn finally came to be interviewed and we went into the kitchen. The landlord's name was Ristad. He had short black hair parted on the left, deep set eyes, clean shaven and had a pleasant demeanor. His eye brows stood out as a feature; they went up in arcs versus downward. He was "straight" in terms of dress appearance, but seemed a bit odd. He turned out to be a Presbyterian minister and the Chaplin at Vacaville State Prison north of Berkeley. After the interview Dawn was convinced that we would get the house. I thought we

Batman Russell with studio skylights background

did well, but after a week or so we heard nothing, so I assumed we didn't get it. Dawn, however, didn't give up hope. She even drove by to see if tenants had moved in yet. We got a call in the second week from the landlord and he wanted to know, if we were still interested. We met with him at the house and he explained that we were his second choice. He had met with the first couple, but when he explained that there might be a spirit in the house they freaked out and bailed. We told him it didn't bother us and we moved in the next week.

Dawn is gifted analytically, but also intuitive, she functions well in both hemispheres of her brain. There did seem to be something funny in the house, such as, noises, things moved or knocked over. We thought it might be a poltergeist. Above the large open main room of the house was a loft attached to a bedroom behind it. Dawn met our house resident one day. She was able to do a drawing of what she saw sitting on the loft railing. She called the entity the "pickle man", sort of like a colorful Mr. Peanut. I decided we should address the issue. I had studied traditional western magic in the sixties. I did a banishing ritual to the house and afterwards the pickle man ceased to appear and there were no more odd incidents.

After we were tenants for a year Reverend Ristad invited us up for dinner at his home in Vallejo, California. He lived alone and during dinner it was obvious that he wanted to discuss the spirit. He felt the ghost may have been introduced by the tenant two occupants before us, Owsley Stanley, the famous LSD underground chemist. Apparently, there were unusual strange activities in the house in the past. Our black next door neighbor, Doris, told me she had called the police a number

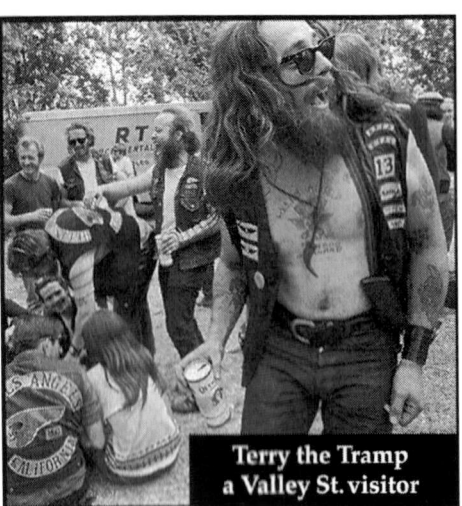

Terry the Tramp
a Valley St. visitor

of times to complain about the live loud music the hippies were playing next door. The hippie band she referred to was the "Grateful Dead". Owsley was their sound engineer at the time. Eventually, the reverend asked us, if we knew the entity's name. We said we didn't. I didn't want to break the bad news to him that the entity no longer resided in the house.

He also told us at dinner that in his position as Chaplin at Vacaville he had often interacted with Charles Manson, the serial killer, who worked

in the prison chapel. He said he supported his release and had testified personally on his behalf at Manson's parole hearings. Dawn and I turned and exchanged a look. We thanked him for dinner, told him we would keep him informed on the spirit developments and departed. On the drive back we reflected on just how much weirder our landlord was than we had originally thought. Fortunately, we purchased our next home and it had no pesky spirits.

CHAPTER 17

IRA PROVOS

One day, Ken McDonnell, a good friend of mine from our group in the Berkeley scene, dropped by my studio. He worked occasionally on the docks in Oakland in a high paying union job. He got into the union as a legacy because his dad was a member. The Port of Oakland was a busy container terminal, the largest in northern California. Ken had blond hair, blue eyes, rosy pink Irish cheeks, a little under six feet and weighed about 200 pounds. Generally, he was usually light-hearted and jocular, but this day he was serious and wanted to talk. He told me that he just come back from Ireland meeting with a guy from the IRA that wanted to smuggle hashish into the West Coast. When I asked, if he thought the guy was real, he said that the guy took him on a long drive north on a narrow Irish road. They turned off to a dirt road and drove up just below a hill. They walked up the hill to observe a live skirmish below with the British and IRA. The guy, Jim McCann[lvi], claimed to be in the second Belfast battalion of the IRA Provisional army, the "Provos", who were at war with the British. We checked him out and found out that in 1971 he escaped from Belfast's Crumlin Road Prison, while awaiting trial for a petrol-bombing at Queen's University in Belfast, Ireland.

McCann wanted to smuggle a large amount of hashish from Pakistan and needed a way to get the load into the USA. Ken and I were peaceful hippies and not into violence. Jim McCann had a character of a different sort. Ken asked me, if I wanted to get involved because this guy was a "heavy" and I think he felt he needed the support. I had a reputation for being trustworthy and familiar with the English's dark history in Ireland. I agreed because I also supported the IRA's effort to unite Ireland politically. There were five of us that covered various aspects of the enterprise including Ken's father useful for his lifelong connections working on the waterfront.

The hashish, which originated in Afghanistan at war with Russia at the time, came through the tribal areas of Pakistan. From there it travelled

130

to Mombasa, Kenya to pick up a load of raw lumber, iroko[lvii], a west African hardwood similar to teak. The iroko shipped to Ireland was made into traditional Irish furniture. The heaviness of the dense wood was useful in disguising the extra weight added from the contraband. The container walls were filled with over a ton of hashish sealed and re-enforced. The container was loaded with the furniture and shipped to Oakland, California.

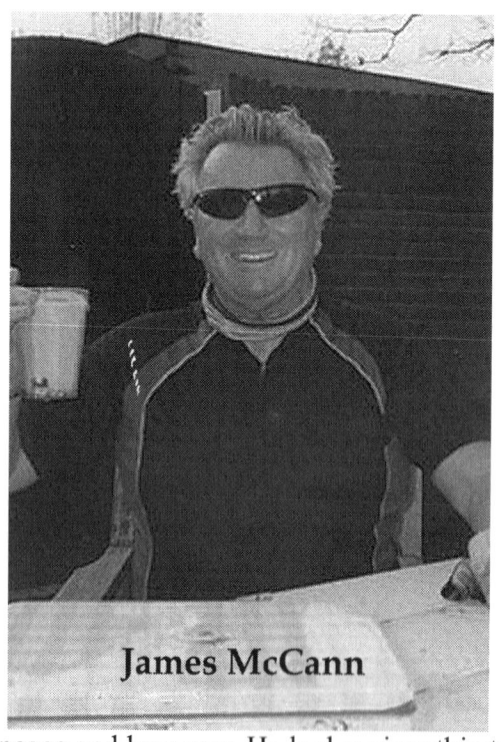

James McCann

Jim McCann was around six feet, one hundred ninety-five pounds with black short hair and clean shaven in good physical shape. His face had an interesting characteristic. He had a very straight prominent nose. If you looked at him straight on, he looked one way, but in profile, he looked like a completely different person, which for a smuggler, I imagine, could be an asset. Jim had the Irish charm and blarney down, but he also had type "A" aggressive personality and viewed himself as a soldier at war with the British. He wasn't a peace and love guy. He had sociopathic tendencies being known to be responsible for several deaths. With this in mind we proceeded cautiously. We set up a dummy corporation called the "All Cargo Corporation", ACC. The container painted in flat maroon with lower case ACC vertically on the side copied the colors of an enormous container company whose initials was "ECC". It blended in perfectly.

On arrival day in the Port of Oakland the adrenalin began to rise. We rented a warehouse that had exits on two different streets to facilitate

escape routes, if necessary. We had lookouts stationed on the roof scan for police or helicopter activity. We got word from our dock contacts that the container had cleared customs and didn't seem to have any cars tailing it, when it left the port. The truck arrived at the warehouse safely and we off-loaded the container, removed the furniture and stripped down the walls.

We drove the hashish to a ranch we used as a stash house in the Russian River area of California in Mendocino county ninety minutes north of San Francisco. McCann brought in two guys he worked with from Ireland, Marty and Duffy. Marty, a tall Dutchman, with sandy colored hair over his ears wore heavy black rimmed glasses like Buddy Holly and had an easy going personality, but Duffy was quite different. Duffy, about five foot nine and one hundred eighty-five pounds had a stocky build with the aggressive countenance of a bar fighter. They were part of McCann's crew that travelled with him on various smuggling jobs around the world.

The ranch had a long sandy dirt driveway from the road with clear sight lines from the redwood grove where the house was located. Duffy was a sharp shooter. I witnessed him shooting the center out of a dime at a considerable distance. We had a high powered rifle with a solid magnum slug. Conceptually, the rifle would be fired at the engine blocks of the first two police cars created a gridlock in the driveway enabling guards to escape from the stash house on off road motorcycles through the numerous fire roads that wove among the redwoods. Fortunately, we didn't have to execute the plan.

The quantity of hashish was too large to keep in the Bay area. To transport the contraband from the ranch we had two identical beige Chevrolet modified station wagons with compartments built under the rear in the gas tank area. One had a light blue interior the other beige. The vehicles were legally registered to false identities. The wagons could hold about a hundred and fifty pounds of hash in the compartments at a time. I was the "transporter". I enjoyed making the run between Mendocino and San Francisco. I love to drive fast pumped with adrenalin. A car would follow me in a rear tail. The tail car's job

had to intercede, if I got stopped by the California Highway Patrol, and safely run the police officer off the road, so I could continue. This proved to be another never exercised precaution. Sometimes though I'd go really fast to freak out the tail car. The wagon would be parked in a nice neighborhood in San Francisco like Pacific Heights. The tail car picked me up and we met the distributor at breakfast at the Seal Rock Inn Cafe near the Cliff House in San Francisco. We gave the keys and location of the wagon with the hash and collected the payment. The distributer gave us the keys and location to the second empty station wagon for the trip back.

It took several months to distribute the entire load. At the end we had to deliver the proceeds to McCann. Ken and I rented a room in the Konocti Harbor Inn in Clear Lake, California to count the money. We had six suitcases full of bills in various denominations about 1.2 million. I don't know, if currency counting machines were invented yet, but we had to do it by hand. It took several hours. At one point, when we were dividing up the shares, I threw a bundle of seventy-five thousand dollars in the plastic waste basket to separate it from the rest. After we finished hours later, we cleaned up the room and repacked. As we were getting into the car, I told Ken to wait and went back to check the room. I had left the seventy-five thousand dollars in the waste basket. Good luck for us, bad for the maid.

After we finished selling the load we decided to celebrate and go on a vacation to the five islands of Hawaii. On Maui we stayed at the Hana Ranch in the Director's House on the hill. There were five of us. Kenny, his girlfriend, Leigh, Dawn, her eight-year-old son, Russell and me. Hana was very undeveloped at the time with only two hotels, truly, a place of old Hawaii with a unique energy. We were there for over a week and had made friends with the couple that ran the horseback riding concession at the hotel. They were fellow northern Californians from Bolinas. In the evenings they would hang out with us at the Director's House. We enjoyed riding through the pastures and one time we witnessed the natural birth of a calf in the field. It amazed me because the calf was so large. The hotel had a traditional luau at the beach that you could ride to on horseback and return to the hotel in a hay wagon.

We were heading to the beach through pastures separated by stone walls connected by gate openings. While Joan guided us, we asked, if we could gallop the horses. Normally, you just clop along at a light trot to the beach. Since we had made friends with Joan, she gave permission. These were older riding horses near the end of their service. My horseback riding skills were honed at Monmouth Beach Club on Beach Day in the Summer led by the reins on a Shetland pony in a circle by a very nice man. This was the first time I rode a full size horse. How difficult could it be?

We took off and hit a gallop with the wind with a hint of sea salt blowing in our faces. Joan indicated we had to make a turn to pass through the opening in the stone walls that led to the beach. We were travelling pretty fast and I started to guide my steed toward the opening. He decided to make a more gradual left arc towards the wall. It became apparent that at the current trajectory we would not be aligning with opening in the gray field stone pasture wall. We came upon the wall at full speed. I tucked my head next to the horse's mane and hung on to the pommel with two hands and closed my eyes. We were airborne…both of us! He made the jump and I only lost footing on one stirrup. In my naiveté I never considered the horse might balk and I would be airborne alone on the way to a possible future in a wheel chair. It all happened very quickly. When Joan's husband found out what happened, he was irritated that Joan let us gallop the stock, but when he found out about my steeplechase jump, he became livid. He was more concerned of damage to the horse than me, which I thought fair. We smoothed everything out in the evening with some fresh Afghani hashish and promised there would be no repeat performances.

We traveled to Kauai, the Garden Island, the oldest and most lush in the chain next. There are always spots on the islands that locals like to keep to themselves. Kenny and I had discovered some on prior visits. In the cane fields on the slopes were lava tubes, which flowed with a small amount of water. You could slide down a long way, slippery and muddy, but a lot of fun. There was another pool Kenny and I had discovered on a prior trip. It was a lava slippery slide in a waterfall that flowed into a pool below. The river emptied into a large pool about

134

thirty feet below. The river bed smoothed by hardened lava and part of it in the center extended over the pool. This made it very safe to avoid rocks, when going down the slippery slide. Most people entered the pool this way. When we were there the first time, we went on the slide in the waterfall, but we saw local kids swing out like Tarzan on a large rope and let go falling into the pool. I was determined this time to experience the rope swing.

The day we arrived was misting lightly and there were no locals at the waterfall, which should have been a sign. We all went down the waterfall a few times and I decided the time had come to try the Tarzan bit. I climbed up the side of the boulders to the top rock and grabbed the rope. I took a deep breath and launched, as I left the rock my flip flop brushed against the surface limiting my trajectory. I felt the rope reach its peak and started swing back toward the rocks. I let go. In my vision no horizon appeared just blue sky. I realized I was falling with my back parallel to the pool surface. About to hit the surface, I did a back fall technique I had learned from jiu-jitsu training. You arch the spine and simultaneously open the arms in a cross and slap the mat, in this case the surface of the water. Performed correctly spinal damage is avoided, as well as, avoiding getting the wind knocked out of you. In Kodenkan Jiu-jitsu we trained doing back falls on mats and later wood floors. Dazed and confused after I hit the pool, Dawn and Kenny dove in to help me out of the pool. They got me back to the top ridge above the pool and I got my wind back. I survived with no damage other than ego and a humongous bruise across my back. I went back to the pool on another trip determined to conquer the swing, but the area had been fenced off with a chain link fence and we didn't have access.

We were scheduled to smuggle another load in six months, but it kept getting delayed. Ken and I decided to see what we could do to move it along. We flew to London and Ken sent a message through channels to Belfast requesting a meeting. Word came back and a meeting was set up in Boston. One night, while in London, we went to see "The Mousetrap"[lviii] the Agatha Christie play, the longest running in West End London, continuous since of 1952. In the second act a loud booming sound shook the theatre. We looked at each other shocked. We

135

thought "earthquake" coming from California. Then we heard the candy lady in the lobby yell out, "Those dirty Irish bastards! Dam them!" It was an IRA bomb exploding in the heat of the IRA "Provos" war against the British in London. This hit me hard. I had to consider that the money McCann made off the hashish sales was going in some cases toward the killing innocent people. I had no problem with the smuggling of hash for the "revolution", but the hard reality of experiencing how the proceeds were being used gave me pause.

Before we left, Ken and I went on a shopping spree on Regent Street in London. We purchased two bespoke traditional English pin striped three piece suits with black cashmere mid length overcoats. Ken even bought a Bowler hat. The last accessories were bumbershoots(umbrellas). The Berkeley hippies were transformed into English bankers. When we entered Boston, a line of custom agents was inspecting baggage. The officer inspecting my passport after looking at the computer called out, "It's a hit!". Each officer in the row down the line called out, "It's a hit." in syncopation. The customs officer looked us over in our banker outfits and apologized.
"I'm sure it's some mistake. It happens all the time. They even have Spiro Agnew[lix] in there." (Spiro Agnew, a corrupt vice-president under President Nixon, had to resign under scandal.)
The officer in his late fifties, obviously of Irish descent, six foot four, pinked skinned and topped with a grey flat top haircut.
"Vincent Lynch is a very common name in Ireland and here in Boson too. You don't live at 415 Fourth Street in Oakland, California, do you?"
I replied, "I live in California, but in Berkeley not Oakland." And showed him my California driver's license, which had the Berkeley, Fifth Street address.
"Hmm, please wait here." He walked over and conferenced with a couple of fellow officers and came back.
"You're free to go. Welcome to Boston."

We left and got a cab to the hotel. I told Ken in the cab that that 415 Fourth Street in Oakland was the studio address. I had no legal association with that address other than payment for rent to the landlord,

136

which included the utilities. The bank acted as landlord on behalf of Leon Hersh's estate, who had passed away. My mailing and legal address was 1444 Fifth Street, Berkeley not Oakland. That meant we were in the feds computer. There must have been surveillance of the studio and associated my name with it. It would not have been difficult because the front of the studio was opposite the Alameda Probation Department. Although disturbing information, but not as bad as the news I received when returning home. The building of my studio was sold in an estate sale.

Chapter 18

Studio Loss

Devastated by the news of the sale of the property, I was informed that I had to vacate in thirty days. I had transformed the entire space at this point. I had white sheet rock walls throughout, a gallery in the front, work area in the center below the sky lights and a sleeping area in the "ice box" with a water bed. The double skylight area and cross beams were covered in silver Mylar left over from the environment we did at the Art Institute for added light diffusion. I had poured my heart, soul and occasional blood into building the interior of the space over several years. It even had heat.

Aside from my emotional attachment to the physical studio, pragmatically, I needed the wall and floor area for the process of the scale of paintings I had been executing. I was working in large eight by ten feet museum scale format pieces. I had gotten a great review in my first show at the San Francisco Art Institute by Alfred Frankenstein, the premier art critic of the San Francisco Chronicle followed by shows at the University of California Berkeley Museum and the Los Angeles Museum of Contemporary Art. My art career had just begun to take off. The strategy abruptly hit a brick wall.

I had experimented with different painting styles…color field, air brush and finally developed a unique style with the help of Dawn's scientific knowledge. Obsessed with mounds from around the world, I wanted to create aerial views. Mounds were used worldwide by many cultures as a means of communication with higher powers. The method I used required a lot of floor space due to the process used to create the pieces.

I built mounds of wet sand on black opaque polyethylene plastic. I added wet canvas and formed it on top of the sand mounds. Yogurt was added to the lower areas of the mounds I introduced mold to the yogurt and sealed the mound in a plastic envelope to promote the growth for thirty days. Wearing a face mask, I opened the plastic envelope and allowed the mold to dry out. I flowed Roplex, which is the acrylic

medium in paint, on both sides of the canvas to seal the front and back. I would purchase Roplex in fifty-five gallon drums due to the volume I used. When the canvas dried, I added glazing with natural substances such as fine granular colored glass, sand, stones, etc. and resealed the surface with the Roplex. As a result, I needed not only wall space to · display, but also, a large amount of floor space to execute the pieces. The concept of continuing to do art wasn't an option because of the amount of the space I needed. I couldn't afford to rent a space that large and scaling down the images would lose their impact. In the course of moving out extremely depressed, I destroyed a lot of paintings that I couldn't fit into storage. I had no place to work and had to suspend doing art.

The studio was my sanctuary more than a place to work. Before I had a studio I used to go up the northern California coast around Elk, California and park the car on the side of Highway One next to the ocean and hike down to the beach. Driftwood scattered across the beach from the rivers draining from the redwood forests of Mendocino county provided the necessary materials. I usually chose a log and made a low lean to with just enough room for my sleeping bag and made the structure to look like a natural occurrence concealing my presence. I would spend a few days meditating. I loved having the ambience of the sound of the waves and smell of the sea echoing the early imprinting, as a baby, on the Jersey shore.

In addition to creating art, the studio had been a place where I could proceed with meditation for extended periods of time in isolation. I had a water bed in the freezer, an effective device to float in total darkness with the door closed in meditation. The wooden ice box walls had two feet of sawdust insulation to muffle any exterior sound. Once, I decided to stay at the studio and remain silent for a month. I minimized my interactions with people and would use a pen and paper, if necessary. The silence, awkward for some people, put them off. I observed how much we talk to fill a silent space and often communicate nothing. On one deep meditation I felt I experienced time as a continuum: past, present, future existing simultaneously. It was like we were in a light tube. The present was the sides, the future the front, and the back the

past. The experience went on for some time, but I only retained fragmented memories. Other than that, I have no deep insight to offer. The only other place I read of a similar experience was in P.D.Ouspensky's *"In Search of the Miraculous"*[lx].

CHAPTER 19

TWIN FALLS

I decided we needed a road trip, and rented a RV to travel to Twin Falls, Idaho to watch Evel Knievel jump Snake River Canyon in a rocket with two friends. Kenny McDonnell, Troy McKeley and myself took off from Oakland in our rented beige and white Winnebago fully stocked with the necessary commodities for the trip northward to the Gem state, home to the famous Idaho potato. Troy, a lanky six foot eight with curly dark brown hair in a ponytail halfway down his back, wore a blue jean jacket and pants. He had dark brown eyes, and angular light skin with a clean shaven face. The potato aspect appealed to all three of us being of Irish descent and the irony that we wouldn't be here, if our ancestors hadn't left their homeland for the lack of them.

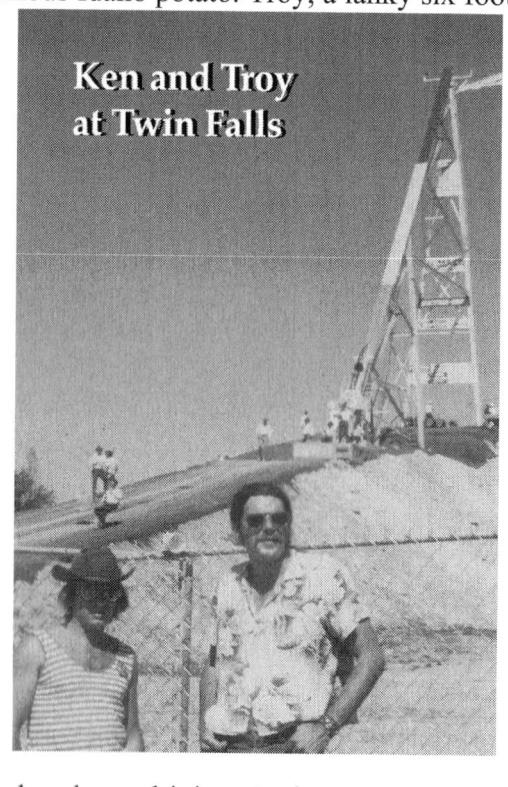

Ken and Troy at Twin Falls

As we passed into Nevada, we had a discussion and decided to pass on the Mustang Ranch[lxi]. We figured we'd end up there for the night, if we stopped. We were still a long way from Twin Falls, Idaho and decided to keep driving. Twin Falls is in the middle of the southern part of the state and the scenery is dramatic. Fields of yellow wild mustard next to clear blue lakes. Gorges cut by rivers like Snake River Canyon below the dramatic Shoshone Falls all framed by the Tetons' white snow caps and Sawtooth mountain range in the background. We decided to arrive early at the site and parked next

to eight portable green johns. The place started to fill up with various groups of bikers riding on all kinds of motorcycles. Motorcycle clubs, outlaw and straight, from all over the western states came to witness the jump, a biker's Woodstock. There were concessions and rock music playing on the stage. Near the edge of the gorge the promoters had built a large triangular earthen berm with the correct trajectory to support the metal launching structure, branded with the commercial logos of Mack Trucks, Chuckles candy, and other sponsors. An electric feeling of excitement filled the air in anticipation of the jump.

On the other side of the portable johns where we were parked, another mobile home pulled up and parked. It was longer and more elaborate than ours. We had a boxy Winnebago and theirs more like a streamline bus. Through some conversation we ended up in their bus. The bus belonged to the "Chosen Few", an outlaw club from Denver that claimed to be in charge of security at the event. The president, Lou, was not what I expected. Slight of build about five foot ten and about one hundred and sixty-five pounds, he had short black hair and appeared to be of Italian heritage. In the bus with him were six club members with club patches on their black leather vests wearing colorful bandanas. They looked like the defensive line of a pro football team. Their presence amply made up for the president's lack of size and brawn. He was in control and did all the talking and his guys just leered. It was intimidating but in situations like this from my experience you had to be assertive. Any indication of fear would be disastrous. Obviously, Lou was attempting to determine, if we were "narks". From his suspicious point of view Troy and I had long hair and looked acceptable, but Kenny had short blond hair, angelic blue eyes and look like a choir boy or a cop.

Lou finally asked, "What are you for…life or death?" His question shocked me at first. I paused and extended my right fist out parallel to the floor with thumb extended. I waited for a few seconds for dramatic effect. I began to rotate my wrist slightly counter clockwise downward and then with a snap I rotated it clockwise for a thumbs up. The gang members approved and cheered. We hadn't passed yet. Lou lit up a joint to pass around. Undercover cops weren't allowed to consume drugs.

142

The joint wasn't just marijuana. I think it had PCP or "angel dust" added. We maintained and all went well. The boys were convinced we weren't narks. The effects of PCP were disorienting and distorted reality in an extremely unpleasant way.

I thought Lou's question was strange because I thought everyone would be rooting for Evel to make it, but apparently there were some with a death wish for him. Evel once said, "All my life people have been waiting around to watch me die." Evel apparently didn't know *himself*, if he would make the canyon jump. Just in case his entourage stopped at every bar on the highway they passed, as they drove across the entire state of Montana.

Jump day finally came and everything ran late. Finally, in late afternoon Evel was lowered into the rocket with a crane boom and strapped in the seat. The rocket fired and he took off straight up the ramp streaming white smoke. Shortly after clearing the ramp beginning his ascent across the gorge the parachutes deployed prematurely. All of a sudden the red white and blue X-2 rocket attached to the parachutes descended downward into the Snake River below on the near side of the gorge wall. Total confusion reigned because nobody knew what was happening. If he went into the river, he would most likely drown. Finally, word came back the rocket had fortunately landed on the river bank and he didn't lose his life.

The reaction was interesting in that most people were pissed off he didn't make it and less concerned for his wellbeing. It eventually

143

became ugly. After he didn't make it a lot of the people left...especially those with families. It was still crowded and were in the front of the area close to the rocket launch site. We decided to stay and leave in the morning since we were self-contained in the RV. The night wore on and the destruction began. The remaining revelers tore everything down and any wood was burned. Bonfires were lit. Small fires were arranged with ramps to facilitate jumps through fires on choppers. It was really getting wild and they attacked the plastic johns to use as bases for the ramps to get some more air on the motorcycles, when they jumped to clear the fires. If we could have left we would have, but we were blocked in and any resemblance to road exits from the site had long been obliterated.

At one point we heard someone climbing up on the roof of the Winnebago escalating potential danger. I didn't know that Troy had brought a gun with him, a .44 magnum like Clint Eastwood of "make my day" fame. He opened the sky light vent in the RV roof a few inches and pointed the eight-inch barrel out the opening. All of a sudden from above we heard.
"Holy Shit! Fuck man! Fuck, Sorry man, no problem, no problem, no problem." A body slithered down the back of the RV and slinked away in the night. At first light we decided to leave and we wove our way slowly through the site avoiding potential flat tires. Burned smoldering debris everywhere, it looked like a battle field the day after. We finally got back on the highway and "Kept on Truckin'" back to the peace and love of SF bay area. .

MUSIC BIZ

David Rubinson

S ometime later I got a phone call from Debbie Shine. She worked as the wardrobe mistress for the Pointer Sisters, four sisters, who were doing a modern version of the Andrew Sisters of the 1940's in song, style and costume. Debbie told me they were looking for new road manager and I should talk to their manager David Rubinson in San Francisco. David Rubinson[lxii], an original partner of Bill Graham and Brian Rohan in the Fillmore Corporation was also a record producer, artist manager and influential in the music scene in the San Francisco Bay Area. I talked to Debbie candidly about what it was like working with the sisters. To me it sounded like a nightmare. I went in any way to have the meeting. I told him I didn't want the Pointer Sister's gig, but I did want to go out as a tour manager with my friend, John Shine, who Rubinson had just signed to a record deal with Columbia Records. He agreed and that's how I began in the music business.

John Shine in the studio

John Shine went on tour with a trio: himself on guitar with a bass player, Paul Zaro and a violinist, Brian Price. It was a club tour performing in the radio markets of major cities to promote the album, such as, The Boarding House in San Francisco, Paul's Mall in Boston and The Bottom Line in New York. In addition to live performance we would do local radio and record store appearances for promotional purposes. It was a relatively short tour and all went well. John and the band were well received. A road manager's function is to coordinate all the logistics of the tour: housing, transportation, advancing shows, collecting money and arranging appearances among other responsibilities. You must anticipate everything that you know will occur in order to prepare for the unexpected. For example, most cities were fine to park the equipment at the hotel, but New York was an exception. There were crews that specialized in ripping off band equipment. Instruments, amps and sound gear were easily liquidated. On John's tour I stashed the equipment van in the Jersey City municipal parking garage with a guard. My cousin, "Cub" Lynch, ran the Jersey City Parking Authority at the time. Jersey City had the additional convenience of quick access to the Holland Tunnel, which empties in downtown NYC near the Bottom Line venue in the village. Tour

managing paid well, but you are only hired for the pre-production, tour and end settlements. It's not a full time job.

When John finished touring, David hired me to go on tour with another act he represented, Terry Garthwaite. She and Toni Brown formed the first woman fronted folk rock band, "The Joy of Cooking". Going out as a solo artist for the first time she had a full band and correspondingly more gear. With this in mind, I asked Ken McDonnell to come on the tour to help out. It was a longer tour, but it went well. Unfortunately, neither of these acts ever had the "rock'n'roll" hordes of legendary groupies at the stage door looking for romance. It was a lot of work, physically and mentally. Towns became a blur. In your daze you punched the floor number in the elevator from the hotel the day before. Feeling the energy of the audience from the stage reacting to the live music was worth all the effort, however. A performance is a collaborative work of many people besides the artists on stage. An extremely rewarding experience, when all goes well.

Terry's drummer stood out. Darrell Griffen was six two about two hundred pounds and moved with the agility of a dancer. Darrell knew karate and could jump over the drum set, flip in the air and land into a full split in front of the base drum. He had played in James Brown's Band. He had great stories about of how James Brown would always fine the musicians for infractions of dress or behavior. James made the band line up like the military for inspection, walking down the line like a general. Often we had rented vans that rattled and Darrell would take out his sticks and play in syncopation with rattles on the side of the van. The improvisations he developed were great. We are surrounded by rhythms and music in our daily life that we are conditioned to block out. Darrell was tuned into rhythms at all times.

Terry's tour concluded in Los Angeles at the Troubadour. David had booked another one of his acts "Heartsfield"[lxiii], a southern rock guitar band. Terry did a great show and "Heartsfield" followed. At the end of their set Keith Moon[lxiv] of "the Who"[lxv] sat in on drums and brought down the house. Voted the second best rock drummer of all time in a

147

Rolling Stone magazine poll, he was plagued with a self-destructive personal life.

David Rubinson Narada Michael Walden Greg Digiovine me

We were staying on Doheny Drive at the Beverly Terrace in walking distance of the club. The Beverly Terrace was a two story trapezoid shaped structure, more motel than hotel, located just over the border of Beverly Hills across the street from The Troubadour in West Hollywood. The entrances to the rooms surrounded a swimming pool in the center on the first floor. The "Heartsfield" guys like to party and invited Keith over after the gig to join them. Keith had a reputation for being a "bad boy" destroying hotel rooms on tour. His moniker, "Moon the Loon". forged by his fascination of blowing up toilets with fireworks and the destruction of television sets. Around one thirty in the morning, while finishing end of tour paperwork, I heard this incredible boom of an explosion. I ran to the door and flew it open. With the band members and crews, we had taken over most of the hotel. On the second floor I looked across at Keith in the center with the *"Heartsfield"* guys laughing their heads off on the other side of the second floor. Keith had plugged a long extension cord into the wall and tossed the TV in the room into the pool. The result created a mushroom cloud of water and

sonic boom. These guys were not my responsibility. I called Carl, their road manager, who is best described physically, as a duplicate of Charlie Daniels[lxvi], the country star, when he had a black beard. He didn't answer. I found out later he was pissed off at the band and hiding from them in another room under an assumed name. I could've killed him.

I went down stairs to deal with the hotel management and informed them we would pay for any damages. It seemed to be under control until the Beverly Hills Police arrived responding to the explosion. They were very polite and I was fortunate that I had to deal with them versus the West

Dawn Randy Jackson

Hollywood Police. They wanted to come in to inspect the place. I argued the point of view of "no probable cause" in that we already resolved any difficulties with the hotel management. I went on how these were just rock and roll hijinks and that "boys would be boys" blowing off a little steam after the gig setting off a few harmless fire crackers. I didn't want them to enter the hotel to witness the alcohol and drug fueled rabble, which could lead to further complications, such as, a drug bust. With the support of the hotel manager, they eventually agreed not to enter and gave us a stern warning.

There was something about UK bands and crews and their love of destruction. For example, Ronnie, a Scottish roadie, we hired from MEH in Europe on Herbie Hancock's tour. He worked on Elton John's Australian tour. There were two large crews that leap frogged each other

149

at consecutive venues. Consequently, the crews had a lot of down time only doing three shows a week. The travel agent would normally book three hotels on the assumption they would be ejected for trashing rooms. Among favorite activities were locating fellow crew members' rental cars and intentionally crash into them. They would then report to the rental company that the car had had an accident. Ronnie said he would have to hide his car, so it wouldn't get trashed. They thought it was great fun and had no respect for property. I never got it. Scottish humor is odd. For example, Ronnie would tell his favorite joke. *In Glasgow a drunk guy with a bottle of beer in hand, stops a passerby, and asks if he knows where the local hospital is located. The pedestrian says yes it's down the street two blocks. The drunk says good and smashes the beer bottle on the pedestrian's head.* He broke into a hilarious belly laugh every time he finished telling it.

After Terry's tour concluded I didn't hear from David for a while. One day while waiting at the traffic light in my modified red Mazda sports car after exiting Highway 80 at the Fifth Street exit for San Francisco downtown, I saw David in the lane next to me in his bittersweet orange Porsche Targa. He saw me and started to frantically wave at me with his window closed, eventually, miming a telephone to his ear with his hand. The light changed and we both took off. I called him and he asked me to come in to his office to discuss a tour.

CHAPTER 21

NEWPORT JAZZ FESTIVAL

David wanted me to tour manage Herbie Hancock, the well-known jazz musician, on an eight-week European tour. David had a dual role of representing Herbie as a manager and also producing his records. It was extremely important to him to have a contented client. Herbie had a six-piece band with two crew members and in my opinion what David offered for compensation wasn't enough for the work entailed. He asked me to meet with Herbie anyway and I went to Herbie's hotel. Herbie asked me why I wanted to do the tour and I replied frankly. I told him that I needed the money to support my work doing art. He didn't like my answer. He told me he wasn't interested. He said he wanted someone, who wanted to be in the music business as a profession. I responded confidently that I could do the tour regardless of my art interest and that David had experience with me on other tours. Herbie could confirm this with him. We parted amicably and I went back to David's office. It turned out Herbie liked me and David offered to make up the difference for my fee from his percentage. I accepted and began the European tour pre-production.

To travel internationally you had to do a carnet for customs. A carnet listed all the gear to prove you brought it with you from the United States to avoid custom duties between countries. With no European Union each country had their own customs. Every road case had to numbered and the contents described. Herbie, a keyboard master, required a lot of them. We traveled with fifty-six cases for the band alone...without sound and lights. As we got closer to departure, I became informed that there might be one last minute gig booked in the USA before we left for Europe. It turned out to be the Newport Jazz Festival held in New York in 1976.

I felt suckered because this would be a complex concert and not part of the original contract. The back story of how the show came about, which I found out later, was interesting. David and Herbie didn't want to do the festival because they wanted to break in the new band in Europe

first. Politically, however, they didn't want to offend George Wein, the festival producer. They proposed to do a Herbie Hancock retrospective consisting of three iterations of his career, the Miles Davis Quintet, the Herbie Hancock Sextet, his *"mwandishi"* band, and the current band with which he was going on tour. They thought it was an outrageous proposal for an artist that hadn't passed away yet to do such a show and George Wein would never go for it. To their surprise he loved the concept and the venue was set for the City Center Theater on West fifty-fifth street in New York City, a beautiful Moorish revival theater with seating over 2200.

Herbie
Hancock

Committing to the gig meant I had to accelerate the tour process to be ready to depart from New York for Europe a week early. We also had to go into New York a week before the gig so the various band members could rehearse together because many hadn't played together in years. I had to book rehearsal spaces, additional hotel rooms and fly in sixteen players from various parts of the USA and Europe. The night before the show, after we had moved out of the rehearsal halls, I had two crew members sleep in the cab of the equipment truck overnight fully armed with the truck backed up to the brick wall in the parking lot of S.I.R., Studio Instruments Rentals. New York was notorious for crews ripping off band equipment trucks.

The next day we arrived about 7:30 AM to do the equipment load in at the theater. We were informed by the union stagehand shop steward that

152

we couldn't load in till 8 AM. Welcome to New York unions. We loaded in and had a lot of additional equipment much more than a normal show. The stage design had three band setups with the drum risers in an arc and each had its own back line of amplifiers. This way the concert could proceed with no delay for set changes. In addition to this David decided to do a live recording of the show, which meant the recording gear also had to be connected. Herbie's keyboard set up alone required dozens of cable connections. When my roadies started to set up the gear for the three bands, they were stopped by a union guy. I went over the stage to resolve the dispute. I told the union guy I had already taken care of the stagehands. He responded, "Good, but I'm the electrician's union and you can't touch an electric cable without an electrician."

"You mean to say my roadies can't touch the cable and have to tell your electrician, which hole to plug each one of these cables into? You see all these cables? Do you realize how long that will take? There are also additional cables necessary for the live recording."

"That's the contract.", he replied.

After discussion explaining the time constraints and offering a bribe, I negotiated for four electricians to sit on chairs in the wings watching, while my guys did their work.

The show was one night comprised of three concerts from different periods of Herbie's jazz evolution. The roadies did a great job and we were able to do the sound checks for all three bands on time. The lineup of players was impressive. From the mid-sixties period of cool jazz with members of the famous Miles Davis Quintet: Herbie - electric piano, Ron Carter – bass, Wayne Shorter – Sax, Tony Williams – drums and Freddy Hubbard – trumpet in the Miles Davis slot. Miles had told Herbie he would come. We had a mike in the wings with its own recording channel in case he appeared, but he never showed up. It was a dark period in Miles' life fueled unfortunately by drug abuse. The second group was drawn from Herbie's most experimental band from his "mwandishi" era of the late sixties and earlier seventies fusing African rhythms, jazz and electronic synthesizers. Herbie – electric piano and clavinet, Buster Williams – bass, Billy Hart - drums, Eddie Henderson – trumpet and flugelhorn, Bennie Maupin – alto flute, and

Julian Priester – tenor and bass trombone. The third group, his current band going on the European tour was a change in artistic direction to more of a funk jazz sound composed of Herbie - electric piano and multiple synthesizers, Melvin "Wah Wah" Watson - guitar, Paul Jackson – bass, James Levi – drums, Kenneth Nash - percussion, Bennie Maupin – tenor & soprano sax and Lyricon, a wind synthesizer, and Ray Parker Jr. – guitar, who was on the album, also sat in for the night. We started exactly on time at 8 pm and finished just before midnight to avoid going into union overtime. Everything went smoothly including the live twenty-four track recording. At 3 AM Omar, the crew chief from S.I.R., and I observed from the balcony the final road cases being struck from the stage and decided to share a joint in celebration. It turned out to be the second most difficult gig I ever had to supervise.

CHAPTER 22

EUROPEAN TOUR

The first concert took place in the open air concert park in the Kirjurinluoto Arena. Of the many synthesizers Herbie played, one brand was the Oberheim. Close to the rear of stage a pen of peacocks was held in a caged area. They were among various animals displayed throughout the park in cages. When Herbie would play certain chord phrases on the Oberheim, the peacocks went ballistic. They started screeching incessantly enough for Herbie to improvise with nature, as an added element to the band. The band picked up on it accenting Herbie's responses to the peacocks, a unique musical moment blending music and nature. The audience went nuts and gave the band a standing ovation after the song.

The original plan was to meet a group of acts in the South of France to tour with for several dates in France and Switzerland. But, instead, our management and the European promoter *added* a gig (for a lucrative fee) on the weekend *before*...at the Pori Jazz Festival in Finland. Nobody had consulted me and this became an "issue". We had hired a UK company MEH (Moving Equipment Hauling) to provide sound and lights, trucking and additional crew. They were waiting in the south of France, but all the band's gear in Finland would have to be transported to France.

When we were loading out of the festival, I got some distressing news. We had to join the other bands in the south of France on Monday and flying the gear was prohibitive. The surface route to get to the South of France passed through Germany on the autobahn. Trucks were forbidden on the autobahn on weekends. I met with the promoter and he arranged for me to meet two local guys from Pori. They were awfully Finnish. They insisted on negotiating the fee for the transportation of the gear in a sauna. I thought this odd, but I figured "when in Rome" and I was desperate. We came to a deal. I couldn't resist at the end asking why do the deal in the sauna. They replied that, when the Finnish Prime Minster negotiated with the Russians, it proved to be the most

155

effective way to getting the best deal. We decided instead of a truck we would break up the load. We used two large vans, which were considered cars on the autobahn, pulling two trailers. It worked. They made it to the south of France on time and we met the Scottish sound and lights crew.

We were doing an eight-week tour and for the first few weeks we performed with "Weather Report", "Billy Cobham/George Duke Band" and John McLaughlin's, "Shakti", which played acoustic fusion music combining Indian music with elements of jazz. John McLaughlin, Herbie Hancock, and Joe Zawinul, co-leader of "Weather Report" with Wayne Shorter, were leaders in the fusion jazz movement of the late sixties and early seventies. I had a couple of conversations with Wayne Shorter…conversations that were not "clarifying". He would make statements that often sound like non-sequiturs, but there would be a subtle relationship. It was a bit confusing to me and I asked Herbie about it. He responded with his classic laugh, "Heh, heh, heh", a softer version of the "Fat Albert" cartoon character, for which, Herbie composed the soundtrack.

"I've known Wayne for years and he is either extraordinarily intelligent or insane. I still haven't figured out which one it is."

Herbie wasn't a difficult artist to work with from my point of view. He was intelligent, logical and had a good sense of humor. If I could make a good case for a decision, he would usually agree. We were both Aries astrologically, which may have helped. Being on the road for extended periods of time is stressful particularly the coordination of the travel and performance requirements. Having a cooperative artist reduced stress for a tour manager. Herbie did have a unique request, however. When possible, we would use a dressing room, as a place for Herbie and local followers of Nichiren Buddhism attending the concert to chant before performances. The ten and five minute calls to performance were given to Herbie over thirty people chanting *Nam Myoho Renge Kyo* and Herbie would nod not missing a beat. There were often odd reactions. One time in the deep South an older black security guard saw what was going in the room and reacted unexpectedly. He started to accuse the people of devil worship and the worship of false idols. I tried to explain,

156

but he refused to listen and said he would have nothing to do with this pagan worship given his faith. He left his post and stormed out of the arena.

We all travelled together as a unit, a very diverse international group. Many of the musicians not only knew one another by reputation, but also had played together in various fluid band configurations over the years. Depending on venue distances, we'd either fly on our own plane or drive by bus. One of the musicians that performed with "Shakti" was H. "Vikku" Vinayakram, who used an ancient Indian instrument called a Ghatam, a clay pot that he played with his hands. He was tiny. The soles of his feet, when sitting on the plane, were six inches above the floor. He always had a cheery smile and ate his own prepared food, which smelled horrendous. He played the Ghatam at incredible speed and the tips of his fingers were hard as stone.

We were travelling by bus in the Swiss alps to Vaduz, Lichtenstein. The European bus had a lot of windows and a clear roof, which facilitated the view of the mountain scenery and snow covered peaks. Jaco Pastorius, the bass player for Weather Report at the time, was an extraordinary talent, who played multiple instruments, as well as, being a composer. But on the bass he employed funk, lyrical solos, bass chords, and innovative harmonics. He is the only electric bassist of seven bassists inducted into the *DownBeat* Jazz Hall of Fame.[lxvii] He approached Herbie and the other band members and said he wanted their opinion on a song that his band had just finished. He said, "I think we have a hit.". He put it into the cassette player on the bus. After the song finished…a long silence, then everyone burst into applause. We played it several more times digesting the composition and analyzing the musical choices. The song was *"Birdland"*[lxviii] written by Joe Zawinul inspired by the famous New York performance venue. When "Weather Report" released their album, *"Heavy Weather"*, in the next year, *"Birdland"* became a monstrous pop hit and eventually a jazz standard.

We had a "mainsman", a lighting roadie that dealt with different electrical standards that various European countries chose. There was

no universal European standard. Normally, we had to connect directly to the electric source and use our rented equipment to change it to the proper voltage to run our sound, lights and band equipment. The venues varied widely.

In Montpellier, France we did a show in a smelly bull ring in an amphitheater that dated back to the Romans. I asked about this stain in the sand next to the elevated stage, the answer, "le taureau", the bull, a recent entertainer. In San Sebastian, Spain we played a large arena, but there was a problem with the grounding of the electrics. You got shocked, when you touched the light desk, which ran the stage lighting. Something was incorrect in the grounding of the desk. The venue was using the promoter's system not ours. Our mainsman couldn't repair the grounding. Since I had finished collecting the remainder of the money for the show settlement before the performance, I decided to call the lights. "Calling the lights" is cueing the follow spot operators to illuminate the appropriate artist in regard to the music focus and changing the stage lighting from a light desk usually next to the sound system board in the audience. I got some heavy rubber lineman gloves that went up to the elbow. I set up twelve presets of stage lighting combinations that could be executed with the press of one button to minimize having to touch the deck. The band did a great set and I tried to match the mood of the music with the lighting presets, as best I could. After the show Larry Coryell, the fusion jazz guitarist, came up to be and said the lights were the greatest he had ever seen for any jazz show and wanted to hire me. I thanked him, but declined. I was simply grateful for not having being electrocuted.

Eventually, we left the tour to perform solo gigs over Europe and Scandinavia. The promoter would send a fifty percent deposit to the agent in the USA to book the date. I was responsible for picking up the remaining percentage at the performance usually in the local currency. The Euro did not exist. I had a manila folder with separated compartments for the currencies from ten different countries. I eventually required all payments in Swiss francs regardless of venue. It worked out well for Herbie because in the two months we were in

Europe on tour they increased in value versus the other European currencies.

We were in Brussels, Belgium and had a problem at the show, a theft from the dressing room, while the band performed on stage. James Levi, the drummer had a pair of fancy red leather dress shoes stolen. Drummers often change shoes to have more of a feel playing the bass drum and high hat, when performing. James born and bred in Oakland, California was a hard core funk drummer. He took pride in his appearance and dressed well. When not playing music, he worked as a security guard at one of Oakland's toughest high schools. Five ten tall and about one hundred and seventy-five pounds, he had a dark black complexion and a round clean shaven face. He had large biceps from working out and had perfected karate skills.

James Levi

It is the promoter's responsibility to secure the dressing rooms and also his contractual liability, if there is an issue. James was livid and a bit out of control. Paul Jackson our bass player and an old friend of James intervened to try to calm him down. At first the promoter denied responsibility, I told him we should go to his office to discuss it. The promoter sat behind his desk flanked by two assistants, one of which James thought was the thief. I sat down in a chair on the other side of the desk. Behind me James was standing on the right with an angry look in his eye and Paul on the left looking deadpan. Paul more physically intimidating than even James

was six feet four and had enormous hands. He played a fretless electric bass like a ukulele.

I told the promoter that the shoes were custom made, worth fifteen hundred dollars and he had to pay for them. The amount far exceeded the value of the shoes. It felt like a scene from a Godfather movie. He hemmed and hawed even referencing we were acting like American gangsters and accused us of being personally responsible for the Vietnam war, extremely unpopular in Europe at the time. Eventually, he reluctantly forked over the money. I then gave him an option. I told him we were leaving the hotel at 10 AM the next day and if he found the thief and returned the shoes, I'd return his money. The next morning the red shoes miraculously arrived at the tour bus before we left and I returned the money to the promoter.

"All Belgians are thieves!" James shouted from the bus, as we departed. James, incredibly pleased to have his shoes returned, said to me, "I got a new name for you, HNC."
"Is that a fact?", I replied. "What exactly does HNC mean?"
"It means you're the 'Head Nigger in Charge' ".
Everybody laughed and I replied, "Thank you, James. I take that as a big compliment."

James Levi was from East Oakland, California. He had toured with several soul groups, such as, the Whispers and Etta James domestically, on the "chitlin circuit", but he had never travelled internationally. Culturally, he was unsophisticated unlike Paul Jackson our bass player, who had traveled the world with Herbie. Paul and James were good friends and Paul convinced Herbie to hire him for the tour. The three of us would often hang out together in off time. In Europe, when James found out the cost of having the hotel clean his clothes, he freaked out. James had a tendency to be either very calm or very intense when conflicted with no stage in between. We set out with Paul to find a laundromat. James only speaks English and in Oakland the primary laundromat chain is "Wash House". We were walking through the city and came upon an older woman with groceries in a bag.

James asked, "Do you know where we can find a wash house?". She looked at him perplexed with three strange men staring at her waiting for a reply. She shook her head.

"Wash House," James said again and started to mime washing clothes on a wash board. Meanwhile, Paul and I are chirping in with short phrases "wash clothes", "washing machine", "soap", "water", "laundromat". The look in the woman's eye was becoming more alarmed. James became completely frustrated in the process.

"Wash house", he repeated louder, "Wash house" louder again. The more she shook her head the louder he said it, as if, it would make it clearer. It had the opposite effect. She said, "Non, Non", and ran off terrified. Our quest had failed. I pointed out to James that increased volume did not guarantee more clarity.

Another time the three of us were in the Meridian Hotel in Nice, France. We were there in late Summer playing a gig in nearby Antibes. In the day the most beautiful women from all the countries in Europe were sunning themselves topless on the beaches. I think this had an effect on the crew's ability to focus on the set up of the sound system on the stage next to the beach. They may have been distracted. It became the worst night for the sound system on the tour, definitely attributed to operator error. Usually, it was perfect.

By this time a lot of my high school French had come back and I could speak and translate menus for the band. Nice, France for James was another world far away from Oakland. We were going out to dinner at a restaurant on the main street next to the sea. We sat down.
I started to translate, "Escargot, snails.
"No."
"Salad Nicoise, tuna, egg, olives?"
"No."
"Bouillabaisse."
"What's that?"
"It's a fish soup or chowder."
Paul agreed with the choice and encouraged James to try.
"Sure, I like fish soup. That sounds good", James replied.
We placed the order and dove into the excellent French bread and butter.

161

Paul and I were served and they served James' dish last. The waiter served a platter with a white china broth tureen in the center surrounded by the different varieties of fish that would be filleted for the soup. It was a beautiful presentation with all the various colors of the fish skins completely intact with eyes looking back at us. James took one look and his eyes widened. He did a long take looking at the bouillabaisse then back at Paul and me. He then repeated it with a silent alarming look. The staff left the table.

James said, "I ain't eatin' that! I ain't gonna eat somethin' that can look back at me."

Paul and I burst out laughing. We negotiated for Paul to take James' order and switch for his. Paul thought the bouillabaisse exceptional. When we finished, we strolled down the *Promenade des Anglais* on a warm summer night with all the "beautiful people". James still hungry, believe it or not, found a Mc Donald's and we stopped. He was content in familiar Mickie D heaven. Paul and I did not miss the irony that we were sitting in a McDonalds' in a home of internationally famous French cuisine.

Paul
Jackson

I was amazed by the differences in the audiences in Germany. In the south in a city like Munich they were enthusiastic, but in northern Germany in a city like Dortmund they were so reserved, I thought they didn't enjoy the show, but in fact, they did. They were two discrete audiences and different as night and day in spite of the close geographic

162

proximity of a six-hour drive by car in the same country. We were close to the end of the tour after playing Dortmund, Germany and we had to travel to Cologne to catch an international flight to Berlin. At the time Germany was divided into East and West Germany. East Germany refused to allow Lufthansa, West Germany's airline, to fly in their air space. Therefore, it had to be an international flight because Berlin was located in the middle of East Germany.

The equipment had to go on surface routes and there were only three available from West Germany to Berlin at the time. As the crew traveled on the road through East Germany to Berlin, they could tell they were getting closer by the soldier's uniforms. First the military uniforms were green East German, halfway through the uniforms were all camouflage and in the last third there were only gray Russian uniforms with red stars.

At a gas stop on the road midway to Berlin one of the lighting crew was sitting on a bench outside waiting for the crew members, who were in the store getting drinks. When the other guys came out he was gone, he disappeared. The roadies were Scottish and multilingual. After inquiries they found out he was taken to the police station. When they went to retrieve him from the station, they found out why he had been taken into custody. He spoke to one of the locals sitting next to him on the bench. A plain clothes policeman arrested him thinking he was a spy transferring information. They were eventually able to convince the police, who they were, a bunch of eccentric long hair roadies and not spies. They had two Volvo tractor trailer trucks to prove the point carrying the band, sound and lighting equipment.

As a tour goes on, the band usually gets tighter musically, but the support staff starts to become less efficient due to physical fatigue. We had left the hotel in Dortmund in the bus and were about half way to the Cologne airport, when I realized something. I didn't have the plane tickets with me; I had left them in the hotel safe in Dortmund. I had to carry all the band's plane tickets for the entire eight-week tour, which were given to me at the tour start in Finland. There were thirteen stacks of tickets for band and crew, that were each seven inches high. I kept

then in a separate bag and stored them in the hotel safe, when out of the hotel to avoid theft. We had a crisis. I told the driver to pull off the autobahn into the next stop, so I could rent a car and go back to the Dortmund hotel. I told Herbie to go to the airport with the band and put the flights on his Amex card and I would follow, when I could. He agreed and called to Bennie Maupin and said, "We should chant." Herbie and Bennie were Nicherin Buddhists, who believe that chanting, "Nam-myoho-renge-kyo", can have an influence on human destiny by chanting for a cause.

At this point in the tour we had the person in charge of Columbia Records in Europe, Herbie's record company, traveling with us on the bus. As I got off the bus at the car rental and he asked, if he could go with me. I rented a BMW and he suggested he could drive. I said no that I had to keep the car floored on the autobahn both ways. We would be traveling at the car's maximum speed.
He said, "I'm an amateur race car driver and I know the German roads."
I smiled, my luck had changed.
"Let's go for it.", I responded.

We took off back to Dortmund. I got to the hotel, picked up the tickets and we started back to Cologne airport. We were going over 200 kilometers per hour in the fast lane, over 125 miles per hour, on the no speed limit autobahn. A Porsche Carrera pulled up behind us and flashed his lights. We pulled over into the middle lane and he flew by. We arrived at the Cologne airport there were three modern terminals arranged in an arc. I realized I had no idea which terminal was the correct one, since I assumed that I had already missed the flight.

My amateur race car driver suggested to try the international terminal in the center. I jumped out of the car and ran into the terminal and scanned the departure board for flights to Berlin. I then heard this squeaky high voice calling, "Monsieur Leeanch, Monsieur Leeanch." This petit French woman in high heels and Air France uniform came running across the terminal toward me.
"Quickly, you must follow me. Vite, Vite!"

I ran down the gate wing of the airport following her carrying my road case and bag of tickets in each hand. As we got close to the end, Israeli soldiers were at a boarding gate and raised their automatic weapons at me.

"Non, Non!", the little Air France lady yelled in her clicking high heels, as we ran by and I was holding both hands up with bags running behind her. She got me to the gate handed me a ticket and I went down the gate tube to the plane.

I walked in to first class on the Air France flight in front of the plane. Not only had I made the flight, highly improbable logistically, but also, the entire band was sitting in front of me in first class smiling and broke into applause. The flight had sold out, so the band got bumped up to first class seats. Soldiers were protecting the gate next to us because of an El Al flight. Since the massacre in Munich four years before at the Olympics[lxix] all El Al flights were guarded by Israeli soldiers in the boarding area and surrounding the plane on the tarmac. I expected kudos from Herbie for my extraordinary recovery from disaster. Instead he turned to Bennie and said, "Ain't that chantin' great!".
I responded, "I'll take whatever help I can get".

On the way to the airport in Berlin we had little extra time. I asked the bus driver to stop at a few significant sites. We stopped at the closest point between the border of East and West Germany, separated by a narrow river. You could see the eyes of the soldier in the machine gun tower on the other shore. On the West German side were plaques dedicated to those, who didn't make it across. Before this the "Cold War" was an abstraction to me, but now standing at the point where the line had been drawn, I was very moved.

CHAPTER 23

BACK IN THE USA

Generally, things went smoothly, but sometimes there were issues collecting the remainder of the fee at the venue. We had a show in St. Louis with a promoter we had not worked with in the past. I attempted to advance the gig by phone, which meant either at the hotel or pay phones. The bus didn't have a phone and there were no cell phones at the time. Faxing, the next big thing, wasn't the typical procedure in regard to communication with promoters before a show.

When I arrived instead of the food in the dressing room indicated in the contract rider, there was a six-foot long submarine sandwich. He tried to 'promote' the sandwich, but I didn't go for it. Something smelled fishy other than the sandwich. I told him that we had to get paid before the band played on stage. He had made the fifty percent deposit with the agent. The promoter was a tall black Muslim complete with bow tie and Nation of Islam assistants dressed in the same manner. I spoke to the stage hand shop steward. He said he hadn't been paid yet and hesitated to work his crew. The show was sold out and the promoter didn't have all the money. The time to play got closer to perform and still no payment had been made.

I went down to the lobby and told a uniformed cop that the promoter didn't have the money and we wouldn't play. If we refused to play to a sold out house, there would be a riot. I suggested he contact the precinct Captain to get some re-enforcements. Shortly thereafter, a Caucasian man six feet two in his fifties wearing a grey fedora and a long brown over coat arrived. He looked like a 1940's movie shamus. It wasn't the precinct Captain; it turned out to be the Commander of the Watch. Apparently, "riot" was the correct word to get attention.

He appeared very relaxed. We met with the stage hand shop steward and settled on putting a cop and our representative in the box office to collect the receipts, as they were paid. We performed and we eventually got the rest of the payment. The Watch Commander, grateful at the end

of the night, thanked me for avoiding a riot of twenty-five hundred predominately black patrons from tearing down a theater. He gave me his card and said, if we were in St. Louis again, don't hesitate to use it. We shook hands and he drove off in his black unmarked Ford.

Getting paid before we played was my top priority. Once we were in Houston playing with Gil Scott-Heron[lxx], a poet, jazz musician and a progenitor of rap music. Also, famous for *"The Revolution Will Not Be Televised"* among others, a spoken word poem with congas and bongos backing him. Artistically, this was an extension of the beat poets reading with jazz backgrounds of the fifties. I came back from the settlement with the club owner and Herbie and Gil were in the dressing room. The owner tried to add some of the advertising costs and other expenses in to the settlement, which weren't our responsibility. I didn't go for it and had a bad feeling about him.
I asked Gil, "Have you been paid?"
He looked me with intense eyes and said, "No…why?"
"I don't trust this promoter. He tried some bullshit on me.", I replied.
His countenance changed and he smirked, "If this motherfucker doesn't pay me, I'll burn the motherfucker's place down."
No doubt he was a serious man and he meant it. He did have a unique method of resolving a payment dispute.

We were leaving Atlanta one night after a gig about 1 AM in a large mobile home we had rented for a portion of the tour. I had sent Herbie and Wah Wah ahead by plane to the next market to do radio and press in advance of the next gig, but the band was travelling on the surface. We were at a point on the highway where you decide to go south or southwest. A clunk sound was heard and "Robbie Roadie", our driver, said something went wrong. It turned out the rear axle broke and he had to pull over. Robbie tried to get assistance on the CB radio in the RV, but we were still in the Atlanta city limits. We couldn't get a response due to too much radio interference from buildings. He kept trying, however, because we were stranded on the side of the highway at 1:30 in the morning. A small silver compact car pulled up on the frontage road next to the highway separated by a chain link fence. An older man got out and he explained that he lived nearby and had picked up

Robbie's signal on his shortwave radio set. He said he didn't sleep much and liked to stay up at night listening to the shortwave. He was our guardian angel. He went back to his house called a tow truck and a cab company for transporting the band to the hotel.

About 3:00 am we checked in to the nearest Hilton. On night duty were two, for want of a better description, "rednecks". The smaller guy had a faded blue Levi jacket with a rebel battle flag patch and the taller of the two asked, "Can I help, y'all?", when I walked in. I explained that we our RV had broken down and I needed six rooms for about five hours until our plane left from the airport in the morning.

His attitude changed, when he saw the four black band members a bit worse for wear after playing a gig and Robbie the hippy ponytailed white driver. The hotel was barely full and built in a quadrangle around a large pool and patio. We were assigned the most remote rooms in the hotel at the far back. The racism was obvious and still unfortunately prevalent in the South at the time. I'm sure the "rednecks" had a good laugh sending the "niggers" to the back of the bus. Unfortunately, it really pissed off some of the band members and they reacted by trashing their rooms before they left playing into a different stereotype.

On the plane to the next gig in Houston I reflected on an experience I had while looking for a job in Berkeley in the new "War On Poverty" program. The office staff was all black. After filling out my application form I waited for my turn to be interviewed. As I sat for over two hours waiting, I noticed several black job seekers, who had arrived after me, kept being called into interviews before me. It was quite obvious what was happening. I had expected that a group that had been discriminated against would be helpful to anyone, who was poor, an artifact of my naiveté. On the other had I also understood especially in the South that equality did not exist. For me discrimination isn't about the color of skin. It's about those in power exploiting those who are not. In the South I was often called a "white nigga" traveling with a band of black musicians. I felt I was in good company, however, when Benny Goodman was accused of the same thing in the South being the first to play with an integrated band Carnegie Hall in 1938.

CHAPTER 24

JUKES

When I stopped working for Herbie, David approached me about a new project. He was very successful at the time producing records for major stars, such as, Carlos Santana, Patti LaBelle, Phoebe Snow, etc. He wanted to set up a company that restored old juke boxes from the forties. I had no experience in this highly specialized area, but the challenge appealed to me.

David Rubinson & Friends occupied the second floor of a two story building that we took over from Francis Ford Coppola, when he moved out. David had produced the soundtrack album for the movie *"Apocalypse Now"* and they were friends. The management and publishing offices were located on the second floor. The first floor was the former Columbia Records recording studio in San Francisco. We had taken it over, technically updated it and called it The Automatt, a reference to the new recording technology of automating mixing boards that the new consoles had and to the old New York City cafeteria, which insisted on the second "T". The first floor contained a reception area, three recording studios, offices and a show room, in which, we would display restored jukeboxes.

We specialized in the period of the first illuminated jukes boxes from 1938 to 1948. They played 78 rpm ten inch records. I rented a warehouse on Howard Street a few blocks from our building. I hired guys from the San Francisco Art Institute. I thought artists would have a higher bar of excellence in the restoration process and I considered these jukeboxes works of American folk art. Finding the machines, which were forty years old, became the first of several hurdles to overcome. Joel Selvin[lxxi], a friend and head music critic for the San Francisco Chronicle, told me there was a guy in the San Francisco Mission district, a coin machine operator, named "Jukebox Jerry" that had eight old machines. Jerry was portly with disheveled hair and dressed in mismatched work clothes with some oil stains on his pants. I went into his dusty, cluttered, dimly fluorescent lit shop. He had a lot

jukeboxes of various vintages. He had eight old Wurlitzers in the back and we attempted to close the deal. They were covered in dust and obviously required full restorations. As I tried to close the deal, he kept wavering on the price. This turned out to be a common occurrence with collectors. They always overvalued what they had. They never take into consideration the cost of restoration, which was labor intensive, as well as, costly in regard to reproduction parts. I had to come back two times, but finally I closed the deal and had them delivered to the warehouse. The machines had to be disassembled and all the components had to be addressed. It required several different skills for the cosmetic and mechanical restorations. I divided the work among a crew of five. The most difficult skill that had to be recreated in the restoration process was "graining", painting metal to look like wood, a lost art. I found the last person in San Francisco that knew the technique and had him to teach it to one of my guys. At the time there were only two other companies doing the same work *Victory Glass* in the Midwest and Tom Cantella's *Antique Jukebox Company* in Los Angeles. Tom had recreated and distributed many of the replacement parts needed for restoration. Tom and I developed a long term friendship. He was a straight shooter and always kept his word.

In order to find jukeboxes, I often had to travel. On a road trip stop in Plano, Texas I met with Wallace McPeak. I would describe Wallace as round in face and stature; balding with red complexion and a smile underlined with double chins. We hit it off. He was a typical Texan a blend of a little boisterousness and southern charm. I had learned from touring the USA with bands that to be effective you had to adapt your behavior and style depending on where you were geographically in the states. For example, in New York you had to be aggressive because that garnered respect. If you tried the same attitude in Atlanta, you would be arrested. There politeness, civility and affectation of southern charm worked more effectively.

Wallace dealt in Wurlitzer band organs and carousels primarily. Band organs are the instruments that a merry-go-round revolves around and produces the accompanying sound. He had a few juke boxes which I purchased, as well as, an antique table. He had two four by six foot

tables with elaborate carved tops that rested on four carved gryphons. One was a dark wood natural finish and the other matte black. I liked the black one, but he was reluctant to sell it to me and said it wasn't quite right. I insisted and bought it because I knew someone who would love it. Zohn Artman, the San Francisco promoter Bill Graham's, *Charge d'affairs*, not only a powerful leader in the San Francisco gay community, but also an avid collector of gryphons in all shapes and sizes. When I stripped the paint from the table it revealed one or the eight wings as plaster. We located a wood turning shop to reproduce the missing wing and it came out perfectly. Zohn loved the finished piece. Wallace was an honest man and I respected that he had my interest at heart cautioning me on my choice.

Another time I had a lead to follow up outside of Fairfax, Virginia. When I called from the road for directions, Jim Wells, the dealer, said I wouldn't have any problem finding his place because there was a big dog in his front yard. His place was in a rural area in horse country. Reading the numbers on the mailboxes as I got closer, I saw he was correct. No Saint Bernard, Mastiff or Newfoundlander in the yard, instead the RCA dog "Nipper" on an enormous scale. Eighteen feet tall and originally installed on top of the RCA building in Baltimore in the 1950's. The RCA company discontinued use of the icon, Jim Wells, who was responsible for bringing the carousel to the National Mall in Washington, D.C., purchased the statue and placed it in the front yard of his home at 8731 Lee Highway in Merrifield, Virginia. He bought the statue for the price of one dollar.[lxxii] He told me that he had to move it very carefully early in the morning at dawn with an enormous crane. His purchase of "Nipper" created controversy. People in Baltimore were trying to register it as a historical building to preserve it. It had been iconic to the Baltimore skyline.

Jim six foot four and in good shape was a former Tennessee State Trooper and he looked the part. He had a pencil mustache and polite manner. He had a large spread with rolling hills, a large home and several out buildings. I went into the one of the barns to inspect the jukeboxes. I opened the door and the motherlode unfolded before me. There were over thirty Wurlitzer model 1015's in various conditions.

Usually, we picked up a few boxes at a time, but this was an incredible stash. I inspected the boxes and most were completely intact complete with coin mechanisms. We made the deal and I took all of them. He asked about the company in California and I explained that it belonged to a record producer and I just ran the restoration company.

"You mean that you won't benefit from the deal?", he asked

I replied, "No, not directly, but it is going to be a lot of work."

"Tell you what. I really like you. Pick one of them speakers on the wall over there for yourself."

"Are you sure?"

"Absolutely, pick anyone you want."

I chose one of the 1946 extension speakers that were released with the Wurlitzer Model 1015, "the bubbler". I chose the plain "Drum" model because it has a flaw in the stencil painting on the outside that appealed to me. I also liked the idea it debuted in the year of my birth. I called the coast and told the crew to head east with the truck.

We had a reputation for the quality of the work we did and had a lot of show business customers. We sold machines to a lot of musicians, such as, Carlos Santana, Maurice White and Neil Young. We restored Francis Ford Coppola's Wurlitzer 1015 and he requested it be filled with Italian opera to accompany him, while cooking in the kitchen. I would deliver to VIP clients personally. The 1015 was delivered to the Inglenook Estate[lxxiii] to the Niebaum mansion in Napa Valley. He had purchased the estate of 1,560 acres with profits from *"The Godfather"*[lxxiv] *films*. The degree of detail in the interior design of the home was exquisite. Gustav Niebaum was a sailor and you could see the influence in the carved wooden ceilings and etched glass doors. We installed model 1015 in the massive kitchen and it worked perfectly. Francis was a happy singing chef.

Sometimes people would want a jukebox restored but wanted to leave certain elements unrestored. Every jukebox had its own story. Marsha Lucas wanted a Wurlitzer 1015 restored. She had purchased it with, George, her husband, when they were effectively broke. They went into an antique shop and fell in love with it on sight. At the time they had mortgaged their house, borrowed from friends and family to make

"American Graffiti". It hadn't been released and they had no discretionary cash. But they decided screw it and they put it on plastic and took it home. Upon completing the appraisal of the juke, I indicated we had to replace the grill cloth for the speaker that was currently covered in a drape fabric instead of gold lame. She declined indicating it reminded her of the antique store experience. She was nostalgic despite the fact that she and George were divorced by then. Marsha Lucas, an awarding winning film editor in her own right, worked on films like *"American Graffiti"*[lxxv], *"Taxi Driver"*[lxxvi] and *"Star Wars"*[lxxvii] among others.

The jukebox showroom in the Automatt studio attracted a lot of attention from the artists recording. Herbie Hancock both mischievous and experimental one time turned on all thirteen machines in the showroom on at the same time. He loved the cacophony, but it pissed David off. David had to resist going ballistic because they were in the middle of a break in a recording session. Another time Carlos Santana was standing next to a machine playing *"You Send Me"* by Sam Cooke with his right hand on the illuminated red plastic.
He mumbled something.
"What did you say Carlos?"
"It's a love thing."
"A love thing?", I asked.
"Yeah, a love thing. You stand here with your girl listening to the song with your arm around her. It's a love thing."
"Right, I got it. It's a love thing."

There were two times when I was able to play an old seventy-eight on one of the jukeboxes in the showroom for which an Automatt client had a connection. The results were unexpected. The first was Jerry Wexler[lxxviii], one of the founders of Atlantic Records. I played *"Shake, Rattle and Roll"* by Big Joe Turner, one of Jerry's early produced records. He had a sad look, as he listened. At the end he said he had regrets. "I shouldn't have cleaned up the way Big Joe sang and just let him just be himself." When Roy Orbison[lxxix] came in to record *"Pretty Woman"*, his standard, for a soap commercial, I took him into the showroom and played *"Obby Dooby"*, his first record, on the original

173

Sun seventy-eight label. He wore a black suit and white shirt with string tie. His black rimmed dark glasses stood out, which were incredibly thick. I didn't know, if he was partially blind. Roy happened to be standing in front of the most dazzling jukebox of the era, a Wurlitzer 850 "Peacock". A question flashed through my mind. *Can Roy see the jukebox?* In silence he listened and said nothing at the end for some time. Finally, he spoke. "I never liked this song. Sam Phillips was looking for another Elvis. That wasn't me. I'm a balladeer, more like Marty Robbins." I thought it would be a really cool experience for both of them and they would get a kick out of it. I never expected the songs would trigger regrets in both of them. This is not that uncommon with artists, however. After they do a work, from their point of view, they often feel that their execution could be improved. There was a man arrested at the New York Metropolitan Museum of Art for altering a displayed painting on the wall with his own brush and paints. It turned out he was the artist.

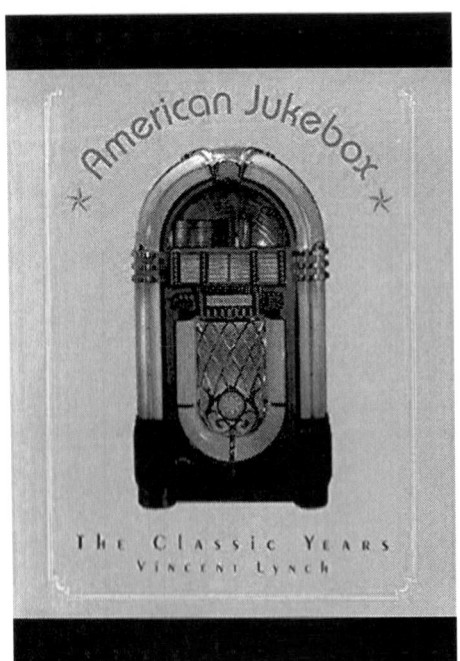

I realized we were working with a diminishing resource. Fewer boxes were available, as time went on, due to values increasing with inflation. I decided I wanted to encapsulate my experience some way. I felt these were beautiful works of American folk art and we should do a book. I approach Joel Selvin, the San Francisco Chronicle critic, and asked if he wanted to write it and I would take care of the art work aspect. He told me I was nuts and refused. I persisted by myself and eventually released several iterations with various publishers. *"Jukebox: The Golden Age"* with Lancaster Miller, Perigee Books and Thames &

Hudson in London and "*American Jukebox 1938*-1948" with Chronicle Books. Totally, we sold over ninety thousand copies.

CHAPTER 25

OH WHAT A NIGHT

D avid asked me to come over to the office to discuss something he wanted me to supervise. He was involved doing a proposal to become the head of Pioneer, the Japanese electronics company, in America. They had just created the laser disk, the state of the art at the time for content delivery and thought to be the next big thing in electronics. Completely absorbed in the process, he told me Willie Brown Jr.,[lxxx] then the Speaker of the House of the State of California, reached out to him and called in a favor. As the Speaker of the House in California, he ruled as the state's most powerful politician more powerful than even the governor. All legislation had to pass through him in this heavily Democratic state. In the past David and an association of record producers and film makers in California were in a dispute with the state's Board of Equalization. The state was attempting to tax all the stages of production to make an artwork versus taxing only the finished product, as the current law stated. It would have had tremendous negative financial impact on the entertainment industry in California, which, as a state, had at the time the thirteenth largest economy in the world. Today with the addition of Silicone Valley it is fifth, larger than the UK. Willie was instrumental in lobbying the Board for a favorable ruling for the artist's side. He called David because he needed help with an event for the Democratic National Convention being held in San Francisco in 1984. He decided to throw a party to end all parties. "The greatest convention party ever held". The event even had a title, *"Oh, What a Night"*.[lxxxi]

In Pier 45 at Fisherman's Wharf, a space of over 50,000 square feet in each pier building, Wendy Linka, Willie's assistant, and a crew had created replicas of sites in the city. There were four performance stages in each section of the pier. Willie, a great promoter had been hawking the party all week during the convention. Jimmy Carter wanted 100 tickets and Willie gave him ten. It became the hottest ticket in town. We had heard the publicity and assumed Bill Graham was doing the show. When we checked to see, if we could get some tickets, he said he wasn't

176

Willie Brown Jr.

involved. Still feuding with Willie Brown over some issue, Bill had declined to help. David told me that Willie called him and said that at five days before the event they hadn't booked any talent yet and he needed help. Jammed with the Pioneer proposal, David told me he wanted me to do it. He said I could use the company employees to help. David and I went over to Pier 45 and did a walk through. He introduced me to the Speaker and Willie responded, "So this is your nuts and bolts guy". We shook hands and walked the pier to inspect it. The displays were artistically lovely, but not suited to having 10,000 people trapesing through in various altered states. We had them remove dirt and some of the other problematic materials. We had to book four hours of talent on eight stages in five days. This sounded like the beginning of a disaster. Willie returned to his office and David went home to work on the Pioneer offer. Below is an excerpt from the New York Times:

A Party With 10,000 Guests
But any of tonight's parties would have had to go far to be as extravagant as Monday's "Oh What a Night!" at Pier 45, near Fisherman's Wharf. That attracted 10,000 party-goers, and an equal number who stood outside behind barricades hoping to get a glimpse of celebrities. The only ones they saw were professional look-alikes of Michael Jackson, Marilyn Monroe, Clark Gable and President and Nancy Reagan. The real Senator Kennedy, the real Jimmy and Rosalynn

177

Carter and San Francisco's real Mayor, Dianne Feinstein, were
whisked by in limousines.
The party was the inspiration of Willie L. Brown Jr., Speaker of the
California Assembly, who persuaded more than 60 donors to supply
food, beverages, entertainment and decor. And oh what decor it was.
Stage sets and backdrops representing local landmarks were arrayed
through two huge buildings, allowing visitors to walk across an 80- foot
Golden Gate Bridge, saunter through the Japanese Tea Garden,
Chinatown and North Beach and relax on benches beneath Coit Tower.
They could also line up for boneless chicken, cole slaw, salami
sandwiches, pasta with pesto or chocolate cake - all served on paper
plates. And the rock bands blared. It wasn't exactly the most elegant
party of the week, just the biggest.[lxxxii]

To compound the logistical issues, the city was overrun with people for the convention. In fact, a candidate, Jesse Jackson couldn't find any office space in San Francisco for staff. David found this offensive and racist. He decided to provide temporary offices for Jesse Jackson's campaign in our building. As it turned out, they ended up with the most convenient offices due to our proximity to the convention floor at the Moscone Center half a block away.

I assembled a team of five people including myself, Michelle Zarin, the studio manager at The Automatt, Don Miley and John Geraldo, who did national dance promotion and Beverley Summerfield, in charge of NARAS, National Association of Recording Artists, in San Francisco. NARAS was the entity that issued gold records and produced the Grammys. We set up offices on the second floor facing Folsom Street.

We not only had to book the acts, but we also had to co-ordinate all the logistics to get the talent to the venue, which had extreme security requirements due to the attendees. I had to coordinate with various police agencies. Earl Saunders, my liaison with the San Francisco Police, went on to become San Francisco Chief of Police. He coordinated with the other agencies. We had a board with different types of colored pins that indicated the affiliation of the officer. Every state politician had their own security, as well as, the secret service and

the FBI. Since they were all in plain clothes, the only way to distinguish them were there pins. The Secret Service had the simplest pin a gold cross about half an inch wide with a colored dot in the center. There were four levels of rank depending on color, a red dot the highest.

Earl informed me that Willie had told him to give us whatever we needed to pull off the show because we were in the eleventh hour. At one point I had to get Peter Wolf, who was producing a recording session in Los Angeles, to the pier at 8 PM to play with the Jefferson Starship in San Francisco. Time was really tight on the flights from Los Angeles. I asked Earl, if we could get a motorcycle escort to the pier. He shook his head and said, "I don't think so." Shocked that he refused and I asked why. He responded, "I prefer that we pick him up on the tarmac and bracket the limo with four patrol cars. It'll be faster and safer." I laughed and gave him a high five.

We worked non-stop for four days, a mammoth task, with one "all-nighter"; all done without support from any drugs other than Peet's French Roast coffee. Michelle did a great job booking acts, but we had to also create individual itineraries for each act depending on where they originated. Each act had a schedule comprised of sound check and performance times, tickets, back stage passes and the most important, parking passes. Everything had to be on paper picked up by hand or faxed. I had a copy made of each piece we generated and at the end we had over a thousand sheets two reams high. There were no cell phones or internet. We were exhausted going into the show.

On the day of the show the pier was patrolled by police dogs all day inspecting equipment cases and the structure of the pier. They had Navy scuba divers patrolling below the pier and a submarine on watch. We also decided to allow people only access from the East side of the pier to control traffic. The west side was closed to the public to allow security, VIP's or the fire department immediate access. Even the Harbor Police were involved keeping a group of people on kayaks protesting something…a common occurrence in the Bay Area. They were kept at a three-hundred-foot perimeter from the pier.

There were four stages in each of the two pier buildings. They each had a theme, such as, a comedy club, a rock stage, country and western stage, the R&B stage, for example, was called "Minnie's Can Do Club", in honor of the historical blues club in the Fillmore district of San Francisco. All the artists performed pro bono, as well as, the technical crews. We recruited crews from the individual clubs in the city to manage the individual stages to keep everything running on time. All the volunteers were enthusiastic at being involved in the party for the convention. Most of them were Democrats. We ended up with thirty-eight acts performing on eight stages over the four hours. Given the sheer number of the performers it was impossible to have a back stage area for everyone. We devised a system of shadows. We had access to a lot of volunteers because everyone wanted to get in to the party. Each artist was assigned a shadow that would follow the artist around the party. The escort would know what time the artist had to be in the pre-stage area to be on time to perform his or her segment of the night. After the artist performed the escort was free to join the party. This method also allowed the performers to circulate and enjoy the party themselves, when off stage. There were too many artists to enumerate. A few were Robin Williams and Whoopee Goldberg on the comedy stage, New Riders of the Purple Sage on the country, Santana, Jerry Garcia and the Merle Saunders Band and the Jefferson Starship on the rock stage.

At the load-in for band equipment there were police dogs to inspect the road cases for explosives and everything seemed to be going well until I got a call on the walkie-talkie, a problem had come up in the parking area. We had created maps of the area to distribute to police officers, so they would know where the parking was for the performer's and politician's limos, as well as, equipment trucks. I was informed on the walkie-talkie that the trucks were arriving, but they weren't being allowed to park in the designated area. I went down to the parking area and spoke with the Captain of the North Beach Precinct. He told me he wouldn't allow vehicles to park there under any circumstances. I told him that the area had been pre-approved by the police at headquarters on Bryant Street. He said he didn't care. I wasn't making any head way in my argument. I left and found a phone in the pier and called Earl Saunders and asked him if could hook me up with the Watch

Commander to resolve the situation. Earl said he would take care of it and I went back down to the lot to resume discussions with the Captain. He was a tall Irishman about six foot five with white hair wearing his blues. I asked him to contact the Watch Commander. He retreated to a police car nearby and got on the radio. He came back with his face reddened and pissed off. I had gone over his head. Through gritted teeth he said, "The Watch Commander approved it. You can park the cars there." I thanked him and returned to the pier.

David arrived the day of the show and tried to take over direction. We had a big argument on the topic of who was in charge. I told him we had worked our asses off and had ownership through our hard work. We had figured everything out without his help other than providing space and the people to execute the task. I felt he usurped our efforts. When the show began, I wasn't sure my argument worked because he was trying to direct all the stage starts from the pre-stage area by walkie-talkie. He was driving the individual stage managers nuts with directions. I went around and told them to forget about what he said on the walkie-talkie and I would come around to tell them, when to start their shows in person and to ignore David. When the performance began, they should inform him on the walkie-talkie. They all embraced the new method happily. I was on the golf cart with Willie and he insisted on introducing all thirty-eight acts himself. No shows would begin until Willie arrived regardless of our schedule.

For staging we planned that there would be two stages in use in each of the two areas of the pier at all times. This allowed for set changes, when stages had finished performing. An incident occurred before the Jefferson Starship performance. I had assigned Michael Coats, a friend and PR person we worked with at the company and also Jerry Margolis, a well-known Los Angeles entertainment attorney to escort Willie to make sure he made each introduction on time to the various stages. We used the empty west side of the pier to ferry him in a golf cart to the applicable iron door entrance closest to the next performance stage.

We pulled up to the entrance where Willie had to enter the pier building with Michael Coats and Jerry Margolis in tow. There were two men in

suits blocking the door. I told them we had to pass and they refused. I explained this was the host of the party Willie Brown Jr., the Speaker of the California House. They said it didn't matter they were Secret Service and securing the door for former President Carter arriving shortly with his wife Rosalyn, son Chip and Steven Stills, the recording artist. There were only the six of us standing there on a moonless night with no other activity on the west side of the pier.

"Use your common sense there's no one else here, but us. The Speaker has to introduce the performers.", I said. "We have our orders.", he responded. At this point Jerry lost his temper. He was half Italian and half Jewish, six feet four and a type "A" personality. Even though, a prominent LA entertainment attorney, Phil Ryan had told me that he had two road rage incidents in Los Angeles that required court ordered anger management therapy. He took a swing at the agent at the door and dropped him. As the agent went down, the wind blew open his jacket and his submachine gun spilled out of his Velcro tear away holster and skidded across the blacktop. The other agent drew on Jerry. At that moment the Carter limo with his secret service detail pulled up. Carter's agents came over and we explained. They let the Speaker go in first and Jerry never apologized. Jimmy Carter and his entourage entered, as Willie introduced the Jefferson Starship.

In the first section of the pier, all the acts ran on time and the other section ran five minutes behind schedule. The event was a tremendous success. At the end David, a wine connoisseur, had promised champagne for all. He broke out two bottles and passed out cups. He didn't anticipate the staff had ballooned from the original five to more than ten times that amount. Two magnums would have been more appropriate given the number of people. We had a shot of champagne and congratulated each other.

When you are involved with an event of this intensity, in a sense there is no experience of duration of time...only moments. When the show began, we were rushing to introduce the next performance, stopping to resolve issues at stages and communicating with the back stage area. The four hours that passed seemed like one. When over, I left in one of the comp limos completely drained with my wife Dawn and Russell.

The adrenalin was wearing off. I collapsed in the back seat with eyes closed smiling to myself, as we drove home to Berkeley over the Bay Bridge. The five of us had pulled off a complete success of what was thought to be impossible to execute in five days.

CHAPTER 26

KUNG FU DIPLOMACY

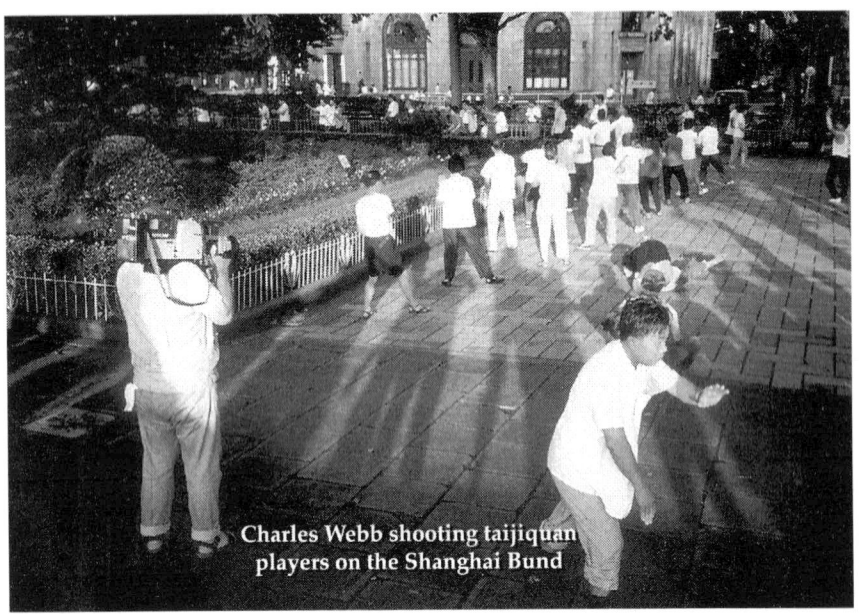

Charles Webb shooting taijiquan
players on the Shanghai Bund

S ally Larson, one of my kung fu sisters, informed me that a new instructor had an outdoor class at Spreckel's Lake in Golden Gate Park. We had both studied Yang taijiquan with Master Choy Kam Man. San Francisco is home to the largest Chinatown in the USA. It is composed of Chinese from Mainland China, Taiwan and Hong Kong, three distinct groups that rarely interacted. As a result, they were an extraordinary group of martial art teachers, who in the tradition of China, taught in parks and public spaces. There were more by far of any other city in the USA. Golden Gate Park, a favorite venue on weekends, resembled the parks in China filled with practitioners.

At the park Sally introduced me to Master Xu Guo Ming a.k.a. George Xu. A Han Chinese about five foot ten in his mid-thirties teaching three martial art styles: Chen Taijiquan, Hsin-I Chuan and Larn Sou Chuan. I had interest in the differences of various taijiquan styles. Chen is the

original taijiquan from which my style of Yang taijiquan was developed. Unfortunately, he was returning to China in a week. I told him I'd like to study with him, when he came back. I also pitched him on a concept I had for a film because of the combination of him being a resident of Shanghai, as well as, a writer for a Chinese martial arts magazine. I wanted to do a film of the most famous martial art masters of Shanghai entitled, *"The Masters of Shanghai"*. I asked if he would be interested in getting involved. He liked the idea and said, when he went back to China, he would do research and interview masters. I couldn't have asked for a better response.

Master Xu Guo Ming
aka
Master George Xu

I began studying with Master Xu at Spreckels Lake in Golden Gate Park, when he returned from Shanghai in the Fall. The students were impressed with his dedication to teaching. Master Choy, my first taiji teacher, would teach a one hour taiji class per week and have a Saturday monthly meeting open to all current and former students. Master Xu's weekend classes lasted three to four hours. The time was roughly broken up into three sections addressing the three unique martial art systems. Chen taijiquan focuses on internal spiraling, joint locking and redirecting the opponent's attack. Hsin-I Chuan (Heart and Intention fist) is an internal system like taiji, which is based on animal forms, but only has attacks and no defensive movements. Larn Sou Chuan is a northern Shaolin system with long extended movements featuring parrying, punching and kicking. We practiced Larn Sou Chuan the most strenuous last. Master Xu would walk around while my

thighs would burn as we held positions in the form giving individual corrections. Sometimes Master Xu would look at us shake his head and say, "Horrible". This group of practitioners had all studied on an average of ten years each in the martial arts with other teachers. None were beginners. His standards were extremely high. He would say, "I am high school preparing you for college in China." He would arrange for students to study with masters in Shanghai, when he thought they were ready. Master Xu would also teach at the lake on Mondays and Fridays mornings and Tuesday and Thursday evenings near the SF Aquarium.

The thing that makes Master Xu unique is that he holds nothing back in teaching and challenges you to try to imitate him. However, the problem was that he developed his skills at a far greater speed than his students. It was frustrating because as we developed a skill, such as "counterweight", he would already have moved on to the next focus. Traditionally, many Chinese teachers refused to teach non-Chinese. A prime example of this mind set was Wong Jack Man[lxxxiii] in Oakland, California, who had an issue with Bruce Lee when he started teaching Caucasians. He had a famous private fight in San Francisco with Bruce Lee over this issue. One of my kung fu brothers, Michael Dorgan, one of Master Xu's students, had studied with Wong Jack Man and said he never would show techniques and considered his study with him a complete waste of his time.

I had composition skills from painting and had received a national award for nature photography, but I had never made a film and had some trepidation. Charles Webb, a friend and filmmaker, arranged through a contact for me to meet with Albert Maysles, the famous documentary filmmaker. Albert was charming and supportive. I told him I had reservations about the niche focus of the film and if it would even have an audience. He said I should go for it. He told me his first documentary film, "*Psychiatry in Russia*",[lxxxiv] was about psychiatry in a Russian mental institution and they had to take a lot of shots surreptitiously hiding cameras in bags. I thought to myself that his topic would definitely have a niche audience.

He also told me a story about a young filmmaker he advised that had a cost effective creative solution to the high cost of 35mm film stock. He would take the roll ends and splice them together. A "roll end" is when some unexposed film is left on the end of a film roll because there wasn't enough film stock to cover the next shot. He said the filmmaker used those pieces spliced together and 16mm film stock to make his first film, *Who's Knocking On My Door ?,*[lxxxv] which took years to make…given the procedure. The filmmaker's name was Martin Scorsese. Albert had convinced me.

Many years later I was with head of our local high school's video department. I was on the technology committee for the school district and we were going to a new equipment demo in the "Black Rock", the CBS building in Manhattan. The elevator doors opened and there were two people on the elevator Martin Scorsese and another man. The doors closed and the elevator ascended. I couldn't resist. I gave him the quick version of the Maysles's story and he confirmed it. I explained why we were there. He was very supportive of the teacher's efforts in exposing high school students to video production and gracious as he advised us on his recommendations in regard to equipment.

Over the summer Brendon Lai, a national martial art supply distributer in San Francisco, was contacted by the Chinese Consul in San Francisco. An event, the First International Wushu Championships, would be held in Xian, China and asked, if there would be interest in sending an American demonstration team. Martial art in China is called wushu or "war art". An American competition team had already signed up to compete in the first Olympics of martial arts. Mr. Lai seized the idea and agreed to organize a team. When George Xu came back from China, we decided to combine the research he had done and do a documentary film of the trip. I intended to make a *"From Mao to Mozart"*[lxxxvi] of martial arts, cultural exchange through a common interest.

When we arrived at San Francisco airport with luggage and eighteen road cases, we had our first hurdle. I went to the counter and the attendant, a six foot four Samoan was extremely courteous, but he said

187

we couldn't ship the equipment as luggage. It had to go as air freight, which would be quite expensive. In my naiveté I hadn't budgeted air freight for the film. In the past I had always been able, as a road manager, to save the artist expenses by avoiding freight charges domestically, but this was an international flight and rules were more rigid. I explained we were in a group on a martial art exchange tour to China. He inquired further with some enthusiasm. It turned out he practiced Kajukenbo and Al Dascascos, our co-captain, happened to be his kung fu brother in the same style. Al was the creator of Wun Hop Kuen Do, a sub-division of the Kajukenbo system. He finally allowed the gear to pass as luggage and we avoided a financial disaster at the outset. It seemed to be a good omen.

In August of 1985, a representative group of American martial artists were invited to the Peoples Republic of China by the Beijing Wushu Team in an effort to promote cultural exchange through the martial arts. We traveled to Beijing, Shanghai, Xian, and the Shaolin temple in Honan Province, the original birth place of the martial arts. Members performed their skills for our hosts and also were able to observe demonstrations by the greatest masters living in China. The team was led by captain, Professor Wally Jay and co-captain Master Al Dacascos. American team member's disciplines demonstrated covered Karate, Jujitsu, Hun Gar Kung Fu, Brazilian Capoeria and Korean Tae Kwon Do. We were fortunate enough to have the unique combination of circumstances that came together at a specific point in time. Brendon Lai focused on the formation of the American team contacting martial artists of different disciplines to assemble a team that was representative from the aspects of age, sex, race, type of martial art discipline, and skill level. George Xu arranged the masters on the Chinese side in advance of the trip with whom we would interact. Their intent was to organize a group that contained some of the most famous martial artists in the United States, as well as, average black belt instructors, who would participate in a cultural exchange, people to people, with the most famous martial artists of China. Without these three primary elements: the invitation of the Beijing Wu Shu Team; Brendon Lai's American contacts, and George Xu's access to the most famous martial artists of China, it is unlikely that the film would've been created. In addition to

188

the dialog established with these famous masters, we were able to observe the positive health benefits of martial arts that permeate the Chinese people as a whole. We also had the rare honor to exchange and perform with the monks of the Shaolin Temple. We were the first foreign film group to film the famous Shaolin Training Hall, where monks have practiced for over 1000 years.

China in 1985 had just begun to become open to foreigners. Only parts of China were open and there were areas where foreigners were forbidden to travel. Because the country was extremely sensitive to the way it was depicted internationally, there were strict controls on access. At this time China represented twenty-five percent of the world's population. People dressed simply and some still wore Mao style jackets. The government fed, clothed and housed a billion people, an extraordinary feat from my point of view. The streets were clean, and the infrastructure well maintained. There were no beggars or homeless in sight. Prior to going to China, I expected a Communist police state, as often described in the West with officers omnipresent, but I experienced something entirely different. The rule of law in China was enforced in a different subtle manner. In a certain sense all citizens were policemen. For example, if you were sitting on a park bench with a local and left your camera behind by mistake, it would be in the same place when you came back a few hours later. If the local was there and a thief tried to steal the camera, she would stop him and tell him it wasn't his and to leave. If she did not, she would be viewed as complicit in the crime for not stopping him because stealing was *"a crime against the people"*. For the offense of not reporting the crime the penalty would be to be sentenced to a "re-education camp". There are also fifty-three offences in China that carried the death penalty even some for white collar crime. They took any violation of the law quite seriously.

In Beijing we did a cultural exchange demonstration with the Beijing Wushu team, the premier team of China. Wushu is the state sponsored martial art based on traditional martial art systems. Our team members demonstrated alternating with the Beijing team. In addition to Wushu team members, several traditional martial art masters also demonstrated their skills. From Beijing we went to the Great Wall an extraordinary

feat of engineering undulating over mountains as far as the eye could see. When we were on the wall, Captain Wally Jay got very emotional discussing what the trip to China meant to him personally. For him standing on the Great Wall became the fulfillment of a lifelong dream.

In the next stop, Shanghai, I had pre-arranged the master's demonstrations over a three-day period. We arrived around 10 PM and were scheduled to shoot the next day. I couldn't sleep, reviewing everything we had to do the next day. I kept waiting for sunrise, but it never came. As I looked out from the Peace Hotel and the Bund below, the sky over the Huang Po river was darkened with clouds and raining heavily. The shooting venues were public parks and I hadn't scheduled any rain days for shooting. We had to scramble to find a useable location. We loaded up the masters and the team on a bus and started the drive to a location that Master George Xu had arranged for the demo at an indoor track and field house. I told George, as we were driving, that it was stupid of me not to plan for bad weather.
I said, "I never thought it might rain. I didn't book any extra days"
He replied, "Good thing not typhoon."
George always had a talent for seeing the bright side. Many times we were in difficult situations and his response would often be, "Not as bad as the Cultural Revolution." The shoot went well and as always we concluded with a ten course meal at a restaurant for the masters and the distribution of gifts. The food in the various restaurants we visited in China had little resemblance to American Chinese restaurants. They usually focused on their regional specialties. Sometimes there would be culinary cultural clashes. In Shanghai eels were a specialty swimming in oil. As Americans we have been conditioned to avoid oil for health issues and we were a bit put off. They explained oil was precious and when Chinese went out to dinner liberal amounts of oil was expected due to it being a special occasion.

The crew consisted of a cameraman/co-director, Charles Webb and a sound/tech engineer, Kurt Lundvall. We used a professional Sony Betacam camera set up similar to a news crew. There were only two Sony dealerships in Beijing and Guangzhou, as a result, we had to bring not only the tape stock, camera, and sound and lighting equipment, but

also, a complete set of repair equipment. We had two double rooms, one for Charles and me, and one for Kurt and eighteen road cases of equipment. Kurt, the head of the AV department at the San Francisco Art Institute, could repair anything. The next two days the weather cleared, and we could conclude shooting in the parks.

The biggest cultural exchange event in Shanghai was with the Shanghai Ching Wu Association, the first martial arts academy founded in China in 1909. Ching Wu members and our team both did demonstrations. Twelve contemporary wushu and eleven traditional styles were demonstrated by men, women, and children, whose ages ranged from eight to eighty-one. Some of the wushu forms demonstrated were double knives, long fist, broad sword, double edged sword, and two person sets. Traditional forms, such as, nine section whip, Eagle Claw, the Lost Track system, the Black Tiger form, and the Drunken style double edged sword form were also performed. The American team demonstrated Small Circle Jujitsu, Japanese Karate, Tae Kwon Do, karate tournament sparring, Filipino Escrima fighting sticks, Brazilian Capoiera and the kung fu styles of Northern Praying Mantis, Hung Gar, Larn Sou Chuan, and Wun Hop Kuen Do.

When we first walked into the Peace Hotel, an Art Deco time warp not only architecturally, but also in content, I heard American big band music wafting out from down the hall. I approached the source of the sound and viewed a scene of Chinese couples in western clothes dressed to the nines. They were ballroom dancing to Duke Ellington's *"A Train"*. For a moment I was in the 1940's except all the people were Chinese not Caucasian.

We had one shot I had to get before leaving Shanghai. The two Peace Hotels built in the 1920's faced the Huang Po River above the Bund, the park area contiguous to the river. The river was a constant flowing highway of commerce with ships of all sizes and in the morning at dawn people would exercise on the Bund next to the river. I wanted to shoot the Bund at dawn from the hotel top floor to catch the people practicing taijquan. It became an issue because the top floors of the hotel hadn't been renovated and obviously no public access was permitted. We

approached the elevator operator at the hotel. Charlie, our translator and a friend of George's from Shanghai, explained that we wanted to go to the top floor, but the elevator operator wasn't going for it. We negotiated and for four packs of American cigarettes he agreed to allow myself, Charlie, Charles and Kurt to go up to the top floor the next morning.

Originally, the government wanted to assign me their official translator, but I knew they would filter everything. I thanked them, but explained I couldn't accept. I told them Charlie had specific skills in regard to film equipment technology and the process of film making, therefore, he would be more effective instructing the additional Chinese crew members we had added as roadies. Pure balderdash, but the Chinese took my point and agreed. There were times, when angry or frustrated, however, Charlie refused to translate exactly what I said. He just would turn his head to me sheepishly and say in an English accent, "I kaan't say that to 'im." It was cute because he translated Chinese to English with a UK accent being taught the Queen's English in Hong Kong. I made a deal with Charlie. In return for doing all the translation on the trip, I would attempt to help him come to the USA. We were eventually successful and today he lives in Calistoga, California.

The top floor was in shambles falling apart, but you could see from the remnants that at one time it looked like an upscale fancy night club. We found a window facing the Bund that had the correct view, but there was a two-foot alcove space from the wall to window due to construction of the top floor. We had to hold Charles's legs so he could extend out the window with the camera. In August Shanghai is very humid in the mornings. We were all set at dawn to shoot the practitioners. When Charles turned the camera on, it didn't work and red LED lights came on. Too much moisture in the camera from the air caused the camera to automatically shut down. Kurt realized immediately the source of the problem. We cautioned him before we departed to be prepared for anything. He went to his gear box and pulled out a hand hair dryer. He said we had to open the camera and dry out the electronic circuit boards. We looked for an outlet to plug the dryer into. There were several different standards of electricity in China.

Meanwhile the sun was rising and we were losing our shot. We ran around frantically looking for a live connection. Finally, we found a receptacle, which worked with one of Kurt's adaptors. We dried out the camera with the hair blower, reinserted Charles in the window holding his legs and he got the shot before the practitioners dispersed for work.

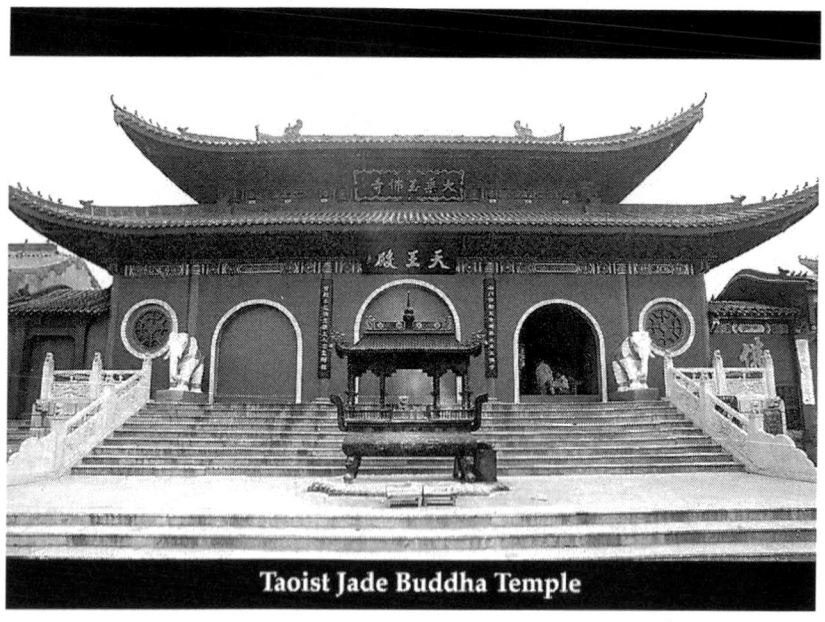

Taoist Jade Buddha Temple

In the course of the trip we met over a hundred masters of various disciplines and styles. I had one personal experience that had a profound effect upon me. It happened while we were having the "required" ten course meal at the Jade Buddha Temple[lxxxvii] in Shanghai. A feature of the temple is its namesake, a large Buddha made out of a single piece of jade imported from Burma. We were told during the Cultural Revolution the Red Guard came to destroy the temple, the policy at the time in China. The people in the neighborhood formed a human chain around the temple and prevented the Red Guard from dismantling it. The restaurant at the temple was a bit different, in that, the cuisine was vegetarian. Other than the obvious vegetables on the accompanying dishes it mimicked a traditional ten course Chinese banquet. The dishes looked and tasted like meat or fish, but were tofu.

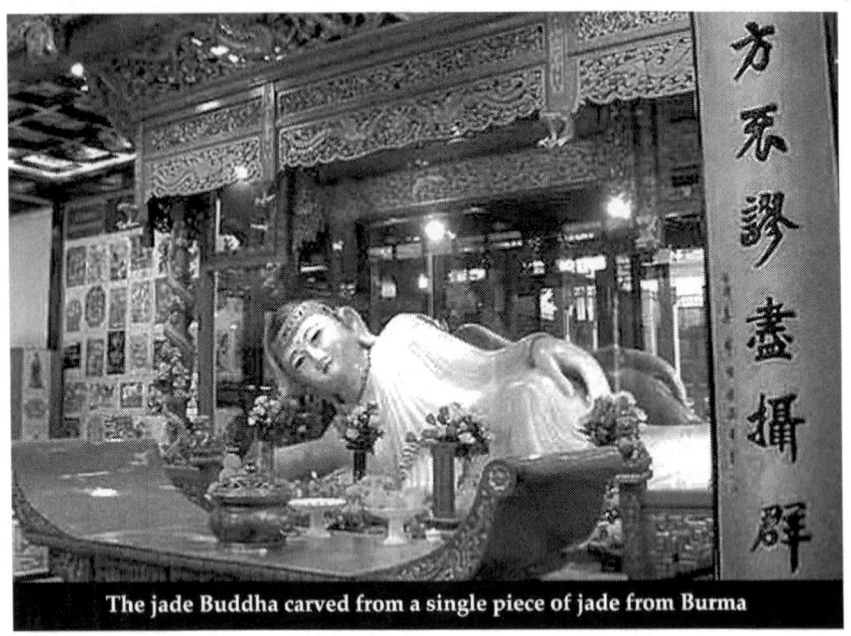
The jade Buddha carved from a single piece of jade from Burma

I sat next to Grandmaster Ma Yueh-liang[lxxxviii], a famous Manchu taijiquan master, who was the senior disciple of Wu Chien-ch'uan, the founder of Wu style taijiquan, and married Wu's daughter, Wu Ying-hua, in 1930. He was also a medical doctor graduating from the Beijing Medical College in 1929 specializing in Hematology and educated both in the traditions of Traditional Chinese Medicine, as well as, Western medicine. He asked me to extend my arm. It was summer and I had on a polo shirt with the skin of my arm exposed. He took his arm palm down and moved his hand twelve inches above my arm between the wrist and elbow. I felt warmth on my skin projecting from his palm. He did the same movement below my arm at the same distance and it felt cool. Blown away, I asked what he did. He explained he sent his qi from the center of his palm, the Lao Gung point, to my arm. When he did the movement below, he withdrew his qi. This physical experience changed the way I viewed qi. Always written about in the Chinese

Grandmaster Ma Yue Liang and his wife

classics, this experience removed it from the realm of the theoretical to an actual physical sensation. As a result of decades of practice, he could project his qi. To me it was inspirational and has fed an enthusiasm to explore this energy to this day.

Ma Yueh-liang had a warm friendly personality. Of the five Grandmasters of taijiquan that we interacted with in Shanghai, he was by far the most interesting and engaging. The other extreme was Grandmaster Fu Zhongwen[lxxxix], the leader of the Yang style of taijiquan that I practice. I was really looking forward to meeting the head of my taijiquan system. He turned out to be aloof and arrogant. At one point in the conversation he said, "Of Yang taijiquan there is no one who knows more." This was most likely an accurate statement, but it didn't fit the model of how a grandmaster should behave in my opinion.

CHAPTER 27

XIAN

We left Shanghai and traveled to Xian in the center of China, home to the tomb of the first emperor and his terra cotta soldiers, as well as, the beginning of the silk road. The First International Wushu Championships were being held in the Xian stadium. The city seemed to have a permanent layer of smog, but it actually was very fine dust composed of the yellow earth from the soil in the region. In the mornings I would have the crew up at dawn to catch people in the parks doing a variety of exercises. By late morning it would be over and the parks would fill with mothers with carriages and some seniors walking their birds. The men, who were smoking long pipes with small metal bowls, brought their caged birds into the park and set the cage on a rock or a bench. The pet birds would learn new songs from the wild birds in the trees above. This increased the bird's repertoire, when it returned to the home. On some mornings we would run into masters from Beijing we had met that were practicing for their performances later in the week, as well as, other small groups of locals exercising. The extra crew we hired in China disproved the myth of hard working Chinese. They were quite lazy and self-absorbed. They were the product of the one child per family Chinese policy. Each raised, as a spoiled little emperor being an only child, reflected in their work ethic. We would wear them out working from six in the morning to eight at night. They lacked endurance and had trouble keeping up with their American counterparts.

When we were in Shanghai, Master Xu had taken me with him to The People's Liberation Army Hotel to meet a qigong master. These hotels were spread throughout China available to veterans at reduced rates that had served in the Army. The hotel architecturally utilitarian had a raw concrete exterior and an interior painted in institutional green. Unfortunately, the master was sick with a cold, so we arranged to meet him in Xian later in the week.

The City of Xian is a walled city with four gates in the cardinal directions. The top of the wall is much wider than the Great Wall. We decided this would be a good demonstration venue. We met the qigong master and his entourage of other masters and their students. The qigong master demonstrated issuing qi from his index finger and Wally Jay, founder of the Small Circle Jujitsu system, could feel the effect on his arm at a distance of twelve inches. Muslim masters demonstrated a form of Hsin-I only taught to those of their own faith. Additionally, a form I had never seen called the "Turtle" style, which involved a lot of back falls on the stone surface and performed in an extremely low stance. At times the head and body movements did emulate a turtle. It's the oddest kung fu style I have ever seen or probably will ever see again.

A beggar, not in either of our groups, was watching us. He came over and claimed he was also a master of the "Beggar" style of kung fu. A character straight out of a Shaw Brothers Hong Kong "chop-socky" movie wearing a floppy red knit wool cap on top of tangled snow white hair, which streamed over his shoulders, a picture completed with a wispy white beard that matched the length of his hair and mischievous glint in his eye. He wore an old khaki army coat and loose fitting pants He exuded the mischievous spirit of a Kokopelli[xc] or a Loki[xci]. On the top of the wall, where we were, a woman vendor sold an over sweet orange drink ubiquitous in China. She had a simple three piece worn wooden stool on which she sat. The beggar master decided he had to prove his metal as a master to the others present. He picked up the stool next to the wall took off his red cap and proceeded to break the wooden stool over his head. The woman vendor turned and saw what he had done. She went ballistic screaming at the beggar and I assume cursing in Chinese. She picked up a piece of the stool and started chasing him with it. Both of our groups thought this spontaneous demonstration hilarious. When the angry woman returned, we explained he wasn't with our group. Unfortunately, this did little to assuage her or restore her stool. I gave her some renminbi to replace the stool. It seemed to be an appropriate production expense since we filmed it. Her mood changed and we departed with a smile from her and "xiexie".

After the demonstration we went to the restaurant with the masters to have lunch. Out of the side of my eye I saw the uninvited beggar eating from the buffet. I figured why not, his persistence should be rewarded. I have no idea how he found the restaurant or got there. We had to go by a jitney to the restaurant located several miles away from the top of wall. When the beggar finished raiding the buffet, he curled up on a couch in the lobby to take a nap. Eventually, the staff approached him and they escorted him out of the hotel. I had to respect the beggar for his nerve.

At our table we had the qigong master and Professor Wally Jay, a member of the Black Belt Hall of Fame, as well as, the Captain of our team. Halfway through the lunch the qigong master asked Wally to hit him on the crown of his head. Wally perplexed and confused didn't know what to do. The master encouraged him and Wally tapped him on the head. The master indicated that Wally must hit him harder. Wally hit his head again. The master's pate was bald and he had slick jet black hair combed back on the sides. The qigong master hit his head two more times himself with his fist. He then spontaneously reached across the table and took one of the empty large liter Chinese beer bottles by the neck and struck it against his head. It bounced back. He hit his head a second time and it broke over his head sending the larger part of the bottle flying across the restaurant, which wasn't appreciated by the restaurant staff. When finished, his wife sitting next to him removed small shards of glass from his scalp. He took his hand and rubbed it over the area where the glass had caused bleeding. He removed his hand, the blood was removed and bleeding ceased. He demonstrated the power of qi to resist impact to prevent injury, as well as, having the ability to heal. It was quite dramatic and took all at the table by surprise, as well as, the restaurant staff.

In the northwest corner inside the wall of Xian is a museum called the Stele Forest or Beilin Museum, a former Confucian temple. There are over 3,000 steles, carved stones of calligraphy and images dating back to the late nine hundreds. Charlie, our translator, stopped at one of the steles and said, "That's it. That's the one. This is where it came from."

Forest of Steles
Xian, China

We asked him what he meant. He said, when he was a little boy, he would sit with his grandfather on the step outside his house and his grandfather would teach him calligraphy. The original they used as an example to copy, as the ultimate rendition of the character, was here carved in the stone before him. Moved, he became silent and teared up.

In Xian we were staying at the All Chinese Sports Hotel. There were teams from all over the world. The electric energy in the hotel was one of brotherhood of martial arts regardless of styles or language spoken, a feeling of camaraderie attending the Olympics of martial arts. One day I came down the stairs and the Shōrin-ryū karate team from Macao was practicing in the lobby. Okinawan Shōrin-ryū is translated in English as "Shaolin School" and is based on the Chinese Shaolin martial arts. Their techniques had great speed and execution. There were so many marital artists in town it overwhelmed the normal available practice areas in the city. I arranged for our team to practice at the regional acrobatic school, a boarding school for the entire province. Children that showed promise in local schools were sent there to study to become professional performers. Some children were as young as eight or nine.

The Xian City People's Stadium holds 18,000 people. The teams were ferried to the stadium by jitneys from the hotel. When we arrived, we beheld a sight I'll never forget. The stadium was surrounded by eighteen thousand parked bicycles and not one car. My first thought…how could you possibly find you own bike? They were all the same standard issue government bicycles. Private cars were very rare in China in 1985 and usually reserved for high government officials.

When I got back to the hotel, I received some shocking news. I was informed that a Chinese production company from Los Angeles had contracted the exclusive rights to film the First International Wushu Championships inside the stadium and we wouldn't be allowed to film. I had a meeting with the other producer and he refused to allow us to just shoot our team's performances. I explained I had the exclusive rights to our team's performance and we could reciprocate given his contract regarding the venue. He still refused. This was one of the most important parts of the documentary and the reason U.S.M.A.R.T. (United States Martial Arts Representative Team) was invited to perform in the first place essential to include it in the film.

We brain stormed and came up with a solution. We surrounded the central performance stage with photographers equipped with motorized 35mm still cameras. We wound up with thousands of slides from all angles for the post-production editing process. We needed thousands of pictures because a fifteen-minute sequence would require twenty-seven hundred slides. There are under 30 frames of video per second. By using three slides per second, motion can be simulated. It turnout to be a nice staccato sequence with dramatic music in the final result in the film.

We made friends with the rival producer's director, Harry, who was an "ABC", American born Chinese. He lived in San Francisco and knew a lot of the same people in the filmmaking scene. He was in a spot with several mismatched cameras. We had Kurt, our tech wizard, try to correct the wide color variations of the multiple cameras he was directing. We did this out of the spirit of supporting a fellow filmmaker so he could "get the shot" in spite of the refusal his boss to allow us to film. Harry was an American kid, who didn't speak Chinese. He had a

small hand held micro-cassette player on which he recorded a journal of his observations of China. Periodically, he would stop, cuff the recorder to his mouth and speak into his hand. This freaked out the Chinese. They approached him to ask questions and he couldn't respond, which made him all the more mysterious or suspicious depending on the point of view. In 1985 a micro cassette was the state of the art and rarely, if ever, seen in China. Our translated told us later they thought he was the secret police.

CHAPTER 28

SHAOLIN TEMPLE

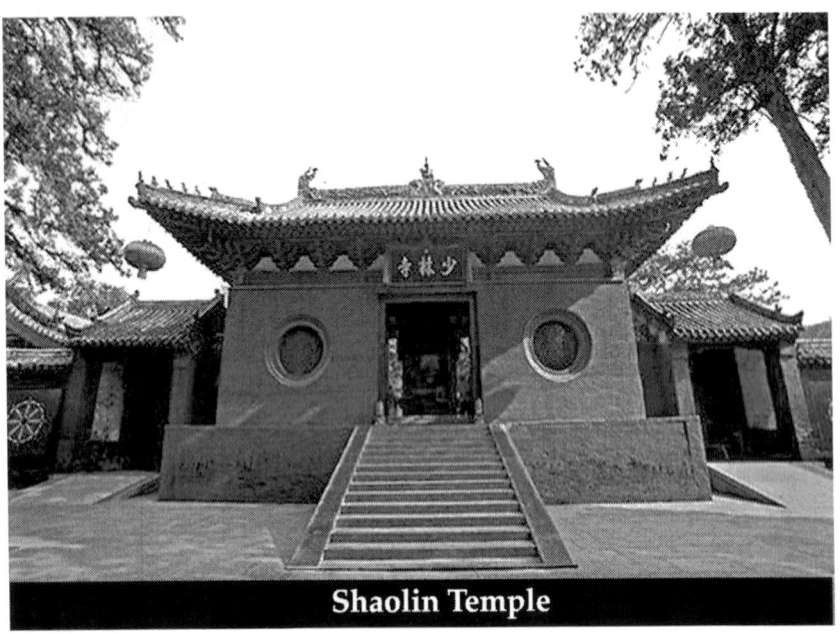

Shaolin Temple

W e had arranged to visit the Shaolin Temple after Xian. Wally Jay, our Captain, felt the seven-hour bus trip too long given his health and Brendon Lai, a major US distributor of Martial Art supplies, had left to negotiate a deal at a traditional Chinese weapons factory for his business. Al Dacascos, our co-captain, took over the leadership of the team with Bill Owens of Oakland, California his training partner. Al, Grand Champion of North America in 1969 and 1970 and Rocky Mountain Grand Champion 1971 and 1972, was also the founder of a branch of the Kajukenbo system, Wun Hop Kuen Do. Bill Owens during his own years of competition won 107 trophies, rated fifth in the World and number one in Region 1 USA for three consecutive years. When our team demonstrated they would perform tournament sport point Karate, Escrima fighting sticks from the Philippines and Capoeira from Brazil. The Chinese audiences loved them.

The long bus trip through rural China passed through areas that were technically forbidden to foreigners. At the time only certain designated areas in China were open to tourists. We felt fortunate to be able view larger parts of the country. We were in area of the "yellow earth", the mythical cradle of the Chinese civilization. The pit stops to relieve oneself became the most negative aspect of the journey. Public bathrooms on the highway smelled horrendous not a place to linger. Most of the Chinese wore face masks. I'll spare you further description. Suffice it to say that I had never seen anything more gross or odiferous in all of my world travels.

We had a lunch stop at a local village on the way in the rural area and all the vegetables were extremely fresh, the original "farm to table". We toured the kitchen and observed food prepared as it always had been for centuries in China. Large woks that sat on ceramic chambers, with wood fuel fed in from below for the fire. When they removed the woks from the stands, flames would shoot up dramatically. After lunch we strolled through the village. One of the team members, Marion, a Karate teacher from Oklahoma City, created quite a sensation, but not for her martial art skill. She had the skill level of a community karate instructor. She wasn't famous like many of the other team members. The team had been constructed to be representative of a true sampling of USA martial artists at all skill levels, sex, race, and styles. She did have something unique that no other member had, however, strawberry blond hair. The Chinese in the village went nuts. The kids were surrounding her and all wanted to touch her hair. They had never seen a woman in their lives that had hair of this color. The whole village waved, as we departed on the bus. She got a rock star reception and felt overwhelmed. We finally got to the hotel near the temple around dinner time...completely exhausted.

The next morning, I had the crew up before dawn to go to the temple. I wanted to be there at sunrise. When we arrived, there was a lone monk with a straw broom sweeping up leaves in front of the entrance. As we drove in we saw an incredible sight. Below the temple was a large school. In the field next to it all of the students were doing morning

203

exercises in large rectangular groups. The ages ranged from kindergarten through high school. They weren't doing calisthenics. They were practicing Shaolin martial art forms. There were over fifteen hundred students. The lower grades were so cute to watch, as they tried to mimic the teacher's movements leading their classes. When we were finishing the establishing shot of the temple, a group of students ran past the front of the temple running several miles after their form training. This all occurred at the break of dawn.

Master Xu Guo Ming (George Xu), my teacher, had arranged through his relationships to meet with the monks. His Hsin-I teacher in Shanghai knew one of the resident Masters at the temple. As Bethlehem is to Christians and Mecca is to Muslims, the Shaolin Temple is seen, by practitioners, as the birth place of martial arts. Since I had studied the martial arts of Tae Kwon Do, jujitsu, kung fu and taijiquan, I always hoped to visit the Shaolin temple one day and it became a strong motivation for me to attempt the film in the first place. My perception of the Shaolin Temple[xcii] came from its depiction in traditional Chinese literature, as well as, Hollywood. I thought I would find something, when I finally got to the temple. This is where the Bodhidharma[xciii] meditated for nine years facing a wall. This was home of Chan Buddhism, which became Zen in Japan. I did a set of taijiquan in one of the courtyards after we took the first shot. I had been practicing for over ten years. A monk sitting in a door way watching ate his morning gruel at six in the morning well after his morning meditation at four. When I finished the form, I realized something. I realized what I sought at the monastery wasn't there physically. It was inside of me, an ironic satori albeit harmonious. I had to travel all the way to the China to find an answer within me all the time.

George arranged for a private meeting with the Abbot, the senior monk translator and our team. We met in one of the assembly halls and were served tea and cakes. They recounted the fascinating history of the temple of it being destroyed and rebuilt over its history, which began in the late fifth century. I figured I'd go for it and asked, if they were interested in doing a cultural exchange demonstration with the American team. They agreed and we set up the spontaneous

demonstration. The temple is set up in a series of courtyards with steps, as you ascended the slope of Mount Song, one of China's sacred mountains and site of the temple.

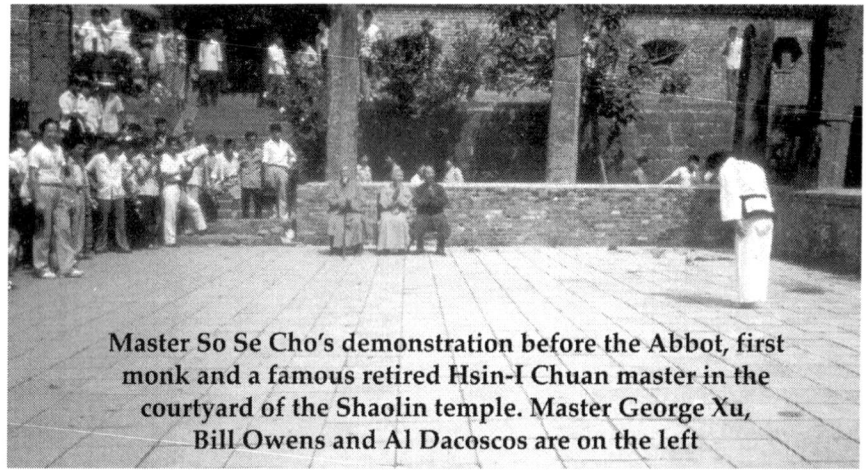

Master So Se Cho's demonstration before the Abbot, first monk and a famous retired Hsin-I Chuan master in the courtyard of the Shaolin temple. Master George Xu, Bill Owens and Al Dacoscos are on the left

Immediately, we attracted a crowd from the tourists visiting the temple. We alternated performances between the monks and team members. The demo went off great. One of the team members, Master So Se Cho, a Korean Taekwondo high degree black belt master, demonstrated katas (forms) and breaking techniques. He owned Macho, a well-known supplier of martial art sports equipment. People thought the name of the company came from the word "macho" or tough, but it didn't. The name was formed from combining his wife's name "Ma", a spiritual teacher, with his name Cho". He lived in Florida at the time, but before he lived in Turkey and awarded the title of the *"Father of Taekwondo"* of Turkey. The government had given him the honor of his image on a commemorative postage stamp demonstrating a flying kick. He decided he'd demonstrate breaking techniques. The bricks the monks chose were gray not typical red bricks. It turned out that they were triple kilned bricks, which meant they were much harder and dense then red bricks because they were fired in a kiln three times not once. The monks decided to really test Master Cho's skill. I thought this was a bit of mischief or perhaps poor sportsmanship on their part. Master Cho and I discussed it and decided he should do it and if he didn't break them, I wouldn't include it in the film. He first broke two bricks, the equivalent

of six, with a hand chop easily. He then broke two more with a flying foot kick. The Chinese audience roared in cheers and even the monks applauded. The tourists, who chose that day to visit the temple, got an incredible show for free that would never be repeated.

After the demo I asked if we could see the cave that Bodhidharma had meditated facing the wall for nine years. There was a legend that he left a shadow on the rock. Being too sacred a site, they refused. As a compromise, however, they allowed us to view the famous Shaolin training hall. The hall had a blue cobble stone floor surrounded by red lacquer racks of traditional Chinese weapons. The walls were covered in a faded mural depicting the history of the temple. The floor positions where the monks would train were slightly concave from centuries of use. Most of the team members had consumer video cameras to personally record their trip. When we entered the training hall, all the cameras died. Their batteries went dead and the cameras stopped recording. Our professional Betacam camera indicated the battery was dead also, but the tape kept rolling. I told Charles to keep filming and we'd keep our fingers crossed. It turned out we got the shot. Apparently, the spirits allowed us to record. An unavoidable sense of age and presence permeated the training hall. Everyone there felt it. The draining of the batteries confirmed it.

We were the first western crew to film the training hall. In 1985 the temple, closer to its original state, hadn't been commercialized. Unfortunately, today it is like Disneyland with shows rivaling Universal Studios in Hollywood. Still high on the adrenalin rush from the experience, we returned on the bus to Xian. We rejoined the rest of the team at the hotel. The time had come to return to Beijing for our departure to the USA and to say goodbye to the Beijing Wushu Team, our host.

We had concern that we might not get the tapes out of China due to their extremely stringent policies at the time to control how the country was depicted on the world stage. The only way to review the material was with a proprietary camera of the same type. Fortunately, all the video content made the flight. On the other end in San Francisco, when Dawn,

my wife, an associate producer, picked up the gear at the airport, there were four portable battery pack belts missing. The Chinese confiscated them and I had to submit a $3,000 insurance claim. We had seventy-five thousand dollars of rental equipment fortunately insured. They looked like ammunition belts, which could be the reason the Chinese seized them.

I decided to stay in China and travel with George and his wife to Jiangxi, a poor province with high unemployment, to visit his brother Gordon (Xu Guo Rong). To travel there I had to get an *Alien Visitors Permit* because this was a remote mountainous area forbidden to foreigners at the time similar to West Virginia in the USA. The primary industries were mining, fireworks production and a bus reconditioning factory. Gordon and George were Shanghai natives, but during the Cultural Revolution[xciv] from 1966 to 1976 China was in turmoil. Educated people from the cities were sent into the rural areas to be "re-educated" by their rural comrades. In 1976, people were allowed to return to their former homes. Gordon had married a local girl during that time period, however, so he wasn't allowed to return to Shanghai. Your rice allotment was tied to the city where you lived. If you left the area, you were on your own for food, as well as, other government support.

In China there was great variation in local food specialties depending on your location: in Manchuria, bear paw, in this area terrapin arm pit, and in the South monkey brain. I was told the Jiangxi cuisine, especially spicy and hot, was intended to introduce more vitamin C in the diet because for two months in the winter, this area produced no vegetables. We visited with Gordon and his wife for a few days. The rooms at the hotel had the old fashion mosquito deterrent spiral coils hanging from the ceiling fans that were used in the USA in the 1940's.

We went to the airport to return to Shanghai. We were using a domestic Chinese airline. Most of these planes were old Russian planes. They had interesting boarding ramps, however, decorated with nineteen fifties American style tail fins with lights. We found out the plane would be delayed for three hours due to a mechanical issue. The plane flew from Shanghai to Nanchang and on to Guangzhou and back again. On the

blistering hot day George's wife became impatient. She went up to the counter to speak with the attendant and found out it would be an additional three hours. She started a heated argument with the attendant at the counter. Apparently at some point from George's cryptic translation, she must have called her the equivalent of a "country bumpkin". People from Shanghai had a sophisticated superior attitude like New Yorkers or Parisians. The attendant started screaming and threw a ball point pen at her. George ushered his wife away from the counter and we waited quietly until the plane came six hours late. Finally, we boarded and were given the air conditioning unit, a paper folding hand fan. About half way through the trip it started to mist and then at three quarters it started to rain inside the plane and the windows fogged up. The air circulation system was apparently running afoul. The hand fans came in handy as umbrellas.

We eventually landed in Shanghai very late at night and there were no cabs because of the six-hour delay. A lone cab came in and we approached from the crowd of passengers waiting and the driver asked which currency we had. We replied FEC and he said he would take us to the city. At that time here were two Chinese currencies, FEC and RNB which stood for Foreign Exchange Currency and Renminbi respectively. RNB was the currency that most Chinese used. With FEC you could shop in special FEC stores to purchase import items or luxury items that were in scarce supply or trade the currencies in the black market. Hence, we were a more attractive fare for the cabbie. The ride to the city was unusual in that there were no street lights on the highway pitch black on a moonless night. On the sides of the road, as we passed by, there were people squatting observing the highway illuminated only by the head lights of the cab. It seemed so odd at this late hour of the night in spite of the heat. We got to George's apartment in central Shanghai and I crashed on his floor and had no trouble falling asleep. I left for San Francisco the next day.

CHAPTER 29

KANTNER BALIN CASADY

Phil Ryan, a well-known San Francisco attorney and law partner of Willie Brown Jr., was the liaison that helped coordinate our group booking "Oh What a Night" and Willie's people, who had constructed the sets, as well as, the San Francisco police. Over the course of the five days of pre-production, we formed a bond. At the time, he represented Paul Kantner, founder of the Jefferson Airplane and Jefferson Starship. Paul had just left the Jefferson Starship and Phil was negotiating the settlement with Bill Thompson, their manager. Paul left the band due to disputes over the group's artistic direction. It was becoming too commercial for him. "I think we would be terrible failures trying to write pop songs all the time. ... The band became more mundane and not quite as challenging and not quite as much of a thing to be proud of", said Kantner in October 1984.[xcv]

Paul Kantner sought legal action over money he claimed he was owed and also to prevent the remaining members from continuing to use the name "Jefferson Starship". The lawsuit was settled in March 1985. Kantner received a cash settlement, the name "Jefferson Starship" became the property of Grace Slick and Bill Thompson and they agreed to use only "Starship", deleting Jefferson, in future concerts. Paul needed management and Phil directed the process for interviewing potential managers with Brian Rohan, a San Francisco entertainment lawyer. Phil, impressed with the job we did on the party, wanted me to interview for the gig.

I had been working for several years in many capacities for David Rubinson...until he had a heart attack. The reaction was interesting when the news hit Billboard that David had a heart attack. I received calls from the presidents of all the major record companies: Clive Davis, Walter Yetnikoff, Bruce Lundvall, etc. seeking information. Herb Albert called and expressed his concern in an especially caring way. Dick Asher and Walter Yetnikoff, who were friends, had approached David to become president of Columbia Records at one time, but David

declined. For eight weeks I ran the company and I thought at that time he might give up some equity in the company, when he returned. Instead he handed me a tube of gold Krugerrands and thanked me. The time had come to look into other options. I had learned a great deal from David about the music business both good and bad. He was a good mentor and even taught me how to appreciate wine.

When Herbie Hancock arrived at the office after the news, his first words were "How's David?". I responded and his immediate second question was "What about the tour?". Artists always think of themselves first. The first question was a courtesy. I told him to relax and told him I had already contacted our agent and the tour promotors. "After all, when I worked for you, you said I was one of the best road managers you ever had." He chilled out, but did have concern that David's health might have a negative impact on his career in the future.

I met with Paul, Phil Ryan and Brian Rohan and got the gig. Paul's life was a mess at the time artistically and financially. He had lost the "artistic direction" argument by being voted out of the band he founded, for the first time he was not in a band since high school. His finances were also in bad shape and had to be restructured. Paul was depressed and had lost his artistic identity with a band that he founded. We discussed it and decided that he should contact Marty Balin and Jack Casady in an effort to form a new band. They agreed and Marty proposed including some of the guys in the current group he played with at the time. We started rehearsals at the "Church" in Mill Valley. The "Church" was a former church, which Marty owned and converted into a practice space. Everything went according to plan and we decided the focus would be a show at The Fillmore in San Francisco to debut the band for record companies to land a contract.

The three amigos of KBC were quite different: Paul, driven and assertive, contrasted with Marty's more reserved demeanor and passive aggressive tendencies, while Jack, the most approachable from an outsiders point of view, was charming and jocular, who usually went along with the general consensus. I thought our original drummer, Barry Lowenthal, played well, but Marty freaked out after the gig at the

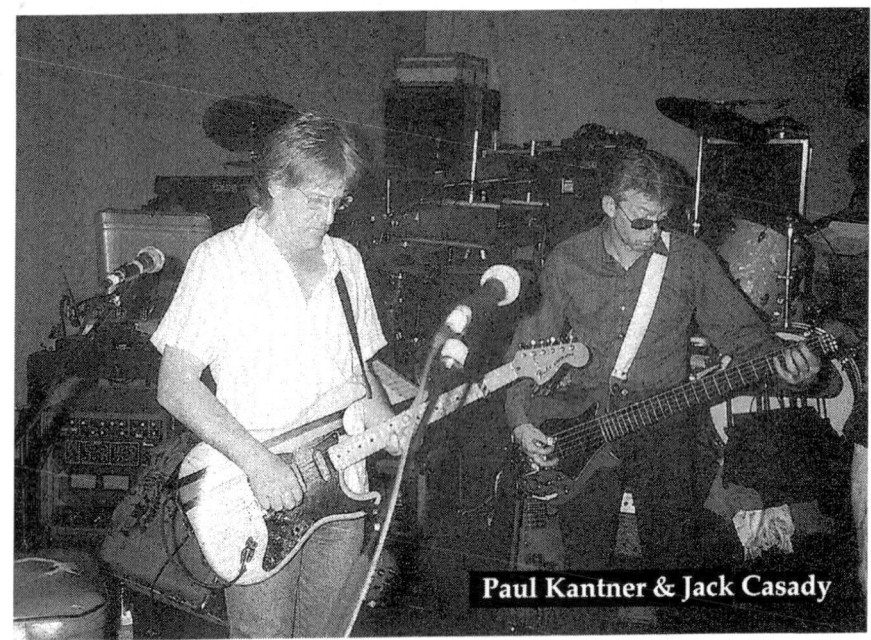

Paul Kantner & Jack Casady

Fillmore and thought Barry wasn't cutting it. The tape didn't reflect Marty's view, but he wanted him fired anyway. It surprised me that Jack, as the bass player connected to the drums, seemed so ambivalent and silent through the process. Often, as a manager, you don't agree with the artist's decision, but you have to go along with the client anyway. It's one of the more unpleasant aspects of the job. When we were auditioning a new drummer, I invited Tony Williams to a rehearsal. Aside from his reputation as famous jazz drummer, he composed music and played several instruments. I thought he could be an interesting influence in the band. Jack didn't click with him, however, I felt he was intimidated. After band discussions, Marty chose a competent rock drummer instead, Darrell Verdusco.

Marty, the opposite of Paul, practiced yoga and consumed health food, while Kantner abhorred exercise and loved steaks and high cholesterol cuisine. Marty, autistic as a child, overcame it with the help of his father. The running joke was there was only one letter difference between "autistic" and "artistic" and only two letters apart. I don't know, if it

211

was an effect of the autism, but he always felt distant and seemed to resent the need for a manager albeit his solo career was stalled at the time and he was unable to secure a record contract. Marty, a changeable Aquarius, would often have very strong opinions on issues that seemed to be set in stone only to reverse himself a few days later. Bill Thompson, the Airplane's manager, once told me not to worry because usually two days later he'd change his mind. He was right.

Paul had a crystal clear vision of the band's direction artistically, a combination of his rock anthem writing and Marty's sensitive ballad compositions. I loved Marty's early work like the song "Today". I remember we were doing a free concert in Golden Gate Park and there were thousands of people. You could hear a pin drop when he sang the song. The only sound other than him singing over the PA was the cry of a baby.

Paul and I collaborated well with one another on all the key decisions. He had good organizational skills, as a band leader, albeit at times abrasive. We shared a similar sense of humor. Paul like most artists was arrogant, which at many times became counter-productive, when attempting to achieve our goals. He loved to ask, "Why?", in regard to proposals, as a method of drilling down to the essential motivations of actions. Sometimes I thought he would ask "why" as a stall to have more time to respond. It proved to be an effective technique.

Paul and I decided to pull out all the stops. The Fillmore in San Francisco is my favorite venue in the USA, as well as, Paul's. I had arranged with Brian Rohan our lawyer to have six record companies at the show and we wanted to blow them away. We had a video artist do the projection appropriate to the musical material performed. We had guest cameos with Robin Williams doing a comedy bit, as a preacher, introducing

212

"*Hold Me*", a country and western song. Robin was a client of Phil Ryan's, a fan of the band and a charming local Bay Area boy from Tiburon. Grace Slick sang with Paul on "*Planes*" and we even had a Noh theater dancer accompanying Marty Balin, while he sang the song "*Sayonara*". The concert, a complete audio video overload, hit a home run. The game was afoot. Two of the companies passed and four were interested. It became two eventually and we finally signed with Clive Davis at Arista Records.

Jack and Paul took me out to the Mandarin restaurant in Ghirardelli Square one night to discuss production aspects of an upcoming show. After dinner they said they wanted to check out a new band at a club south of Market Street. We walked into the club, "*DV8*", and there was a cheer. My incredible wife, Dawn, pregnant at the time, had arranged my fortieth birthday surprise party. A true surprise because I had no idea or warning. She transported my museum scale paintings to the club and they hung on the walls. There were about 120 people from all of my three worlds: The San Francisco Art Institute, the music industry and my kung fu brothers and sisters. Dawn had a theme that people had to dress in sixties style and they looked hilarious in their dusted off duds. The music was a combination of Motown and classic psychedelic. It was interesting to view the interaction of the disparate groups. One of my kung fu brothers fell in love with Mimi Chen, a beautiful local radio personality. I had to break his bubble because she was already in a relationship with Chris Issac, a handsome rock star. There were music people like Narada Michael Walden and Randy Jackson. At this time Randy was a sought after session musician, who worked on most of Narada's sessions with Whitney Houston, Aretha Franklin, Gladys Knight, George Benson, etc. It preceded his "American Idol" days and his record executive career.

George Xu, my kung fu teacher attended with my fellow students. They offered him marijuana, which he had never smoked. He took a few puffs, but he said it didn't have an effect. This disappointed his mischievous students. I had a crescent shape canvas of the moon and the surface was very dark, subtle and difficult to create. Wavy Gravy,[xcvi] who helped Dawn set up, decided it too depressing and re-painted it day

glow yellow. I could have killed him. I told him the painting was entitled the *"Darkside of the Moon"*.

214

Wavy replied, "Oh, whoops!".

I just sighed. How can you be mad at a clown that entertains the terminal cancer patients at the UCSF Children's Hospital, co-founder of SEVA and other charitable organizations? It was a memorable night and is a testament to how extraordinary my wife is.

We had negotiated a lucrative contract with Arista Records and Clive Davis was enthusiastically engaged in our success. As a result, in anticipation of the record release, Arista funded a junket for radio Program Managers from all the major USA radio markets. The band would play a live version of the record at Wolfgang's in San Francisco Thursday night, November 20th and there would be a reception afterward at the Sheraton Hotel. Dawn was very pregnant and due around the beginning of the week. Marty started to get nervous and insecure about the coming gig. He told me he thought he couldn't depend on Paul. He wanted me to assure him I would be there. I told him the baby was coming in the beginning of the week and not to worry. Dawn had a few false alarms Monday and Tuesday and went into labor after midnight Wednesday. I thought Meghan would be delivered Wednesday, but sixteen hours later on Wednesday afternoon Dawn was still in labor. We had taken a private Lamaze class and I was doing the massage technique and guiding the breath counting. Exhausting for me, but surely worse for Dawn. Meanwhile I kept in touch by pay phone with the crew at the gig, the record company and Paul.

By 2 PM Thursday Dawn had been in labor 38 hours, dilating very slowly and completely exhausted from the sustained labor. I had to get to the gig and I decided to abandon the natural birth process and introduce Pitocin to aid the dilation. As she began to dilate more quickly, the labor pains intervals increased frequency. It was very difficult for her and she will deny it, but at times gasping between breaths some expletives were directed at me. Finally, at 4:42 after forty hours of labor Meghan arrived. Dawn exhausted but glowing with smiles took Meghan in her arms transformed.

When I saw Meghan in the nursery, her head seemed a bit squished on the side.

I asked the nurse, "Is she going to stay that way?"
She slapped me on the arm and said,
"She's beautiful. You're crazy!"

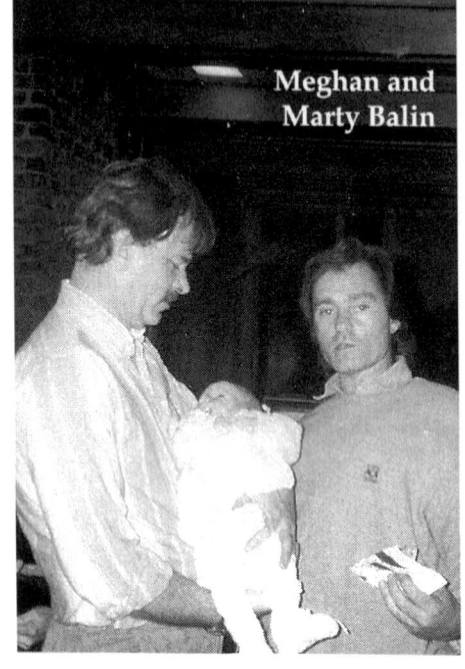

Meghan and
Marty Balin

My clothes were soaked with perspiration and I had to go home to shower and change before going to San Francisco. I kissed Dawn goodbye and told Russell to hold down the fort.

I stood in the hot shower for a long time and lost track of time with a new baby and the critical show on my mind. I was physically exhausted. I summoned my energy, hopped in my red modified Mazda RX-7 and headed over the Bay Bridge to the club, "Wolfgang's", on Columbus Avenue above Fisherman's Wharf. When I got to the club, the band had already finished and the party had moved to the Sheraton. Cynthia Bowman, our publicist was there and lit up when she saw me.

"It's a girl?", she asked.

"Yes and she's very healthy."

"That's fabulous, but you have to go. The party has already started and you have to meet with the national Program Managers and Abby Konowitch from Arista. He wants you to interview three directors with him for the video."

The party was in full swing. It's valuable to have the artists interact with the radio program managers to give them a one to one personal experience. Hopefully, in the future it would give them something to reflect on, when choosing cuts to play. Abby and I met with video directors and made a final decision. The party finished around 2 AM and I have absolutely no memory of driving home over the Bay Bridge

back to Berkeley, but apparently I made it. Dawn at home the next day told me that my brother Dennis, while in San Francisco, had called her in the hospital to congratulate her. I thought it was the mental fog from the pain killers and she dreamed it. It turned out she was correct; he did call from San Francisco being on a brief business trip.

One of the perks of being in the Bay area music scene was not only the shows, but also, the parties afterward. I think the most exclusive was Mick Jagger's fortieth birthday party in a small club, "The Old Waldorf", with a capacity of less than three hundred. Often passes or invitations were counterfeited to gain access to exclusive events. The invitation to Mick's party was a broken piece of mirror with the information etched on the glass. You needed it to get in the door. It was the ticket. *"The Wild Tchoupitoulas"*[xcvii] with help from Aaron Neville did a call and chant set in their style to sort of sanctify the club. Junior Walker and the All Stars[xcviii] performed next, with Mick Jones of Foreigner sitting in on a version of *"Urgent"* Foreigner's current hit single. Junior not only helped produce the record, but also performed an incredible sax solo on the cut.

Sam and Dave[xcix] followed and it turned out it to be the last time they ever performed together. This was small club with great sight lines and you could tell something was odd, in that, they weren't developing eye contact with one another on stage. It seemed to have no effect, however, on their electrifying performance. They seemed to compete trying to top one another. The Stones played next and at various times other musicians joined in. They played mainly rhythm and blues not their greatest hits. Obviously, all the musicians were having a great time jamming, as well as, the audience stoned on a variety of substances. Keith stood out trading solos. Much of it is a bit foggy now, but Mick did come around to each table and thank everyone personally for coming. Robin Williams's quote in regard to the sixties could apply: "If you remember the sixties, you weren't there". It should be noted that this was not the only Mick birthday party. He celebrated it in each city on the Stones tour at various clubs with different talent line ups.

I'd work all day on the music business and if there weren't any recording sessions or gigs, I would edit the footage from China at Charles Webb's editing studio in North Beach till two in the morning. We had to cut a two-hour film from twenty-nine hours of footage, a mammoth task. I arrived at my office on Howard Street near Fifth Street in San Francisco around 10 AM after doing taijiquan in my backyard in Berkeley. I would leave the editing suite around 2 AM and travel back over the Bay Bridge to home. They were long days. We worked on a three quarter tape system with a timecode work print in order to assemble the final edit decision list to create the master from the original Betacam footage. The process went on for months and we finally finished.

The next task was to sell the film. TV had three major national networks and regional networks in secondary or tertiary markets. Normal markets would have five to seven TV stations. I went to annual Film and Video Show in Las Vegas seeking distribution, but they preferred a series not a one off documentary film. One of the distributors pointed out it cost the same amount for a one-page ad for a series as that for a single film. He made a sound point. I came back and we went into the footage and cut out six demonstration films. I then brought over Master Xu's Hsin-I master from Shanghai, Master Yue Hue Long and filmed him in Golden Gate Park In San Francisco. I released eight titles and the "China's Living Treasures" series was born. I didn't realize that once you published media, people expected new titles over time. I never intended to do more than one film, but had to create the series in order to generate capital to return to investors. The series ended up with sixty-two titles.

CHAPTER 30

BUD HOUSER

Bud Howser

My office on the second floor of a two story building faced Howard Street just west of Fifth Street in the south of market area. Blue Bear Recording Studio occupied the first floor, when I moved in and later an electric fixture company. The San Francisco Chronicle newspaper was a half a block down Fifth Street and the M&M bar across the street anchored the corner, a lively place depending on the hour. The M&M was a workingman's bar and a local tradition, filled with reporters such as, Warren Hinkle[c] with eye patch and Bassett hound in hand, and staff workers in day time, and at night with an influx of the printers arriving on their lunch hour around midnight. A dirty, dingy dive on the inside had probably not been repainted since the 1930's, but had the cache to bring in city luminaries

like Mayor Alioto, who use to meet in the basement for private lunches with cronies.

Warren Hinkle

Ed the bartender told us of a film he was attempting to produce on the oldest living gold medalist from the Olympics. He had gotten the rights to the story of Bud Houser.[ci] Since the Olympics were being held the next year, it seemed like a good property. His first choice for interviewer was Jim McKay[cii] of Wide World of Sports fame. Jim was retired, but Ed found out that he was still under contract to ABC and couldn't do it. His second choice was Marty Glickman.[ciii], an American radio announcer, famous for his broadcasts of the New York Knicks basketball games and the football games of the New York Giants and the New York Jets. He also worked at Yonkers Raceway calling the races and was one of the most influential sports announcers of his time.

As a radio announcer he devised a method of calling a live basketball game using terms for the floor positions and is credited with coining the word "swish" for a clean shot. I met him as a child at the raceway because my dad was the Executive Vice-President.

I told Ed I thought I could convince Marty to do it. We flew down to La Costa near San Diego, where he was doing a corporate event, to meet him. He agreed to do the documentary. We set up the time window we'd need and decided the location would be Bud Howser's

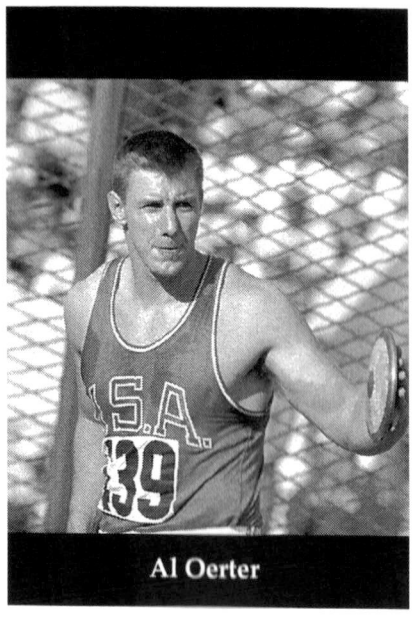
Al Oerter

220

home in southern California. Conceptually, Marty would monitor the conversation between Bud Houser and Al Oerter.[civ] Al Oerter had set world records in the discus and the first American to win four gold medals in consecutive Olympics from 1956 to 1968. This feat wouldn't be repeated until many years later by Carl Lewis and Michael Phelps. Bud Houser had participated in the 1924, *"Chariots of Fire"*,[cv] Olympics and the 1928 Olympics. He was also the flag bearer for the 1928 American team. In 1924 he won the shot put and the discus and in 1928 he repeated in the discus. He was responsible for developing the spinning throw of one and a half turns. Prior to that discus throwers would stand take a few back swings and throw from a relatively static standing position. The weight of the gold medals surprised me. They were much heavier than I anticipated. The shoot went well at the house and after…I noticed Marty handling the seven gold medals on the table in a very pensive way.

Marty Glickman

We had one more shot to finish up with Marty and Bud. I wanted to use the Los Angeles Coliseum for its Olympic history[cvi] and I thought it the perfect venue for two Olympians. I arranged with the grounds crew to shoot on their lunch break and they agreed to remove the lawn mowers. It was a long shot of them walking and sitting in the stands conversing without a single other human in the stadium. It was quite dramatic, but Marty topped it. There were bronze plaques on the walls of the arches of famous historical sports figures at one end of the Coliseum. Marty standing in front of a plaque spit on it. Shocked, I asked why he spit.

The plaque commemorated Dean Cromwell, a famous University of Southern California coach. Marty, an eighteen-year old sprinter from Syracuse University, participated on the USA 1936 Olympic team as a runner in the 400 relay. He was informed after arriving in Berlin that he and Sam Stoller, who was also Jewish, wouldn't be running in the finals. They were replaced by Ralph Metcalf and Jesse Owens, who were black. It was clear given the time trials that the Americans would win the event. That is the true story of how Jesse Owens became the first American to win four gold medals in one Olympiad.

Dean Cromwell

Avery Brundage

Glickman said that Coach Dean Cromwell and Avery Brundage were motivated by antisemitism and the desire to spare Adolph Hitler, the Führer, the embarrassing sight of two American Jews on the winning podium. It was better to have "schwartzers" than Jews on the platform and at the awards ceremony. Adolf Hitler saw the Games as an opportunity to promote his government and ideals of racial supremacy. The official Nazi party paper, the *Völkischer Beobachter*, wrote in the strongest terms that Jews and Black people should not be allowed to participate in the Games.[cvii] However, when threatened with a boycott

of the Games by other nations, Hitler relented and allowed Black people and Jews to participate, and added one token participant to the German team—a German woman, Helene Mayer, who had a Jewish father. At the same time, the Nazi party removed signs stating "Jews not wanted" and similar slogans from the city's main tourist attractions. I couldn't help but think that when Marty was handling the gold medals at Bud's house that he was thinking that he should have had one of his own.

I understood his hatred. As a reward for his service to the Führer, Avery Brundage, Cromwell's co-conspirator, was given the construction contract for the new German Embassy in Washington, D.C. two years later, as well as, the contracts to build two factories in Germany.

CHAPTER 31

KBC END

The KBC Band had toured domestically, as well as, internationally and we were finishing the second album, but Clive Davis, president of Arista wasn't convinced on all the selections. It came down to artistic choices between the record company and the artists. Paul and Marty were at odds as usual and decided to dissolve the band and not complete the contract with Arista. This was a disaster for me financially and professionally. I had invested several years in the project. I had brought Paul back from financial ruin restructuring his finances and artistic oblivion. I felt betrayed by Paul and Marty because they had both been put back in the public eye because of their recording contract with a major label. I never expected any support from Marty, he was generally difficult and ungrateful. Jack never asserted himself and had his own issues with relationships and drugs at the time. Paul, however, really surprised me with his cavalier attitude considering all the work that had gone into the project.

I had to negotiate the cancelling of the contract with Roy Lott, head of business affairs, and it was quite difficult. I informed our agent, Steve Martin, of the decision and we devised a strategy to start to have Paul play some gigs with "*Hot Tuna*"[cviii], Jorma Kaukonen' s and Jack Casady's band. The concept was setting up the foundation to do a "*Jefferson Airplane*" reunion tour. In the end the band chose Los Angeles management and agency representation. A positive aspect of the negative situation was that Steve Martin and I became life-long friends even after my involvement in the music industry. Steve, a rare person in the music industry, because he had ethics and his word could be trusted. He has a large presence to match his size and heart with snow white hair, blue eyes and a pink angelic Irish face. I also came to the realization that I had only a limited amount of control when working with artists due to their ephemeralness. Paul didn't live up to specific agreements we made, which resulted in the loss of a client, as well as, a friend. At one point we were very close and he stood as my daughter's godfather.

I had finished the first eight volumes in the China Living Treasures series and decided to focus on video production. In the video series I could control all aspects of pre-production, post-production and distribution. I decided to proceed in a different direction. My wife Dawn was offered a job on the East Coast and my daughter Meghan was two years old. Returning to the East Coast would give Meghan an opportunity to have a grandma experience with my mother, who lived in New Jersey. We decided to move out of the Bay Area.

CHAPTER 32

THE QUAKE

OAKLAND POLICE PHOTO

I was sitting on my grey leather couch in my office writing checks for bills with my back to the windows that faced Howard Street. I was scheduled to leave the next day for the East Coast to begin the cosmetic restoration of the house we purchased in New York. The building started to shake. It irritated me. I didn't have time for a tremor and it annoyed me. The shaking didn't stop, however. Instead of a few seconds it lasted to over fifteen seconds, which seemed like minutes, while the building shook. I made my way over to stand under a doorjamb doing a funny dance on the moving floor. The whole building was in motion. I looked out the window. The blacktop surface of the four-lane wide one-way street rolled, as if, shaking a carpet. The street light posts connected to the eight-foot wide sidewalks tipped and almost touched our building. Immediately all the traffic lights went out. It wasn't a tremor. I thought, this is the big one. With no electricity I tried

the phone and the lines still worked, but the buttons on the various lines in the receiver wouldn't light up. Cell phones did not exist.

It was toward the end of the day and evening fast approaching. I called my sister in New York and told her we were alright and to call my mother so she wouldn't worry. I left the office and headed to the entrance to the Bay Bridge only a few blocks away to return to Berkeley. The traffic was a bit chaotic given there were no traffic lights at the intersections, but people were very courteous and took their turn at the appropriate time. I got to the entrance of the bridge and there were cars coming off the bridge from the entrance ramp. This meant something was terribly wrong. At the time I didn't know part of the Bay Bridge had collapsed. I decide to go over to the Mission District to the Different Fur Recording Studio owned by my friends Susan Skaggs and Howard Johnson. When I got to Nineteenth Street, most of the staff were on the sidewalk with candles and chairs having a spontaneous party. By this time night had fallen. They had a portable radio to try to figure out the status of the city in regard to damage. The two areas I had been in South of Market and the Mission District had no power. The Bay Bridge wasn't an option, so I decided to head to the Golden Gate Bridge to Marin county in order to connect with the Richmond-San Rafael Bridge to return to Berkeley through Richmond. I made my way through the various neighborhoods of San Francisco like the Castro, the Haight Asbury and Cow Hollow on the way to the Golden Gate Bridge. There were people in the busiest intersections directing traffic. Sometimes a Power and Light worker, but often just a citizen with a flashlight. There was a tremendous rallying of support for each other as one race, the human race, and everyone wanted help in whatever way they could. The Mission District, a poor Hispanic neighborhood, where the recording studio was located had no incidences of looting or theft.

I made it over the two bridges, which fortunately had survived the quake. When I got home, Meghan was there with Dawn. Dawn worked on the San Mateo Peninsula. Her ASCAP office building was on a land fill above the actual fault. Her vehicle became one of the last cars to cross the San Mateo Bridge to the lower East Bay to return to Berkeley. Russell arrived shortly after. He had been in the BART tube under the

bay, when the earthquake took place. Everyone was safe. And it seemed like an omen to support our departure.

At 6.9 it was the biggest earthquake since 1906 in San Francisco[cix] and the first earthquake broadcast live on national TV. It occurred just before the beginning of the third game of the World Series between the Bay Area teams of the San Francisco Giants and the Oakland Athletics. The quake did over six billion dollars in damage. I had to delay my departure for three days until the San Francisco airport resumed normal flights. When I flew out, the aerial view of the city revealed the catastrophic damage.

FOOTNOTES

[i] https://en.wikipedia.org/wiki/Frank_Hague

[ii] https://en.wikipedia.org/wiki/A._Harry_Moore

[iii] https://en.wikipedia.org/wiki/Jackie_Robinson

[iv] copyright - All rights reserved by LI Phil

[v] https://en.wikipedia.org/wiki/Lillian_Gish

[vi] https://en.wikipedia.org/wiki/Jersey_Shore_shark_attacks_of_1916

[vii] https://en.wikipedia.org/wiki/Stanford_White

[viii] https://en.wikipedia.org/wiki/Seabright_Lawn_Tennis_and_Cricket_Club

[ix] https://www.nytimes.com/1978/03/12/archives/henry-d-mercer-is-dead-at-84-founder-of-steamship-company.html?search-input-2=henry+d.+mercer

[x] https://en.wikipedia.org/wiki/Robert_Trent_Jones

[xi] https://en.wikipedia.org/wiki/Creature_from_the_Black_Lagoon

[xii] https://en.wikipedia.org/wiki/Greentree_Stable

[xiii] https://en.wikipedia.org/wiki/Please_Mr._Postman

[xiv] https://en.wikipedia.org/wiki/Hitsville_U.S.A.

[xv] https://en.wikipedia.org/wiki/Happy_Days

[xvi] https://en.wikipedia.org/wiki/American_Graffiti

[xvii] https://en.wikipedia.org/wiki/The_Seven_Deadly_Sins_(1962_film)

[xviii] https://en.wikipedia.org/wiki/Becket

[xix] copyright - Bill Denver/Equiphoto – all rights reserved

[xx] https://en.wikipedia.org/wiki/Monmouth_Park_Racetrack

[xxi] https://en.wikipedia.org/wiki/Harkness_table

[xxii] https://en.wikipedia.org/wiki/Rollie_Free

[xxiii] https://en.wikipedia.org/wiki/Ren%C3%A9_Magritte

[xxiv] https://en.wikipedia.org/wiki/Amos_%27n%27_Andy

[xxv] https://www.jfklibrary.org/learn/about-jfk/jfk-in-history/green-berets

[xxvi] https://en.wikipedia.org/wiki/Nighthawks

[xxvii] https://en.wikipedia.org/wiki/Ichabod_Crane

[xxviii] https://en.wikipedia.org/wiki/Walter_Cronkite

[xxix] https://en.wikipedia.org/wiki/Cannery_Row_(novel)
[xxx] https://en.wikipedia.org/wiki/Free_Speech_Movement
[xxxi] https://en.wikipedia.org/wiki/Napalm
[xxxii] https://en.wikipedia.org/wiki/Concord_Naval_Weapons_Station
[xxxiii] https://en.wikipedia.org/wiki/Selective_Service_System
[xxxiv] https://en.wikipedia.org/wiki/Cold_War_(1953%E2%80%931962)
[xxxv] https://en.wikipedia.org/wiki/Cuban_Missile_Crisis
[xxxvi] copyright- Jerry Burchard - all rights reserved
[xxxvii] https://en.wikipedia.org/wiki/Question_authority
[xxxviii] https://en.wikipedia.org/wiki/Freedom_of_Information_Act_(United_States)
[xxxix] https://en.wikipedia.org/wiki/Black_Panther_Party
[xl] https://en.wikipedia.org/wiki/Diggers_(theater)
[xli] https://en.wikipedia.org/wiki/The_Lineup_(TV_series)
[xlii] https://en.wikipedia.org/wiki/Muir_Woods_National_Monument
[xliii] https://en.wikipedia.org/wiki/The_Apu_Trilogy
[xliv] https://en.wikipedia.org/wiki/Night_of_the_Living_Dead
[xlv] https://en.wikipedia.org/wiki/Monterey_Pop_Festival
[xlvi] https://en.wikipedia.org/wiki/Ahimsa
[xlvii] https://en.wikipedia.org/wiki/Pachuco
[xlviii] https://en.wikipedia.org/wiki/High_Sierra_(film)
[xlix] https://en.wikipedia.org/wiki/The_Brotherhood_of_Eternal_Love
[l] https://en.wikipedia.org/wiki/Easy_Rider
[li] https://www.wikiart.org/en/diego-rivera/the-making-of-a-fresco-showing-the-building-of-a-city-1931
[lii] https://en.wikipedia.org/wiki/Chicago_Seven
[liii] https://en.wikipedia.org/wiki/Julius_Hoffman
[liv] copyright- John Filo - all rights reserved
[lv] https://en.wikipedia.org/wiki/Kent_State_shootings
[lvi] https://en.wikipedia.org/wiki/James_McCann_(drugs_trafficker)
[lvii] https://en.wikipedia.org/wiki/Iroko
[lviii] https://en.wikipedia.org/wiki/The_Mousetrap
[lix] https://en.wikipedia.org/wiki/Spiro_Agnew
[lx] https://en.wikipedia.org/wiki/In_Search_of_the_Miraculous
[lxi] https://en.wikipedia.org/wiki/Mustang_Ranch

lxii https://en.wikipedia.org/wiki/David_Rubinson
lxiii https://en.wikipedia.org/wiki/Heartsfield
lxiv https://en.wikipedia.org/wiki/Keith_Moon
lxv https://en.wikipedia.org/wiki/The_Who
lxvi https://en.wikipedia.org/wiki/Charlie_Daniels
lxvii https://en.wikipedia.org/wiki/Jaco_Pastorius
lxviii https://en.wikipedia.org/wiki/Birdland_(song)
lxix https://en.wikipedia.org/wiki/Munich_massacre
lxx https://en.wikipedia.org/wiki/Gil_Scott-Heron
lxxi https://en.wikipedia.org/wiki/Joel_Selvin
lxxii https://en.wikipedia.org/wiki/Nipper
lxxiii https://en.wikipedia.org/wiki/Inglenook_(winery)
lxxiv https://en.wikipedia.org/wiki/The_Godfather_(film_series)
lxxv https://en.wikipedia.org/wiki/American_Graffiti
lxxvi https://en.wikipedia.org/wiki/Taxi_Driver
lxxvii https://en.wikipedia.org/wiki/Star_Wars
lxxviii https://en.wikipedia.org/wiki/Jerry_Wexler
lxxix https://en.wikipedia.org/wiki/Roy_Orbison
lxxx https://en.wikipedia.org/wiki/Willie_Brown_(politician)
lxxxi
https://www.washingtonpost.com/archive/lifestyle/1984/07/16/tonight
-the-town-is-willie-browns/0484f4c3-aea5-43dd-b788-
f454141308bf/?noredirect=on&utm_term=.742796f46468
lxxxii https://www.nytimes.com/1984/07/20/style/in-san-francisco-the-
week-of-100-parties.html
lxxxiii https://en.wikipedia.org/wiki/Wong_Jack_Man
lxxxiv https://en.wikipedia.org/wiki/Albert_and_David_Maysles
lxxxv https://en.wikipedia.org/wiki/Martin_Scorsese
lxxxvi
https://en.wikipedia.org/wiki/From_Mao_to_Mozart:_Isaac_Stern_in_
China
lxxxvii https://en.wikipedia.org/wiki/Jade_Buddha_Temple
lxxxviii https://en.wikipedia.org/wiki/Ma_Yueliang
lxxxix https://en.wikipedia.org/wiki/Fu_Zhongwen
xc https://en.wikipedia.org/wiki/Kokopelli
xci https://en.wikipedia.org/wiki/Loki
xcii https://en.wikipedia.org/wiki/Shaolin_Monastery

xciii https://en.wikipedia.org/wiki/Bodhidharma
xciv https://en.wikipedia.org/wiki/Cultural_Revolution
xcv https://en.wikipedia.org/wiki/Paul_Kantner
xcvi https://en.wikipedia.org/wiki/Wavy_Gravy
xcvii https://en.wikipedia.org/wiki/The_Wild_Tchoupitoulas
xcviii https://en.wikipedia.org/wiki/Junior_Walker
xcix https://en.wikipedia.org/wiki/Sam_%26_Dave
c https://en.wikipedia.org/wiki/Warren_Hinckle
ci https://en.wikipedia.org/wiki/Bud_Houser
cii https://en.wikipedia.org/wiki/Jim_McKay
ciii https://en.wikipedia.org/wiki/Marty_Glickman
civ https://en.wikipedia.org/wiki/Al_Oerter
cv https://en.wikipedia.org/wiki/Chariots_of_Fire
cvi https://en.wikipedia.org/wiki/Los_Angeles_Olympics
cvii https://en.wikipedia.org/wiki/Marty_Glickman
cviii https://en.wikipedia.org/wiki/Hot_Tuna
cix https://en.wikipedia.org/wiki/1989_Loma_Prieta_earthquake

Made in the USA
San Bernardino, CA
07 June 2020